D1126000

**Modern Painting and
the Northern Romantic Tradition:
Friedrich to Rothko**

ROBERT ROSENBLUM

Modern Painting and the Northern Romantic Tradition

FRIEDRICH TO ROTHKO

With 314 illustrations

ICON EDITIONS

HARPER & ROW, PUBLISHERS

NEW YORK, EVANSTON, SAN FRANCISCO, LONDON

Contents

Foreword and Acknowledgments

In the kind invitation I received to be Slade Professor of Fine Art at Oxford University, it was suggested that my eight public lectures be of a broad and speculative character. To most art historians, especially in the English-speaking world, such a challenge would be an uncommon one. For better or for worse, we feel more at home in the secure foothills of facts than in the precarious summits of ideas, and are happier proving a date than constructing a new historical synthesis. Still, like many of my colleagues, I have often had a nagging desire to try my hand at something more adventurous and lofty than the usual scholarly article; and the Slade Lectures seemed the now-or-never opportunity to attempt a more airborne than earthbound reading of that large segment of art history, from Romanticism to the present, which we loosely refer to as 'modern art'. I should say that in many earlier offguard moments—especially in more casual and generally unfootnoted essays on topics ranging from Friedrich to the 'Abstract Sublime'[1]—I have had glimmers of a new structure of the history of modern art; and on one earlier occasion, I explored the topic, 'Romanticism and Twentieth-Century Art', in the three Lethaby Lectures I gave at the Royal College of Art, London, in June 1970. Nevertheless, it was the Slade Professorship that finally granted me the chance of ordering these diverse *aperçus* into a more sustained, eight-part argument. These eight lectures were first given at Oxford University in April–May 1972; then repeated with, I hope, some changes for the better at the Institute of Fine Arts, New York University, during the fall term, 1972; and are now revised and presented here with the usual risks attending the transposition into a book of a series of lectures whose persuasiveness may have depended in good part upon techniques of audio-visual sequence and informal delivery rather than upon the leisurely scrutiny of an argument on a printed page.

The gist of my ambitious argument is this: that there is an important, alternate reading of the history of modern art which might well supplement the orthodox one that has as its almost exclusive locus Paris, from David and Delacroix to Matisse and Picasso. My own reading is based not on formal values alone—if such things can really exist in a vacuum—but rather on the impact of certain problems of modern cultural history, and most particularly the religious dilemmas posed

in the Romantic movement, upon the combination of subject, feeling, and structure shared by a long tradition of artists working mainly in Northern Europe and the United States. Such a view is by no means intended to minimize the glories of the French tradition of modern art, which hardly needs support. It is meant rather to suggest another, counter-French tradition in modern art, which may help us to understand better the ambitions and the achievements of such great artists as Friedrich, Van Gogh, Mondrian, and Rothko by viewing them not, so to speak, through Parisian lenses, but rather through the context of a long Northern Romantic tradition, whose troubled faith in the functions of art they all share.

Inevitably, such a structure of modern art must be almost as schematic as that structure which, for example, would read all of painting after 1863 as a series of necessary formal deductions from the premises of Manet's *Déjeuner sur l'herbe*. Therefore, I must stress that I myself am all too conscious of the many subtle and perhaps unsubtle historical distortions I have had to make for the sake of internal logic. Perhaps the most incautious of these is my far too simple-minded polarization between French and non-French art, as if all French painters were concerned primarily, if not exclusively, with art-for-art's sake, and all Northern European painters with its opposite extremes. Still, I have taken the risks of this and other generalizations in the hopes that they will put into clearer focus my overall argument until the time that future historians may wish to take the trouble to refute or to refine it. Being even more aware of the dangers of historical legerdemain than of the occasional necessity of ordering facts into a sweeping structure of ideas, I am very skeptical of any absolutes in history, and especially in the history of modern art, where the works of art themselves are so constantly and so rapidly being uncovered and revaluated. I should be deeply distressed, then, if my own structure of what I now see as a cohesive tradition in modern art were to be codified by innocent readers into a fixed historical truth. Thus, I offer the following with the reservations of an historian who knows how flexible the history of modern art should be and who, trespassing on many fields that are not his own, has had to depend all too often upon secondary sources. I have no reservations, however, about my hope that these lectures will provide many thoughts to agree and to disagree with and that, most of all, they will upset considerably the traditional balance-of-power between Paris and the rest of the world in the often repeated history of modern painting.

To thank all those who have helped to stimulate and to refine the ideas and facts of a book whose origins are more than ten years old is a nervous-making task; for the debt must

surely be larger than one remembers. Nevertheless, the lion's share of my gratitude must certainly go to my students, first at Princeton University and then at New York University. Listening to my tentative ideas in lectures and then challenging or supporting these ideas in seminars, they not only made it possible for me to lay the foundations of this book but also provided many structural and ornamental details. I have tried, when memory permitted, to thank, in the footnotes, specific people for specific debts; but I should add here a further assortment of acknowledgments. At Oxford University itself, where these lectures were first delivered and where my work was furthered by the generous and cloistered hospitality of All Souls College and its warden, John Sparrow, I profited enormously from the ever-receptive scrutiny of Francis Haskell, who questioned my rasher generalizations and encouraged my more moderate ones; and from the equally kind attention of H. G. Schenk, whose studies in the cultural history of Romanticism were so in tune with my own ideas. No less profitable were my conversations with Philip B. Miller, of the City College of New York, who has so often been willing to share with me his insights about German Romanticism in general and about Kleist and Friedrich in particular. I wish to thank, too, William Vaughan, who escorted me through the Friedrich exhibition he helped to organize at the Tate Gallery in 1972 and who discussed with me, one by one, the pictures included there. For other kinds of gratitude, I should also cite my student, Kristin Murphy, who, studying Munch, was willing, as a specialist, to read and to check my own amateur words on this artist; Frederick Spencer Levine, who kindly sent me a copy of his Master's Thesis on Marc, from which I borrowed heavily; Robert Welsh, without whose learned writings on Mondrian my Chapter VII would have been mere speculation; Gerda S. Panofsky, who often helped me with botanical identifications; Helen Winkler, who was kind enough to show me through the Rothko Chapel in Houston both by day and by night and to answer my many questions about it; and Mrs. Dominique and the late John de Ménil, without whose enlightened patronage the Rothko Chapel—my final example of the Northern Romantic tradition—would not have existed at all.

R.R.

New York, 1973

Part I Northern Romanticism and the resurrection of God

1 Friedrich and the divinity of landscape

THE ALPHA and the omega of this eccentric Northern route that will run the gamut of the history of modern painting without stopping at Paris may be located in two works: Caspar David Friedrich's *Monk by the Sea*, a picture whose 1 seeming emptiness bewildered spectators when it was first exhibited at the Berlin Academy in the autumn of 1810; and a characteristic Mark Rothko of the 1950s, whose image of 2 something near to nothingness was equally disconcerting to its first audiences. If these paintings look alike in their renunciation of almost everything but a somber, luminous void, is this merely an example of what Erwin Panofsky once called 'pseudomorphosis',[1] that is, the accidental appearance at different moments in the history of art of works whose close formal analogies falsify the fact that their meaning is totally different? Or does this imply that there may be a true connection between Friedrich and Rothko, that the similarity of their formal structure is the result of a similarity of feeling and intention and that, indeed, there may even be a tradition in modern painting that could bridge the century and a half

1 CASPAR DAVID FRIEDRICH
Monk by the Sea
1809

2 MARK ROTHKO
Green on Blue
1956

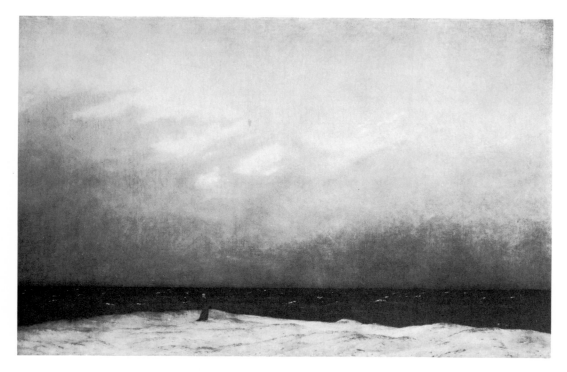

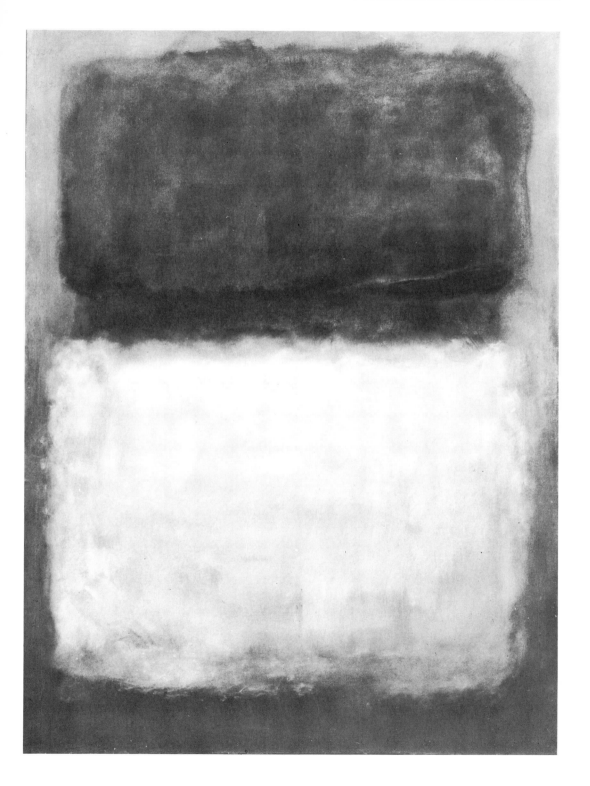

that separates them? And if this is the case, is it possible that such a tradition might have only peripheral contact with the time-honored history of modern painting, which finds its landmarks primarily in Paris, in David's *Oath of the Horatii*, in Manet's *Déjeuner sur l'herbe*, in Picasso's *Demoiselles d'Avignon*, in Matisse's *Red Studio*?

To approach the question from a still broader angle, what is one to make of even further formal analogies that may be found between other non-Parisian artists of Friedrich's generation and other non-Parisian contemporaries of Rothko? If one considers, for example, the definitive image that made the work of, say, Jackson Pollock and Clyfford Still as well as Rothko immediately identifiable, is it only a coincidence that these very configurations may all be found in the works of Northern Romantic painters? Thus, the archetypal forms of Rothko (a static expanse of dematerial-ized, luminous color), of Pollock (a dynamic whirlpool of equally bodiless energy), of Still (a slow but relentless surface growth of incommensurable shapes like those on bark or rock) can all be found within the repertory of only one of Friedrich's contemporaries, the great Joseph Mallord William Turner, a master whose choice of spectacular motifs in nature ranged from the glowing, Rothko-like mystery and calm of the haziest sunrises and sunsets, to the furious, Pollock-like *perpetuum mobile* of blinding blizzards and tem-pestuous seas, to the errant, Still-like geological patterns that marked the ancient surfaces and contours of grottos and mountains. Is this significant? Is the recurrence of Turner's isolation of nature's primordial elements—light, energy, elemental matter—within the more abstract vocabularies of, respectively, Rothko, Pollock, and Still, only a coincidence?

To begin to answer these questions, one might return to Friedrich's *Monk by the Sea* and confront the difficulties one would have in locating the painting within traditional, pre-Romantic subject categories. Could it possibly be considered a genre painting or, more likely, a marine painting in the tradition of those Dutch seventeenth-century masters—Ruisdael, Van de Velde, Van de Capelle—who painted the sea viewed by figures on the shore or from another boat? For it was their works that would have provided the firmest support for Friedrich, who was born in the Baltic coastal town of Greifswald and who, from his artistic beginnings, explored the motifs of shore, sea, sky, and boats. Yet within this Northern Baroque tradition of sea painting, the tradition most accessible to and compatible with Friedrich, the *Monk by the Sea* strikes an alien, melancholic note, strange not only in the presence of so dense, so haunting, and so uninterrupted an expanse of somber, blue-gray light above a low horizon, but in the disturbing absence of any of the expected compo-

308
297
293

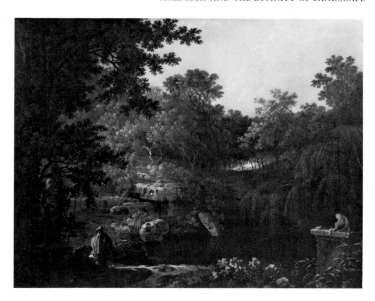

3 RICHARD WILSON
Solitude
1762

nents of conventional marine painting. Indeed, as Marie Helene, the wife of Friedrich's artist-friend Gerhard von Kügelgen, complained, there was nothing to look at—no boats, not even a sea monster.[2] By any earlier standards, she was right: the picture is daringly empty, devoid of objects, devoid of the narrative incident that might perhaps qualify it as genre painting, devoid of everything but the lonely confrontation of a single figure, a Capuchin monk, with the hypnotic simplicity of a completely unbroken horizon line, and above it a no less primal and potentially infinite extension of gloomy, hazy sky. Just how daring this emptiness was may even be traced in evolutionary terms, for it has recently been disclosed in X-rays that originally Friedrich had painted several boats on the sea, one extending above the horizon, but that then, in what must have been an act of artistic courage and personal compulsion, he removed them, leaving the monk on the brink of an abyss unprecedented in the history of painting[3] but one that would have such disquieting progeny as Turner's own 'pictures of nothing' and the boundless voids of Barnett Newman.

That the only figure who contemplates this bleak vista is, in fact, a monk may suggest a tradition other than marine or genre painting in which to locate Friedrich's picture, a tradition exemplified in such a work as Richard Wilson's *Solitude* 3 of 1762, in which a pair of monks take their lonely places in a landscape made all the more melancholy by the presence of weeping willows.[4] Still, even the incipient Romanticism of this moody landscape, which harks back to Salvator Rosa and which reverberates with the unworldly, ascetic associations evoked by the presence of two monks,[5] seems contrived and

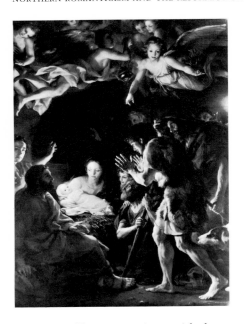

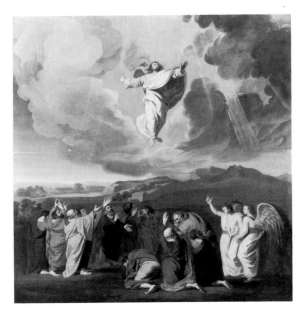

impersonal by comparison with the uncommon starkness and intensity of Friedrich's solitary monk before nature. Although we would surely hesitate to call Wilson's painting 'religious', despite the presence of religious motifs, Friedrich's painting suddenly corresponds to an experience familiar to the spectator in the modern world, an experience in which the individual is pitted against, or confronted by the overwhelming, incomprehensible immensity of the universe, as if the mysteries of religion had left the rituals of church and synagogue and had been relocated in the natural world. It has almost the quality of a personal confession,[6] whereby the artist, projected into the lonely monk, explores his own relationship to the great unknowables, conveyed through the dwarfing infinities of nature. For modern spectators, Friedrich's painting might even fulfill the transcendental expectations of religious art although, to be sure, it conforms to no canonic religious subject and could therefore be considered in no way a religious painting by pre-Romantic, that is, pre-modern standards.

Friedrich's dilemma, his need to revitalize the experience of divinity in a secular world that lay outside the sacred confines of traditional Christian iconography was, as we can still intuit from his works, an intensely personal one. Yet it was also a need that was shared, on different levels, by many of his contemporaries who responded to the eighteenth century's repeated assaults upon traditional Christianity and who hoped to resurrect or to replace the stagnant rituals and images of the Church. Friedrich's intentions, in fact, are closely paralleled in theological terms by the writings and

4 ANTON RAPHAEL MENGS
Adoration of the Shepherds
1771–72

5 JOHN SINGLETON COPLEY
Ascension
1775

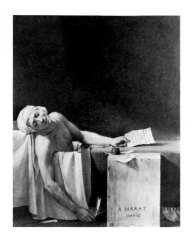

6 JACQUES-LOUIS DAVID
Death of Marat
1793

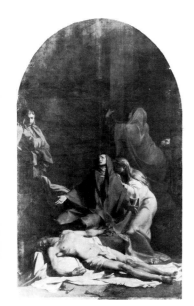

7 JEAN-BAPTISTE REGNAULT
Lamentation
1789

preachings of another German Protestant of his generation, Friedrich Ernst Daniel Schleiermacher, who was born in 1768, just six years before the artist.[7] Living in Berlin, which had become in the eighteenth century one of the strongholds of anti-Christian sentiment, Schleiermacher hoped to revive Christian belief in drastically new terms. In 1798 he published anonymously a treatise, *Reden über die Religion an die Gebildeten unter ihren Verächtern* (On Religion: Speeches to Its Cultured Despisers), a plea to preserve the spiritual core of Christianity by rejecting its outer rituals and by cultivating a private experience of piety that could extend to territories outside Christian dogma. And his own preaching concentrated on *Selbstmitteilung*, that is, a kind of personal unbosoming of subjective responses before the mysteries of divinity, a communication of feeling that offers a theological counterpart to Friedrich's monk. Just as Karl Barth was later to find in Schleiermacher the figure of a reformer of modern theology who tried to adopt the moribund conventions of the Church to the new experiences of the modern world,[8] so too could Friedrich be considered a pivotal figure in the translation of sacred experience to secular domains. Indeed, Schleiermacher's theological search for divinity outside the trappings of the Church lies at the core of many a Romantic artist's dilemma: how to express experiences of the spiritual, of the transcendental, without having recourse to such traditional themes as the Adoration, the Crucifixion, the Resurrection, the Ascension, whose vitality, in the Age of Enlightenment, was constantly being sapped.

For artists working in the later eighteenth century, the perpetuation of these time-honoured themes—when demanded, that is, by the requirements of academies or the commissions of church or court—was a difficult task, and usually involved the respectful but often stillborn paraphrasing of venerated masterpieces from earlier ages of great religious art. Such is the case in Anton Raphael Mengs's *Adoration of the Shepherds* of 1771—72, which offers only the most modest variations on the classic statement of this theme by Correggio; and such is the case, too, in John Singleton Copley's ambitious *Ascension* of 1775, which offers only an awkward, earthbound echo of Raphael's heaven-borne *Transfiguration*. For, beginning at that time, the experience of divinity, of martyrdom, of spiritual realms, was translated more and more into subjects that lay far beyond the pale of the Church. In France in particular, the political events of the Revolution and Empire demanded the transposition of Christian martyrs and deities to contemporary historical experience, so that Jacques-Louis David's murdered Marat of 1793, the representation of an atheist by an atheist, has usurped the role of Jean-Baptiste Regnault's martyred Christ painted for the Chapel at

4

5

6

7

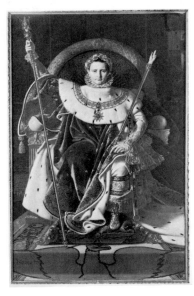

8 JEAN-AUGUSTE-DOMINIQUE INGRES
Napoleon I on his Imperial Throne
1806

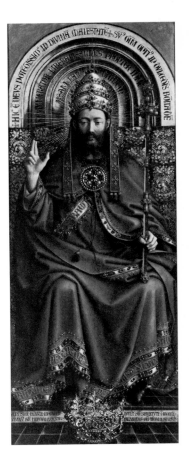

Fontainebleau before, and exhibited after, the events of 14 July 1789. '*Personne n'y croit plus*' is what Chateaubriand was to write about religion in 1797;[9] but if no one in France believed in it any longer, other new religions were to take the place of Christianity. The pseudo-Christian martyrs of the Revolution were succeeded by the pseudo-Christian deity of Napoleon, who, in Ingres's unforgettably hieratic icon of 1806, has occupied the throne of Jan van Eyck's *God the Father*, translating timeless, motionless, heavenly power into the persona of the new emperor of France. And even in Spain, which had conserved most tenaciously the trappings of the Church, the realities of contemporary history were recorded with passions borrowed from Christian formulas.

9 JAN VAN EYCK
God the Father
(from the *Ghent Altarpiece*)
completed 1432

10 FRANCISCO JOSÉ DE GOYA Y LUCIENTES
Executions of May 3, 1808
1814

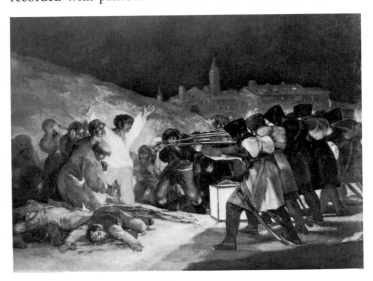

So it is that Goya's *Executions of May 3, 1808*, a painting of 10 1814 that commemorates the martyrdom of Spanish guerrillas who had risen against the Napoleonic invaders, remains for modern spectators an even more potent image of suffering and the doubts of redemption than its Christian counterpart, *The Agony in the Garden*, painted by Goya five years later and 11 given to a church in Madrid.

These secular translations of sacred Christian imagery into the language of modern semi-divinities—new martyrs, new heroes, new heads of state—can be found throughout Western art of the Romantic era, in David, Ingres, and Goya or in Anglo-American masters like West and Copley, who could rephrase the tragic deaths of such modern military leaders as General James Wolfe or Major Francis Peirson in terms of traditional Pietàs.[10] In both Catholic and Protestant countries, these transvaluations of Christian experience were inevitably based on the corporeal motifs inherited from Christian iconography: palpable visions of earthly tragedy or heavenly grandeur as conveyed through noble figural compositions. Yet in the Protestant North, far more than in the Catholic South, another kind of translation from the sacred to the secular took place, one in which we feel that the powers of the deity have somehow left the flesh-and-blood dramas of Christian art and have penetrated, instead, the domain of landscape.

Already by the 1760s and 1770s, those decades in which one first begins to feel the stirrings that became more and more agitated in the course of the Romantic movement, there were artists as far afield as Ireland and Switzerland, who suddenly turned to specific sites in wild nature that seemed to elicit at the least, curiosity, and at the most, divine revelation, in the intrepid tourists who observed them. Undoubtedly inspired by another Irishman, Edmund Burke, whose *Philosophical Enquiry into the Origins of Our Ideas of the Sublime and the Beautiful* (1756) was to become a major aesthetic source for the first generation of Romantic artists in search of overwhelming and fear-inspiring experiences, the painter George Barret could record on his native Irish soil the Powerscourt 12 Waterfall and exhibit this topographical fact of sublime nature to a London audience of the 1760s.[11] Similarly, a Swiss master, Caspar Wolf, could paint at the same time the 13 astonishing falls and mountains of his native Alps, geological wonders that had earlier been considered more of a dangerous obstacle to Continental transportation than a source of visual and emotional awe. But we fortunately have the abundant words of contemporary writers to tell us, as Goethe did in the 18 August 1771 entry of the young Werther's heartfelt outpourings, just what sensations such landscapes might arouse:

11 FRANCISCO JOSÉ DE GOYA
Y LUCIENTES
Agony in the Garden
1819

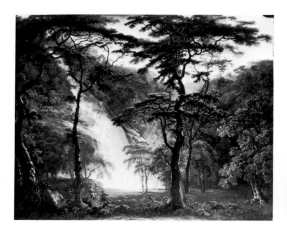

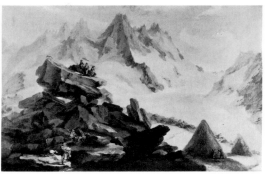

I felt myself exalted by this overflowing fullness to the perception of the Godhead, and the glorious forms of the infinite universe stirred within my soul! Stupendous mountains encompassed me, abysses yawned at my feet, and cataracts fell headlong down before me; rivers rolled through the plains below, and rocks and mountains resounded from afar.

12 GEORGE BARRET
Powerscourt Waterfall
c. 1764

13 CASPAR WOLF
The Lauteraar Glacier
1776

Like all such words, feelings, and images first defined in the mid-eighteenth century, these would be multiplied in number and intensity in the decades that followed. There is, for instance, that example of sublime geological gigantism—now so conspicuous in the Tate Gallery—James Ward's 14 painting of the Yorkshire wonder, Gordale Scar, a site which had long been considered unpaintable and which, as early as 1769, had been admired 'not without shuddering' by the poet Thomas Gray.[12] The very dimensions of Ward's painting—about eleven by fourteen feet—are now meant to make us shudder no less than the breathtaking scale, which reduces the cattle (and therefore us) to Lilliputian dimensions, and the dark and erratic contours of the clouds overhead that almost touch the jagged silhouettes of the scar itself.

On the other side of the Atlantic and on the other side of the Channel, these native British landscape sublimities could be even further magnified. Most prominent among these sublime sites was (as it still is) Niagara Falls, which could be seen by London spectators at the Royal Academy as early as 1774 in a painting, dependent on secondary sources, by the Welsh master, Richard Wilson, but which naturally became a perpetual challenge to native American painters, from 15 Trumbull and Vanderlyn to Fisher and Church, who studied its terrifying grandeurs *in situ* and who tried to expand their pictorial imaginations and, like Ward with *Gordale Scar*, even the actual dimensions of their canvases in order to encompass such sublimities.[13] As memorable as these pictorial records of Niagara are, the revelations of a foreign visitor, the Irish

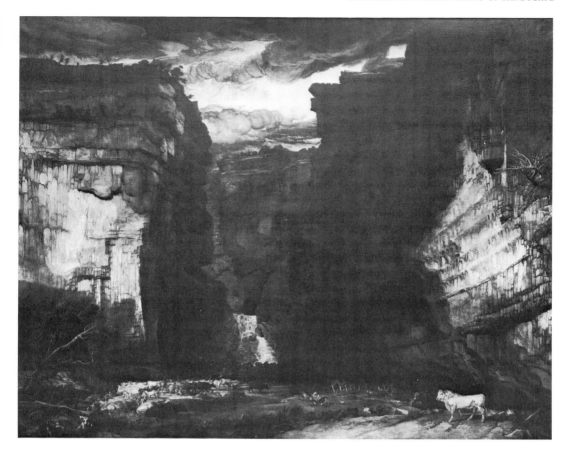

14 JAMES WARD
Gordale Scar
1811–15

Romantic poet Thomas Moore, made even more explicit, in a letter to his mother of 24 July 1804, the curious new Romantic amalgam of God and nature:

I felt as if approaching the very residence of the Deity; the tears started into my eyes; and I remained, for moments after we had lost sight of the scene, in that delicious absorption which pious enthusiasm alone can produce. We arrived at the New Ladder and descended to the bottom. Here all its awful

15 FREDERIC EDWIN CHURCH
Niagara Falls
1857

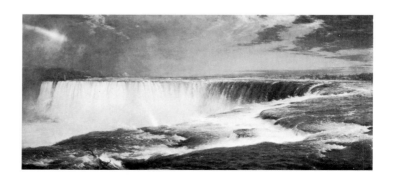

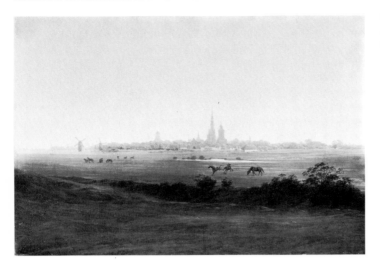

16 CASPAR DAVID FRIEDRICH
Meadow at Greifswald
after 1820

17 JOSEPH MALLORD WILLIAM
TURNER
*Petworth Park, Tillington Church
in the Distance*
c. 1830

sublimities rushed full upon me. My whole heart and soul
ascended toward the Divinity in a swell of devout admiration,
which I never before experienced. Oh! bring the atheist here,
and he cannot return an atheist. I pity the man who can coldly
sit down to write a description of these ineffable wonders;
much more do I pity him who can submit them to the
measurement of gallons and yards. . . . We must have new
combinations of language to describe the Fall of Niagara.[14]

Moore's relocation of divinity in nature, far from the
traditional rituals of Christianity, could be inspired in many
Romantics not only by torrential cataracts and vertiginous
abysses, but also by the opposite extreme of an uncommon
stillness and silence. Even within the precincts of inhabited,
cultivated landscapes, masters like Friedrich and Turner
could project an aura of mystery that began to tread upon
16 otherworldly realms. Thus, in both Friedrich's view from a
meadow of his native city, Greifswald, and in Turner's
17 equally distant view from the park at Petworth of the village
of Tillington, a strange quiet reigns over the vast expanse of
land. Indeed, the mood is so hushed and meditative that the
topographical facts of the distant architecture—the tiny
houses and church spires whose diminutive silhouettes are

just visible through the haze on the remote horizon—become almost visionary in character, the apparition of some Heavenly City of Jerusalem viewed across a plain radiant with a quietly glowing sunlight.

The mood of intense communion with the most impalpable of nature's phenomena—light, color, atmosphere—is made even more explicit in some of Friedrich's early paintings where figures—in one case, a woman before a meadow at sunrise; in another, two men before the sea at sunset—contemplate in quasi-religious stillness the mysteries of nature's most commonplace daily dramas. In both these works, the presence of static figures, seen from behind and frozen into place by the starkly simple symmetries of the compositions, permits the spectator a maximum of empathy, for he can easily take his place beside or within these faceless beings who

18
19

18 CASPAR DAVID FRIEDRICH
Woman in Morning Light
c. 1809

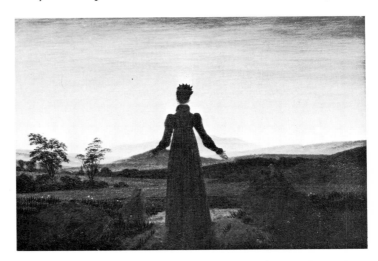

19 CASPAR DAVID FRIEDRICH
Two Men by the Sea
c. 1817

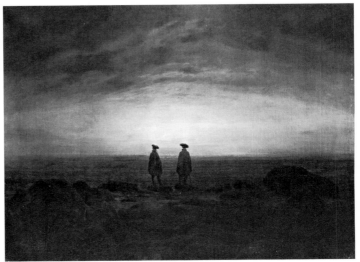

seem transfixed and absorbed by the luminous spectacle before them. The experience is akin to Emerson's passionate search for a primal immersion in a God-given nature:

Standing on the bare ground,—my head bathed by the blithe air, and uplifted into infinite space,—all mean egotism vanishes. I become a transparent eye-ball; I am nothing; I see all; the currents of the Universal being circulate through me; I am part or parcel of God. . . .[15]

Or it is like the avowal of Friedrich's disciple, Carl Gustav Carus, who in his letters on landscape could write:

. . . When man, sensing the immense magnificence of nature, feels his own insignificance, and, feeling himself to be in God, enters into this infinity and abandons his individual existence, then his surrender is gain rather than loss. What otherwise only the mind's eye sees, here becomes almost literally visible: the oneness in the infinity of the universe. . . .[16]

For in these paintings, as in these written testimonies, the experience of the supernatural has once again been transposed from traditional religious imagery to nature. Transcending conventional categories, these pictures by Friedrich can no longer be considered genre or landscape or marine painting. The relation of the figures to the landscape now bears a privacy, an intensity which trespasses upon the domain of a kind of silent, Protestant meditation upon the mysteries of the beyond. Pitted like Emerson against the infinity of the universe, these lonely figures now seek to merge with the God-given world outside them—indeed, the woman seems almost to be raising her hands in an orant posture that would move in the closest harmony with the ascent of the sun on the horizon, whereas the two men contemplating the sunset are

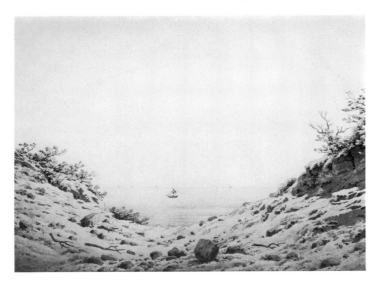

20 CASPAR DAVID FRIEDRICH,
Coastal View
c. 1824

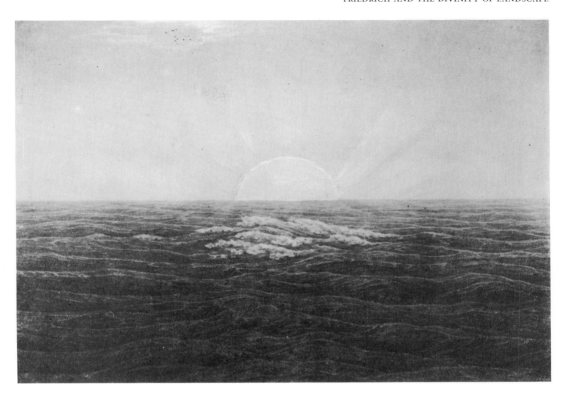

21 CASPAR DAVID FRIEDRICH
Sea with Sunrise
1826

so reduced in scale that they seem on the verge of that kind of spiritual absorption described by transcendental poets and writers of the Romantic era.

If these figures are standing both literally and figuratively on the brink of some elemental and mystical experience in nature, Friedrich, on many other occasions, actually drew and painted the stark spectacle they might be contemplating. Fascinated by the barren dunes of the Baltic coast, he could 20 at times record their bleak contours in settings that locate us near a precipice of nothingness. Such landscapes, evocative of nature in some primitive, uninhabited state, become more discernibly symbolic in other drawings that offer more literally a Book of Genesis imagery. In the first of a series that represented a cycle of life[17]—a theme that in various symbolic guises obsessed Friedrich's melancholy imagination—one is presented with a vision of the primeval emergence of order out of chaos: in the exact center, the barely discernible semi- 21 circle of the sun casts its lucid rays upon the chaotic movements of the primal sea below. The composition is as elementary as the subject—it is constructed on axes of both vertical and horizontal symmetry—and the forms within it are no less rudimentary in their reduction to a perfect horizon and the stark contrast of air and water. Even without the commentaries by Friedrich's contemporaries, which articulate the

23

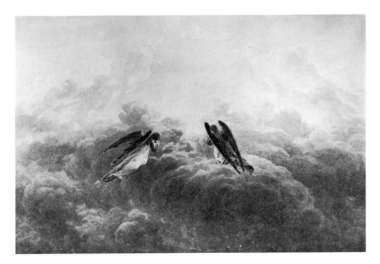

22 CASPAR DAVID FRIEDRICH
Angels in Adoration
c. 1834

23 JOSEPH MALLORD WILLIAM
TURNER
Angel Standing in the Sun
(Exh. R.A., 1846)

symbolic character of this drawing,[18] we can feel that an image of such elemental clarity and power could in no way be confused with a prosaic record of the casually observed data of nature. And it should be said, too, that by distilling natural phenomena to so primal a condition that mythic experiences can be evoked, Friedrich expressed an ambition that would recur, as we shall see, throughout the later history of modern painting.

That for Friedrich there was no boundary between the natural and the supernatural could be demonstrated even

more emphatically by other drawings in this cycle of life
series. In a later one, for example, the primal sunlight that had 22
cast its rays upon the chaotic waters is viewed through the
movement of clouds accompanied by praying angels who
float through these elemental vapors. Similarly, Friedrich's
contemporary, Turner, could paint sunlight with such
fervent, quasi-religious intensity that we are not surprised to
find, in a painting exhibited at the Royal Academy in 1846,
that part of the golden glow has congealed into the super-
natural form of an angel. Such a capacity to translate the 23
natural into the supernatural is one thing, among many, that
decisively separates Turner's analysis of shimmering light
from that of the Impressionists, just as it separates Friedrich's
intense scrutiny of nature from that of the many Realist
landscape painters working later in the nineteenth century.

If the conveying of the spirit of the Crucifixion through
Because Friedrich, like Turner, imposed upon everything
he drew and painted an explicit or implicit sense of super-
natural power and mystery in nature, it becomes especially
difficult to categorize his various works as either religious or
secular in character. They are, in fact, both, and nowhere
more tellingly than in those paintings which are nominally
Christian. Of these, the most conspicuous is the so-called
Tetschen Altar, a work commissioned in 1807 by the Count 24
von Thun-Hohenstein for a private chapel in Bohemia. It is
presumably a Crucifixion (and its frame, designed by
Friedrich, even includes such traditional Christian symbols as
the Eye of God and the Eucharistic wheat and wine), but it is
one so thoroughly unlike traditional paintings of this subject
that it quickly offended such a critic as Friedrich von Ram-
dohr, who, after seeing the painting exhibited in Friedrich's
studio in the winter of 1808, wondered whether it was 'a
happy idea to use landscape for the allegorizing of a particular
religious idea, or even for the purpose of awakening devo-
tional feelings.' He concluded that it was really 'an impertin-
ence for landscape painting to seek to worm its way into the
church and crawl upon the altar.'[19]

If the conveying of the spirit of the Crucifixion through
the almost exclusive means of landscape seemed heretical to
Ramdohr, he left unnoticed an even more surprising innova-
tion in the *Tetschen Altar*, namely, that the Crucifixion itself
is not a representation of a flesh-and-blood Christ on the
Cross, but rather of a gilded crucifix, that is, a man-made
object, a relic of Christian ritual and art of a sort that might
be found on a pilgrimage route in the forest. As a result, the
painting, surprisingly, could be interpreted as belonging
entirely to a modern world of empirical observation,
although a world whose component parts have been selected
and organized so carefully that each element is charged with
meaning. Friedrich himself, in a text edited by Semler, a

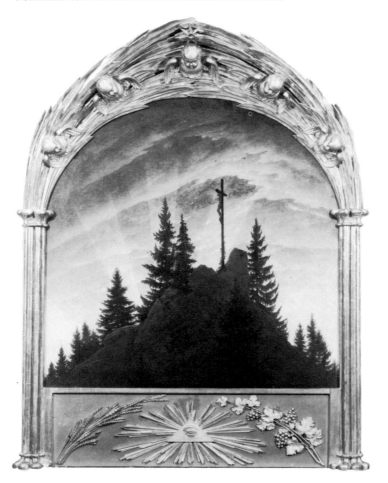

24 CASPAR DAVID FRIEDRICH
Cross in the Mountains
1808

25 CASPAR DAVID FRIEDRICH
Winter Landscape with Church
c. 1811

writer sympathetic to these new interpretations of landscape, described the Christian implications of his painting, which could, theoretically, be only a secular scene of a crucifix viewed against a sunset: 'The cross stands high on a rock, firm and unshakable like our faith in Christ. Fir trees surround it, lasting through the seasons, like our hopes in Him who was crucified.'[20] Thus, even without the presence of the crucifix that faces the concealed sunset, as Friedrich's thoroughly secular woman faces the sunrise, the landscape itself, in its dramatic contrast of the closeness of firm rock and tree against the remoteness of a pervasive luminosity whose setting source is hidden from us, would suggest some uncommon event in nature, composed in terms of an emblematic polarity of dark and light, near and far, palpable and impalpable.

Friedrich's peculiarly modern ambition to alter the iconography of earlier Christian art in the interests of resurrecting faith in the supernatural can be seen in many other paintings that offer what might be called a spectator

approach to Christianity, in which we observe scenes of piety and ritual, and man-made objects of Christian art and architecture. In one such example, we see a winter landscape 25 with a pilgrim who, arriving at a shrine marked by a crucifix (like that in the *Tetschen Altar*), throws away his crutches. In the background, a Gothic church façade, obscured by mist on the horizon, appears like a vision. Or, in another painting, a rude mariner's cross, silhouetted on the shore of the island of Rügen against a rising moon, is seen next to an anchor. 26 These man-made objects and natural facts—the cross, the anchor, the moonrise—could all be explained empirically as the record of something that might plausibly be observed on an island's coast at nightfall, yet again, the intense simplicity of the composition, the absence of any other distracting objects or events, lend everything a fresh Christian meaning. Even the anchor newly revives its traditional Christian symbolism of hope within the context of the cross, though the painting could obviously not be accepted within the traditional pre-Romantic canons of religious art, for its meaning is too private and ambiguous. How pivotal Friedrich's transformation of religious painting is for the modern tradition may be suggested by the fact that even Gauguin's *Yellow Christ* of 1889 is part of its progeny: a painting not of *the* Crucifixion but rather of a man-made crucifix in Brittany,

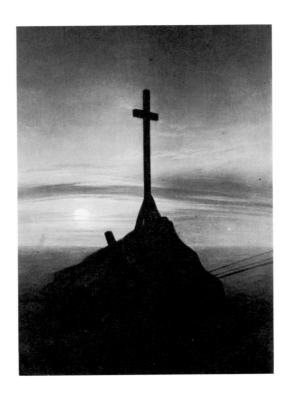

26 CASPAR DAVID FRIEDRICH
Cross at Rügen
c. 1815

an object worshipped by those simple peasants who, like Friedrich's wayfarers, monks, and mariners, still maintain their Christian faith in a modern world of doubt. Friedrich's shift from traditional Christian subject matter to its surrogates —the trappings of Christian piety and the phenomena of nature—was truly of vast consequence for later art.

Among the observable phenomena which Friedrich's genius could invest with a transcendental significance was a motif that became more and more prominent throughout Western art of the late eighteenth and early nineteenth centuries: Gothic architecture. In many cases the record of these architectural survivors of, and witnesses to, a long-lost age of Christian faith might be experienced as religious only by implication. This is especially so in England where, for instance, a watercolor by Thomas Girtin of Kirkstall Abbey in Yorkshire (1800) could be interpreted as representing a serene image of Gothic architecture in the context of un-spoiled, harmonious nature, analogous in its gentle, contem-plative tone to Wordsworth's almost exactly contemporane-ous 'Lines Composed a Few Miles Above Tintern Abbey' (1798).[21] In works like these, however, in which the record of casually observed topographical fact seems so straight-forward, it would be a strain to attribute symbolic meaning to the Gothic abbey, even though in Girtin's watercolor, or, still more emphatically, in some German views of Gothic architecture like those by Carl Blechen, one finds the pervasive Romantic sensibility to the natural or organic aspects of Gothic architecture—a feeling that it is virtually a God-made object, its forms almost identical with the growth of leaves and branches, its cathedral naves a metamorphosis of a forest of trees.[22]

Friedrich, to be sure, shared this viewpoint, and in some of his records of that architectural survivor of the Middle Ages which so fascinated him, the ruins of a fourteenth-century

27 THOMAS GIRTIN
Kirkstall Abbey
1800

28 CASPAR DAVID FRIEDRICH
Ruins of Abbey at Eldena
c. 1824

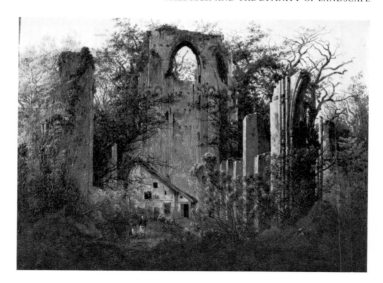

29 CASPAR DAVID FRIEDRICH
Abbey under Oak Trees
1810

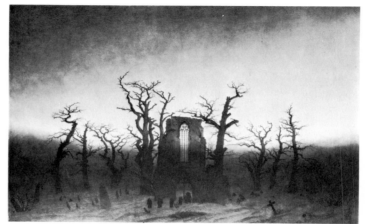

abbey at Eldena, he offered a relatively more matter-of-fact statement of the overgrown relics of this Gothic building, a statement which, like those of many of his contemporaries, might appear too casual, too objective to carry a symbolic burden. But more often Friedrich transformed these and other Gothic data into images charged with meaning about the relation of the natural to the supernatural, of the here and now to the beyond. In an earlier view of a Gothic ruin 29 inspired by Eldena, a view so melancholy that it was referred to by the short-lived German Romantic poet Karl Theodor Körner as a *Totenlandschaft*,[23] a 'landscape of the dead,' it is impossible to mistake these Gothic ruins for merely picturesque relics of a bygone age. Aligned, characteristically for Friedrich, on a central axis, they form the frozen, inflexible focus of a funerary procession of monks who carry a coffin that has arrived at what is literally and figuratively the painting's dead

center, the tiny Gothic portal ruin which marks the transition
from the more darkly and substantially modeled forms of the
immediate foreground to the fainter, more hazily modeled
forms that begin within the bodiless sanctuary of the church's
ruined nave. It is as if we were crossing the very threshold
between life and death, between this world and a world
beyond. Everything contributes to this astonishing image of
the passing into a Christian afterlife: the simple crosses of the
graveyard, almost mistakable for the cruciform patterns of
the adjacent trees and branches; the contrast between the
small Gothic portal, still of human dimensions, and the soar-
ing heights of the abbey choir beyond, scaled to the experi-
ence of divinity, not of man; the season itself, the bleakest,
most silent winter, whose deathly mood of virgin snow and
leafless trees is the exact counterpart to Schubert's melancholic
song cycle, *Die Winterreise (Winter's Voyage)*.

Once again, a comparison of Friedrich's painting with
some of his contemporaries' most famous paintings of Gothic
architecture can underline his potent genius for transforming
fact into symbol. Thus, almost any one of Constable's views
of Salisbury Cathedral, while sharing Friedrich's sensibility
to the analogies between nature and the Gothic—here almost
a literal nave of trees framing the view of the cathedral from
its close—is far too sunny in mood, far too picturesque in
vantage point to convey any transcendental message.
Similarly, Corot's painting of Chartres Cathedral, for all its
insistence upon the natural qualities of the Gothic stone,
which almost seems to grow from the soil and masonry of
the ambient land and houses, and upon the asymmetry of a
pair of trees analogous to the asymmetry of the cathedral
towers themselves, is nevertheless a tourist's-eye view of this

30 JOHN CONSTABLE
*Salisbury Cathedral from the
Bishop's Grounds*
1823

31 CAMILLE COROT
Chartres Cathedral
1830

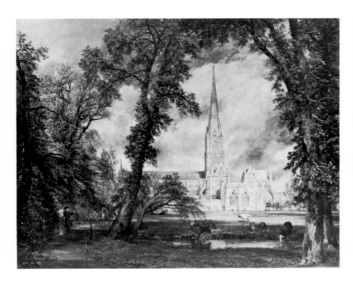

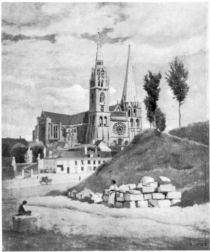

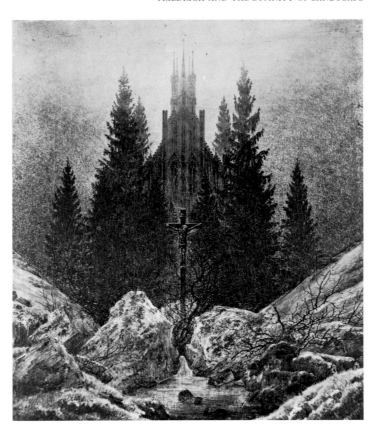

32 CASPAR DAVID FRIEDRICH
Cross and Cathedral in the Mountains
c. 1813

medieval monument, a view whose interpretation of
Christianity and transcendental mysteries can, at the most, be
only implicit.

But Friedrich's attitude toward Gothic architecture was
usually explicit, as in, most conspicuously, the painting of a
Cross and Cathedral in the Mountains of *c.* 1813. Here, another 32
wayfarer's crucifix is seen in the woods, in front of a Gothic
cathedral façade that floats in the hazy background like a
vision defying gravity and palpability. Although these two
relics of Christianity—the Crucifixion and the Gothic façade
—belong to the realm of empirical fact, their conjunction
with such elements of nature as fir trees (which almost
camouflage the frontal silhouette of the church) and a river
source (which almost seems to flow, like blood, from the base
of the cross) immediately imposes a symbolic content upon
these diverse objects of Christianity and of landscape. A
message of faith is conveyed by the coming of new life from
the cross, by the steadfastness of the fir trees, and by the
promise, in the distant Gothic apparition, of some triumphant
resurrection in a world accessible more by spiritual than
physical means. And quite as important, the structure of the

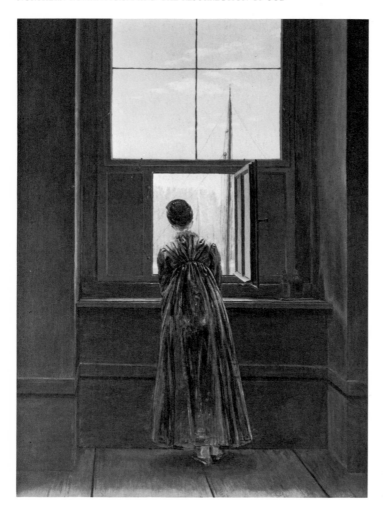

33 CASPAR DAVID FRIEDRICH
Woman at a Window
c. 1822

painting—a strong frontal symmetry that echoes the cruci-
form pattern of the cross itself—makes it clear that the ran-
domness of nature has been replaced by a fixed, emblematic
order that may elucidate an eternal truth.

Friedrich's search for new symbols to elicit transcendental
experience was so intense that it converted almost all earlier
categories of secular painting into a new kind of religious
painting. Such metamorphoses can be traced, too, in his
treatment of ships, a motif that would be expected in the work
of an artist born and raised on the Baltic coast. Some of his
views of ships in a harbor might just possibly be considered
mysterious, moonlit extensions of a seventeenth-century
Dutch tradition of marine painting. Yet, in many other
works, it becomes difficult or impossible to read these boats
as simple records of maritime activity in Greifswald. In one
33 case, the endlessly evocative *Woman at a Window,* the view

34 CASPAR DAVID FRIEDRICH
Stages of Life
after 1818

of the top of a ship's mast beyond the altar-like privacy and enclosure of the shuttered window can conjure up, as in so much Romantic poetic imagery from Coleridge to Emily Dickinson, a mood of mysterious longing for voyages to uncharted regions that may be geographic, spiritual, or both. Elsewhere, Friedrich is far more direct about the ship as a symbol of human destiny, a symbol that could be used by his American contemporary Thomas Cole with overt allegorical intention in a cyclical work, the four-part *Voyage of Life* of 1842, in which the ages of man are traced in the progression of a figure in a boat who passes from youth to old age and ultimately, by extension, into the unexplored waters of death. In Friedrich's *Stages of Life*, the details may still defy 34 the precise interpretation possible in Cole's series, but the overall metaphor of a life cycle, symbolized by the progression from youth to maturity to old age in the five figures on the shore (of whom the children, in imitation of a ship, raise a flag on high) and echoed in the differing positions of five ships moving from the horizon to the eternal rest of the coast, is inescapably clear.[24]

Metaphorically clear, too, is Friedrich's painting of an Arctic shipwreck. Although this chilling motif of frozen death was to begin in Friedrich's *œuvre* as early as 1798 in a picture that seems almost as literal and documentary as a 35 seventeenth-century Dutch painting by Hondius of an Arctic disaster, it quickly took on a symbolic content. Like Wordsworth, whose brother's death by drowning in 1805 so strongly influenced his own search for religion, Friedrich must have been acutely affected by the death of his own

brother, Christoffer, his junior by a year, who drowned on a winter day—8 December 1787—while trying to save Caspar's life. But even without this traumatic childhood experience, Friedrich would surely have found a melancholic symbol in the theme of an Arctic shipwreck. In his now famous painting of this subject, which used to be misidentified with a lost painting of the wreck of a ship called the *Hoffnung* (Hope),[25] the poetic truth of the traditional but incorrect title still holds: man's ephemeral aspirations are dashed against the eternal omnipotence of nature and her often malevolent forces. Inspired by an actual account of William Parry's expedition of 1819—20 in search of the Northwest Passage, Friedrich transformed the facts and illustrations of a travelogue into a tragic image of the no-man's-land of death. Here, in a frozen world that has turned into a cemetery, we discern slowly the splintered remains of a wrecked ship, whose skeletal traces are almost wholly absorbed and concealed by the jagged pyramid of a shattered iceberg. In its spiky, attenuated patterns, this chilling phenomenon of nature becomes a kind of Gothic mausoleum, whose original monumentality, before man's intervention disturbed it, is suggested by the mirage-like vision of yet another iceberg at the far left, located like some unattainable goal at an incalculable distance from the sharply delineated foreground.

Friedrich's use of a ship as a symbol of man's hopes and of the passage from life to death was, like so many of his conscious and unconscious symbols, paralleled in many works by his contemporaries.[26] Turner, for one, provided a close analogy in *The Fighting Temeraire*,[27] which translates into grandiloquent allegory a moment actually observed by the

35 CASPAR DAVID FRIEDRICH
Arctic Scene
1798

36 CASPAR DAVID FRIEDRICH
The Polar Sea (formerly *Wreck of the Hope*)
1824

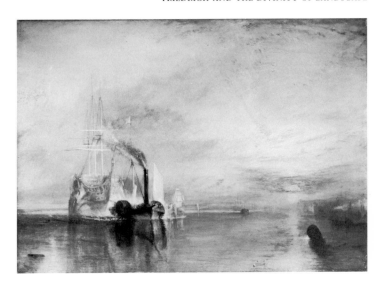

37 JOSEPH MALLORD WILLIAM
TURNER
*The Fighting Temeraire tugged to
her last Berth*
1838 (Exh. R.A., 1839)

artist: the towing away, in the summer of 1838, of Lord Nelson's warship from the naval base at Sheerness on the Thames to the shipyard of a private wrecker. Seen against and almost absorbed by a molten sunset, *The Fighting Temeraire*, once a glory of British naval prowess in the Napoleonic Wars, becomes a specter on its way to a maritime grave. The poignancy of this symbolic burial is further underlined by the sooty little tugboat in the foreground, which offers a realistic foil of the mundane here-and-now to the visionary spectacle of the passing of man's achievements beyond some distant horizon. Again, as in Friedrich, there is a pathos-ridden contrast between the relative palpability of an object in the foreground and the incorporeal mystery of those objects which lie in some remote, inaccessible beyond. Turner's ships, like Friedrich's, become Flying Dutchmen, maritime ghosts that evoke metaphors of spiritual journeys.

How different the attitude of these Northern artists was from the great masters of French Romantic painting may be quickly suggested by the most famous of all scenes of maritime disaster, Géricault's *Raft of the Medusa*, exhibited at the Salon of 1819. Here, the imagery is anthropocentric: however malevolent or overwhelming the forces of nature, it is still man who dominates the scene, expressing emotion through the traditional metaphor of the human body, now reduced to those extremities of corporeal suffering common to French Romantic art. In Friedrich, Turner, and their Northern contemporaries, human passions become more and more relegated to the domain of nature, where man acts either as a luckless or evil intruder, to be devoured by avalanches, snowstorms, tempestuous seas, or as a silent, worshipping

35

meditator, to be equally absorbed by nature's quiet, almost supernatural mysteries: immeasurable vistas of water and luminous sky, distant horizons obscured by fog, and even the more commonplace wonders of flowers and trees.

In this light, it is worth introducing here another prominent motif in the work of Friedrich and his contemporaries that, like their search for new means to experience God-given mysteries outside the confines of religious orthodoxy, was to have extensive progeny in the later history of modern painting. This might be called, to borrow John Ruskin's famous phrase in *Modern Painters*, the 'pathetic fallacy.'[28] Ruskin was referring, in literary examples, to the curious attribution of human feelings to non-human subjects, especially landscape elements; but he might well have been characterizing the new attitude of so many Romantic, and especially Northern Romantic, artists to nature in general and to trees in particular. Often, in the landscape painting of the early nineteenth century, we feel so intense an empathy of the artist with the life of an individual tree that this inanimate landscape component can suddenly become a sentient, almost human presence. Even so generally objective, if hardly

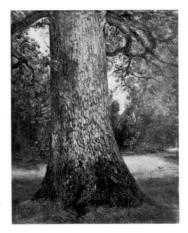

38 JOHN CONSTABLE
Elm Tree
c. 1821

39 CASPAR DAVID FRIEDRICH
*Village Landscape in Morning Light
(Lone Tree)*
1822

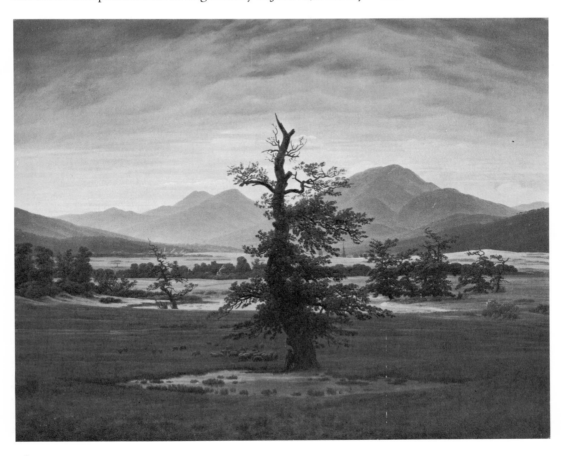

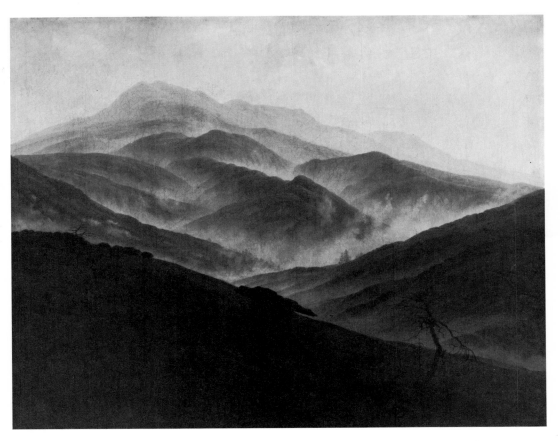

40 CASPAR DAVID FRIEDRICH
Mountain with Rising Fog
c. 1815

dispassionate, an artist as John Constable could experience 38
trees as if they were particularized, humanoid creatures[29] and
could paint them, as in his record of an English elm, as if he
were executing a portrait. For Friedrich, this empathy is even 39
more intense, as in his painting of a single tree against a
landscape, centralized to receive the maximum of our atten-
tion and further humanized by the presence, under its
sheltering branches, of a lone shepherd leaning against its
trunk. At times trees can be the protagonists of far more
dramatic situations, as in Friedrich's painting of a Silesian
mountain landscape in which we are located just above the
green line and see, separated at opposite ends of the rugged
terrain, the lonely survivors of this altitude so hostile to living
things: a leafless tree at the left, whose upright strength is 40
contrasted to the more broken, barren tree at the right,
accompanied by a firmer, younger tree that almost evokes a
family drama or a life cycle.

There is even stronger stuff in the work of other Northern
Romantics, such as a painting of a birch tree in a storm by
Friedrich's Norwegian artist friend, Johan Christian Claussen 41
Dahl.[30] Here we see the literally cliff-hanging drama of a

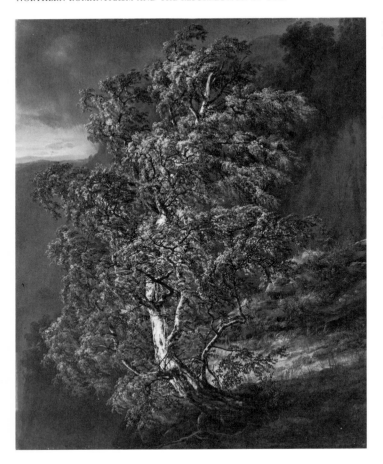

41 JOHAN CHRISTIAN CLAUSSEN
DAHL
Birch tree in Storm
1849

42 THOMAS COLE
Landscape with Dead Tree
c. 1827–28

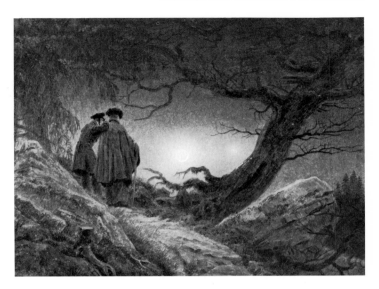

43 CASPAR DAVID FRIEDRICH
Two Men Contemplating the Moon
1819

poor tree clinging for its very life at the edge of a dangerous precipice, just as we experience in the trees of the American painter Thomas Cole the kind of terror before malevolent 42 nature which had earlier been communicated to us through such human *dramatis personae* as, say, James Thomson's ill-fated lovers, Celadon and Amelia, struck by lightning in a summer thunderstorm, described in his poem, 'The Seasons.' Cole himself articulated vividly the feeling these Northern trees were meant to evoke:

My attention has often been attracted by the appearance of action and expression of surrounding objects, especially of trees. They spring from some resemblance to the human form. There is an expression of affection in intertwining branches. . . . [Trees] assimilate with each other in form and character. Expose them to adversity and agitations, and a thousand original characters start forth, battling for existence or supremacy. On the mountain summits, exposed to the blasts, trees grasp the crags with their gnarled roots, and struggle with the elements with wild contortions.[31]

Many of the trees in works by Friedrich and his circle convey this humanoid vitality described by Cole. There is, for instance, the leafless oak tree in *Two Men Contemplating the* 43 *Moon*, which seems almost to be dancing before the incantatory power of a rising moon; or the passionately swaying willow tree, in a work that has also been attributed to a Friedrich disciple, Carl Julius von Leypold,[32] where the 44 leafless branches vibrate in ghostly silhouettes defined by the overcast light of the moon.

Such Romantic extremes of empathy with nature, where branches almost appear to be the exposed nerves of a suffering

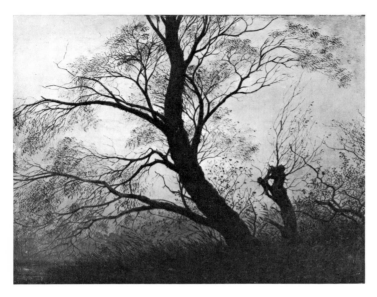

44 CASPAR DAVID FRIEDRICH
(also attributed to Carl Julius
von Leypold)
Trees in Moonlight
c. 1824

creature, did not, however, expire with the presumed death
of the Romantic movement in the mid-nineteenth century.
96 In fact, one need only look ahead to an early drawing by Van
Gogh of the roots of a tree (April 1882) to realize that the
tradition of the 'pathetic fallacy' had consequences that
survived long past the deaths of the great Romantic landscape
painters. Here, Van Gogh's own words, which relate the
drawing to a figure study, *Sorrow*, can underline the point:

The other drawing, *Roots*, represents roots of trees in sandy
soil. I have now tried to give the landscape the same feeling
as the figure, as though clinging to the earth in the same
convulsive and passionate manner and yet torn out of it by
the gale.[33]

They are words, we shall see, that will be no less appropriate
275 to the early tree studies of Piet Mondrian, who, like so many
other Northern artists of the nineteenth and twentieth
centuries, perpetuated and revitalized Romantic experiences.

2 Cosmogonies and mysticism: Blake, Runge, Palmer

THE WORD 'crisis' is applied so freely by scholars to any turning point in history that it has lost much of its impact. Still, there may be an excuse to continue thinking of the late eighteenth century as more 'critical' than other periods, especially in terms of the dilemmas posed by the assaults on religion and traditional Christian art. T. E. Hulme once referred to Romanticism as 'spilt religion,'[1] and in these terms, we have already seen much evidence of the spillage in landscape painting, especially as practised by such Northern Protestant artists as Friedrich and Turner. And we have seen, too, how orthodox religious expression was transformed into other kinds of new forms and symbols: sea voyages, lone figures contemplating nature, burials, Gothic architecture, often recorded with a structural starkness and simplicity unfamiliar to the intricate patterns of seventeenth- and eighteenth-century art. How critical the situation was can be suggested by the fact that many artists and thinkers even considered the possibility of making new religious systems to replace or to resurrect the enfeebled faith in Christianity. Friedrich von Schlegel might have been speaking for many artists when, envisioning a reconstruction of the Catholic Church that might assimilate the events of the French Revolution, he wrote to Novalis: 'I am thinking of founding a new religion or at least of helping to preach it. Perhaps you are better qualified to make a new Christ—if so, he will find in me his St. Paul.'[2]

In fact, many Northern artists responded to the religious crisis in exactly this way—by attempting to create their own religious systems, which they hoped might usher in the dawn of a more pious and spiritual era. The most conspicuous example, as both artist and system-maker, of this new breed of private religion is William Blake, but it is symptomatic of the crisis around 1800 that his search for new cosmogonies and new religious iconography was shared, no less than his formal means of expression, by many of his Northern contemporaries. Above all, there is the Danish–German master Asmus Jakob Carstens, who, born in 1754, only three years before Blake, similarly thought of himself as belonging not to the petty, worldly traditions of patronage and academic training against which Blake had also rebelled, but rather as being a kind of universal artist and thinker, working in some supranational realm of idea and spirit.[3] Like Blake, Carstens

was fascinated by images of primal power, figural divinities nourished by the *terribilità* of Michelangelo's art, which Blake could know only from reproductions but which Carstens, an expatriate in Rome for the final years (1792—98) of his short life, could experience first-hand. But the results, in form and intention, often overlap.

In two exactly contemporary works by these masters— Blake's *Ancient of Days* and Carstens's *Birth of Light*, both of 1794—one finds nothing less than two private interpretations of the origins of the universe, passionately ambitious efforts to rewrite the Book of Genesis for a Western world that, in the 1790s, after the apocalypse of two major revolutions, must have demanded, for some, even cosmological revisions. Blake's *Ancient of Days*, the frontispiece for his epic poem, *Europe: A Prophecy*, is, in symbolic terms, an intensely personal compound of everything from medieval compass symbolism and Michelangelesque deities to Blake's own invention, Urizen, the primal creative force whose delimiting of freedom by reason and geometry is an evil act.[4] Carstens's *Birth of Light* is equally esoteric, if less personal in its cosmogony, for it illustrates, with Blakean homage to the sublime power of the Sistine Ceiling, the cosmological fantasy of a probably mythical Phoenician author, Sanchuniathon, who, as later recorded by Philo Herennius of Byblos, described the genesis of light (Phanes) through the interaction of the original creative power (Phtas) and night (Neithe).[5] Both works suddenly exist in a symbolic world, freed from those roots in empirical observation which underlay even the most idealized examples of baroque art, and exempted from even

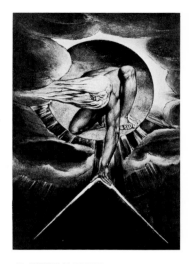

45 WILLIAM BLAKE
Ancient of Days (frontispiece to *Europe, a Prophecy*)
1794

46 ASMUS JAKOB CARSTENS
Birth of Light
1794

47 WILLIAM BLAKE
Elohim Creating Adam
1795

42

the laws of gravity. It was characteristic of both these artists that they found the medium of oil painting repugnant, for it seemed to them a technique oriented to the illusions of prosaic fact, whereas it was the domain of symbols, defined by the linear heraldry of drawing, that Carstens and Blake wished to occupy. Blake in particular often thought like a medieval artist, creating emblems of some visionary truth that dealt with the kind of Book of Genesis subject unthinkable in the art of the earlier eighteenth or seventeenth century. What artist after Michelangelo and before the Romantics could have envisioned, as did Blake, so primal a scene as the Hebrew Lord, Elohim, creating Adam, a watercolor of 1795 47 in which the awe and terror of creation itself can newly be seen and felt? Once again, Blake seems to work more like a medieval than a post-Renaissance artist, representing as he does the four elements in emblematic terms and organizing his flat hierarchic composition around the pure, circular blaze of the sun, the equivalent of a golden halo.

Both Blake and Carstens rejected firmly what they considered the petty subjects and the mimetic illusions of trivia and ephemera that dominated the artistic traditions into which they were born in the mid-eighteenth century. For them only symbols and concepts existed. Yet it was inherent in their predicament that their art, attempting the universal, achieved the esoteric. Their private exhibitions (Carstens's in Rome, 1795; Blake's in London, 1809), which were held in defiance of official academic systems of patronage, attracted only the smallest circle of devoted friends; and their symbolism even to scholars today remains, like the private symbolism of so much late nineteenth- and twentieth-century art, difficult and ambiguous in its meaning. Though dealing with eternal verities, their meanings are obscure in source or interpretation. Who but Carstens would have illustrated Space and Time, as discussed in Immanuel Kant's *Critique of Pure Reason*?[6] Who but Blake could have illustrated a River of Life or a Sea of Time and Space, whose complex composites of medieval and Neo-Platonic sources and personal invention constantly strain the exegetic skills of modern Blake scholars?

Who else, indeed, but another Romantic maker of cosmogonies, the German painter Philipp Otto Runge? Throughout his short life (1777—1810), Runge dreamed of a four-part cycle of paintings, the *Tageszeiten (Times of Day)*, which would encompass a whole new iconographical system that was to revitalize Christian art and was to be enshrined in a chapel designed for this purpose where specially composed music would also contribute to the foundation of a new kind of religion. Of these Romantic dreams, there are only verbal descriptions and four schematic studies, of which one, *Morning*, was also executed in some penultimate painted

versions. But it is remarkable to see how often in their concept and structure these icons of a new religion resemble works by Blake. Runge's plan for *Evening*, for example, closely parallels Blake's late illustrations to the Book of Job, such as *When the Morning Stars Sang Together*. Obsessed by the ambition of representing symbols, ideas, spiritual phenomena, both artists curiously revive a format common to the medieval manuscript page—a vertical structure that arranges on an axis of symmetry a heraldic vision of heavenly domains. Revealingly, both use, again in a medieval tradition, symbolic marginal decorations that turn the whole into a kind of cryptogram, a private language of image and symbol which was actually referred to, in Runge's case, as 'hieroglyphs.'[7]

Blake's art in particular seems totally removed from empirical observation, rejecting as it does the evidence of the senses in favor of the concepts of the mind and spirit. Nevertheless, it is worth noting that, in structural terms, it often parallels the work not only of Runge, but even of Friedrich, who at first might seem so closely rooted in the perception of natural phenomena that his art should be located at a pole opposite to Blake's. Thus, even Friedrich's drawing, *Sea with Sunrise*, though ultimately based upon the perception of natural phenomena, bears analogies with Blake's *Elohim Creating Adam* in terms that pertain both to its obsession with primal creative forces and to its equally primal artistic structure, which insists on the purity of circular forms and other patterns of elemental clarity.

48 PHILIPP OTTO RUNGE
Evening
1803

49 WILLIAM BLAKE
Book of Job
'*When the Morning Stars Sang Together*'
1823–25

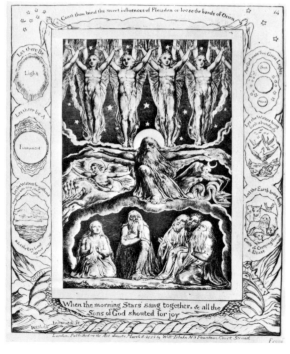

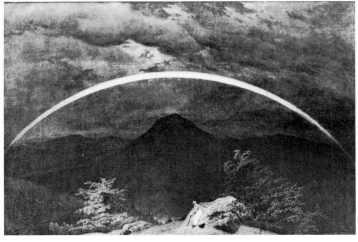

50 WILLIAM BLAKE
Four and Twenty Elders
c. 1805

51 CASPAR DAVID FRIEDRICH
Mountain Landscape with Rainbow
c. 1810

In the same way, Blake's vision of the biblical *Four and* 50
Twenty Elders might be thought of as a kind of abstract,
eyes-shut counterpart to Friedrich's more empirical vision of 51
a mountain framed, like Blake's elders, with the perfect arc
of a rainbow, which spans the width of the image in an
emblematic geometry that locates the whole in a symbolic
realm. Indeed, in their common use of, in Blake's phrase,
'fearful symmetry', Friedrich, Runge, and Blake himself
impose, whether on the most abstractedly conceived or the
most specifically perceived elements—God or a sunrise,
angels or a mountain—a sense of fixed, immutable order, as
if some permanent truth that transcended the irregularities
and casualness of the commonplace world had at last been
disclosed. Those earlier pictorial structures of the seventeenth
and eighteenth centuries, oblique, illusionistic structures that
stressed the shifting ephemera of perception with their
asymmetrical dispositions, their patterns of flux and diversity,
have now been replaced by the stark, almost simplistic clarity
of absolute symmetry. And like so many other innovations
of the Romantics, this structural archaism, a counterpart to
the search for themes of elemental truth, was also to have
enormous consequences in the later history of modern art.

Although they may often share this penchant for com-
positions frozen in the emblems of a pure geometry, Blake
and Friedrich approach their spiritual goals from opposite
extremes of experience. Friedrich, for all his recommenda-
tions that the artist paint with his spiritual, not his bodily eye,
nevertheless looked at the multifold appearances of nature
with a scrupulous eye for detail. Blake, we feel, could almost
have been blind, for all the reflection of the visible world to
be found in his art. Such a polarity between the abstract and
the empirical, the universal and the specific was, in fact,

common to the art of the Romantic period, almost as if the easy fusion of the specific and the general that characterized both the high and low styles of the baroque and rococo had been rent asunder.

In no artist's work is this peculiar Romantic duality more apparent than in Runge's, where the extremes of the most close-eyed perceptions of nature and the most visionary, abstract forms and systems are juxtaposed and, at times, combined. This may be demonstrated, for example, in the difference between his first, schematic drawing for *Morning*, in the *Times of Day* cycle, and the later version of this executed in paint, where suddenly the skeletal abstract form of this complex icon—at once a classical Aurora, a newborn Christ, and a medieval lily of purity—is given the substance of the most scrupulous observation of the wonders of natural

52
53

52 PHILIPP OTTO RUNGE
Morning
1803

53 PHILIPP OTTO RUNGE
Morning (small version)
1808

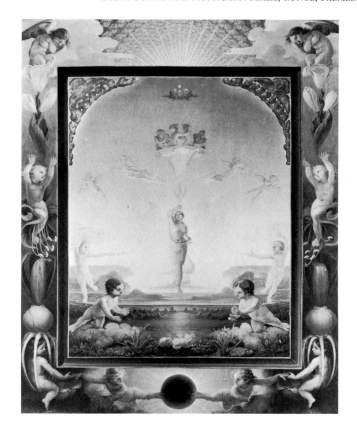

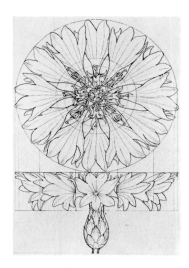

54 PHILIPP OTTO RUNGE
Cornflower
c. 1808

phenomena: the suffusion of dawn's colored light across a meadow, the botanical detail of the tough tendrils of growing lily bulbs, the plastic energy of children's twisting skin and muscles.

That same tension between literal, earthly truth and an abstract symbolic structure can be seen less ambitiously in Runge's extraordinary flower studies, where, like Goethe in his botanical search for the *Urpflanze*, the archetypal plant, he scrutinized the particularities of species—a cornflower or a nasturtium—but imposed upon these minutiae of nature an abstract order, either through geometric patternings that related the flower to a generalized form or through the technique of silhouettes, so fashionable around 1800, which suddenly translated the three-dimensional palpability of a flower into a flat and frozen emblem. The very activity of studying so closely and so accurately a wide variety of flowers was, for Runge, not only a scientific endeavor shared by his botanist friend, Gustav Bruckner, but also, as it was for so many Romantic poets, a way to find the mysteries of the supernatural in the smallest of nature's manifestations. It was clear to him, as he wrote to Ludwig Tieck on 1 December

54, 110

47

1802, that flowers and trees must have originated in Paradise and that they were 'very understandable creatures.' Like those Romantic landscape masters who first expressed the 'pathetic fallacy', Runge found that 'landscape would . . . consist of the premise that people would see themselves and their properties and passions in all flowers and plants and in all natural phenomena.'[8]

Because Runge thought of the miraculous details of nature as reflections of divinity, it is not surprising to find that his plants, flowers, and trees can often support symbolic figures, like the personification of Nature who burgeons forth from the leaves of a plant. Here, too, Runge provides analogies with Blake in his insistence on turning all fact into symbol. When Runge and Blake draw or paint, say, lilies or sunflowers, these are not for domestic use, and have no relation to Baroque still-life traditions. Thus, the lily that rises toward the heavens in Runge's *Morning* is irradiated by divine light, which can nurture the birth of heavenly angels. And a sunflower by Blake, unlike one by Runge, is not even botanically plausible; it is, rather, the symbolic throne for a symbolic creature, Beulah, Blake's private personification of Arcadian harmony culled from such diverse sources as Bunyan's *Pilgrim's Progress* and the Book of Isaiah. In both cases, the flowers have left a world of human dimensions and human reason far behind. Scrutinized so closely, they loom like apparitions in a pure realm of spirit untainted by mundane human activities. The figures that inhabit their petals could be either giants or pygmies, for they belong to no earthly

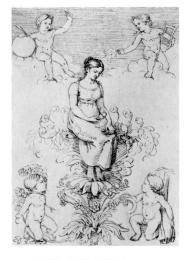

55 PHILIPP OTTO RUNGE
Nature
1810

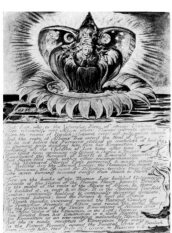

56 WILLIAM BLAKE
Beulah Enthroned on a Sunflower
c. 1818

57 PHILIPP OTTO RUNGE
Study for Rest on the Flight into Egypt
1805

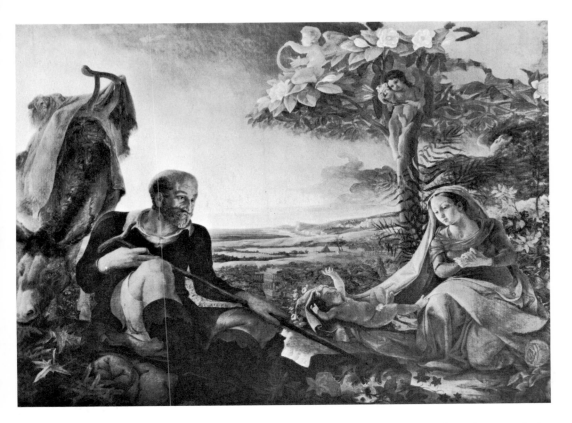

58 PHILIPP OTTO RUNGE
Rest on the Flight into Egypt
1805–06

race. As we shall see, the Romantics often destroyed the traditional Renaissance and Baroque sense of a human hierarchy of size and importance. A flower, looked at closely and passionately enough, could take on an overwhelming significance that dwarfs or obscures everything around it. The seeds of these flowers were to blossom again in modern painting, in such new and different guises as the flower paintings of Van Gogh and Mondrian.

Runge's sense of a mystical presence in all the phenomena of nature is perhaps demonstrated most astonishingly in the metamorphic translation of a landscape drawing into the religious protagonists of the painted *Rest on the Flight into* 57
Egypt.[9] Here, the sepia sketch alone conveys something more 58
than the simple data of landscape: the dark, gnarled oak tree at the left seems to contrast tellingly with the radiant mound of earth in the center (from which an infant tree trunk with tiny new branches outstretched like fingers is growing) and with the firm upright tree at the right. The sense of some immanent mystery in this landscape is then fulfilled in the painting for which it is a preparatory study. The old oak in

shadows becomes the bearded figure of Joseph and his donkey, which eats thistle-like leaves that may be identified as gall, symbolic of the Crucifixion, while at the right, the fertile, sunlit earth seems to have blossomed into the Christ child himself, who reaches toward the light of a new day as if to receive his God-given energy. A young tree, possibly to be identified as a Christmas Rose tree, burgeons not only with lily blossoms, a traditional symbol of the Virgin, but with an angel who, almost literally growing out of the tree trunk, proffers a lily to the Christ child's upraised hands, as if this flower, too, were a symbol of the virgin dawn that was suffusing the world.[10]

Runge's obsession with images of total purity was characteristic of many Romantics' passionate wish to reconstruct a world from scratch, whether in actual political terms, in the utopian dreams that preceded and could still follow the apocalypse of the French Revolution; in religious terms, in the ambitious efforts to resurrect Christianity or to create an entirely new religious system; or in artistic terms, in the desire to paint with a total innocence of earlier artistic heritages. Runge's often quoted statement, 'We must become children again if we wish to achieve the best,'[11] summarizes not only metaphorically the goals of many Romantic artists and many artists of the later nineteenth and twentieth centuries, but also reflects quite literally his fascination, like that of such contemporaries as Schiller, Novalis, and Wordsworth, with children as vehicles of some primal, unspoiled mystery in nature.[12]

At times, Runge's children are overtly symbolic, as in the baby who lies on the meadow in *Morning*, his arms outstretched to the new light of day like the Christ child in the *Rest on the Flight* or, for that matter, like the woman in Friedrich's painting who similarly appears transfixed by the rising sun, her arms rising in empathic response. But if the association of an infant with Christ, a new era, and a new dawn might be expected in the complex iconographic invention of the *Times of Day*, such associations are more surprising in the realm of portraiture. Yet even here Runge found in children an almost mystical reflection of nature's purest, rawest energies. Thus, in the portrait of the artist's parents standing sternly and stiffly beside their grandchildren[13]— Runge's one-and-a-half-year-old son, Otto Sigismund, and three-and-a-half-year-old nephew, Friedrich—the parallelism between the elderly couple and the children is almost like an illustration of Wordsworth's famous phrase, 'The child is father of the man', especially in the way the elder child looks up questioningly at his grandparents while holding the hand of his little cousin in a manner that echoes the interlocking of the adults' hands. But the peculiar quality of the children—a

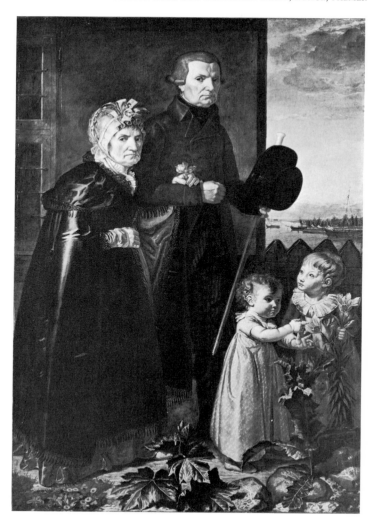

59 PHILIPP OTTO RUNGE
The Artist's Parents
1806

kind of tough, bursting energy—is above all related to the
expansive growth of the lily plant which they hold and point
to. Indeed, just as the landscape study for the *Rest on the
Flight into Egypt* seems miraculously to blossom into its
human protagonists in the painted version, so too does the
lily plant (which in the preliminary studies for this portrait
was sketched in without the accompanying children) seem
almost to be the source for the vitality of these two infants.
The irrepressible growth of the plant's tough stalks and
blossoms partakes of the same young sap that seems to swell
through the pneumatic flesh of the children. And the plucked
rose held by the grandmother underlines the contrast between
the artificiality of the adult human world and the naturalness
of a children's world which still belongs to an unspoiled
Realm of Flora.

Even more powerful in its conveying of the organic energy of children in a natural environment is Runge's unforgettably
60 intense portrait of the three children of his friend Hülsenbeck, viewed outside their country home near Hamburg. Here, without the presence of a full-grown person to measure relative sizes, the scale becomes strangely distorted, an Alice in Wonderland view of a child's world. The two elder children, a boy and a girl, rise to monumental heights before a picket fence that, by adult scale, is impossibly low; and the contrast between the extremities of near and far, so recurrent in Northern Romantic painting, produces swift recessions of almost de Chirico-like irrationality. Demonstrating an attitude pervasive in so many Romantic painters, Runge rejects the hierarchy of a man-made world and looks, instead, at his subject with an up-close, nearly hypnotic intensity that locates it in a mysterious domain remote from human intervention. This passionate empathy with the glassy stare and

60 PHILIPP OTTO RUNGE
The Hülsenbeck Children
1805–06

red-cheeked faces of children looked at neither as little adults nor as adorable pets, but as containers of natural mysteries, is the counterpart to so many new Romantic attitudes toward children as symbolic vessels of a God-given purity and vitality. Moreover, Runge again associates the uncommon thrust of their growth—their pudgy flesh almost seems to be bursting before our eyes—with that of plants. The infant in the wheelbarrow is metaphorically part of the enormous sunflower plant which he grasps, with animal vigor, in his right hand. His own primal strength joins forces with the jungle-like energy of the plant, which invades the painting from top to bottom and which echoes the muscular exertion of the elder boy, who raises high a riding crop that curls upward as forcefully as the sunflower stalks. It is a primitive, untamed world, dominated by a kind of magic plasm, and peered at in wonder by a Romantic who hoped to uncover the secret wellsprings of nature's vitality.

Runge's art encompasses simultaneously the visionary and the empirical. Whereas his goals may have been those of a religious mystic, he sought access to the supernatural, like such earlier German mystics as Jakob Boehme or Meister Eckhart, through the manifestations of the natural, even to the point where his investigations of color, light, or botany fully partake of the scientific knowledge of his contemporaries. That combination of the closest scrutiny of nature and an awareness of a divine immanence within nature's surface manifestations was hardly unique to him. It was, in fact, closely paralleled in the work of a British artist, Samuel Palmer, who is often carelessly categorized as a disciple of Blake, but whose intense perception of natural phenomena separates him profoundly from the older master. Still, many of Palmer's youthful efforts can be placed within the Blakean world of a figural art that would revive the symbolic power

61 SAMUEL PALMER
Study for a Resurrection
1824

62 SAMUEL PALMER
Study for Altarpiece
1824

of archaic religious images. In the so-called Ivimy Sketch-
61 book,[14] an album of wildly ambitious projects drawn by
Palmer in 1824, when he was only nineteen, he envisions in
one place a vast polyptych altarpiece that would resurrect on
English soil the religious faith embodied in the Van Eyck
Ghent Altarpiece, which Palmer knew through a copy in the
London collection of Charles Aders.[15]

The Eyckian conception of a magical scrutiny of the
microcosm as a vehicle for the revelation of a divine macro-
cosm must have been compatible with Palmer's nascent
interest in observable nature; but a Blakean taste for Michel-
angelesque figural sublimity is also evident in this youthful,
unrealized dream. Thus, in a sketch for one section of the
62 altarpiece, Palmer imagines a resurrected Christ, viewed with
such compelling frontality and symmetry that it towers above
63 us like a giant. In another study, a Blakean scene of Creation,
equally Michelangelesque divinities soar through boundless,
abstract spaces. Indeed, the same cosmological ambitions
could be found in the work of another artist stunned by
64 Blake's *terribilità* in the mid-1820s—George Richmond. In
his *Creation of Light* of 1826, he joins that group of Romantic
cosmogonies by Carstens, Blake, and Runge, attempting the
most sublime vision of Genesis that seems half abstract in the

63 SAMUEL PALMER
Study for the Creation
1824

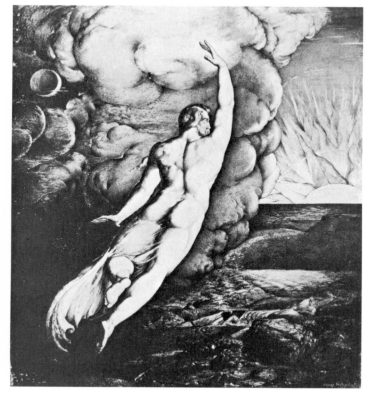

64 GEORGE RICHMOND
The Creation of Light
1826

65 WILLIAM BLAKE
Rest on the Flight into Egypt
1806

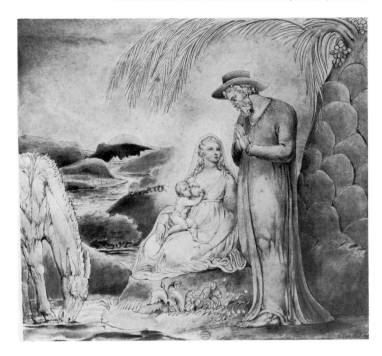

66 SAMUEL PALMER
Rest on the Flight into Egypt
c. 1824–25

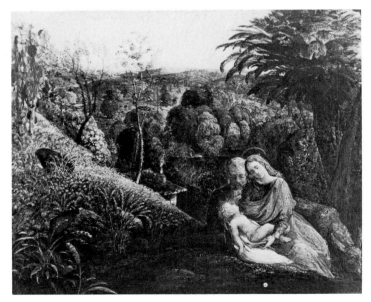

figure of the deity and sun, and half real in the vista of an
English landscape below. It was characteristic, too, of the
archaizing goals of such a subject that Richmond's painting
is executed in both tempera and gold, pictorial techniques
that evoked the symbolic painting of the late Middle Ages,
before the invention of oil techniques permitted what

Richmond, like Blake and Carstens, would have considered
the decline of art in the direction of mere illusionism, of the
mindless copying of the trivial facts of earthly life. How
loathsome to these artists were those multitudes of seven-
teenth- and eighteenth-century paintings that simply mir-
rored, in the deceptive, virtuoso fictions of oil paint, the
materialistic facts of property and pleasure: still-life, genre,
and portraiture. To represent the primal mysteries of
Creation, a pictorial medium that would fix images in time-
less symbols was needed.

Yet within this conceptual world of bounding contours
and abstract structures, the close perception of nature's
surfaces began to appear. It might be useful, in this light, to
65 consider three interpretations of the *Rest on the Flight into
Egypt*, one by Blake, one by Runge, and one by Palmer. That
by the oldest of these artists, Blake, born in 1757, belongs to
so abstract a realm that the figures, like the landscape, seem
totally ethereal, a kind of mystic ectoplasm contained in
58 pulsating, wiry contours. That by Runge, born in 1777, in
the generation following Blake's, combines this kind of
abstract shell with realistic surfaces crammed with wondrous
66 descriptions of natural phenomena. That by Palmer, born in
1805 of a still younger Romantic generation, seems finally to
have overbalanced the equation of the abstract and the
empirical in favor of the latter, while preserving a sense of
supernatural mystery in the close record of the golden
shimmer of light upon the surfaces of the dense foliage in a
burgeoning landscape that is as much Eden as England.
Although the landscape still seems sufficiently enchanted to
create an ambience where the Virgin's gold-rimmed halo is
thoroughly plausible, it nevertheless pursues naturalistic
directions that begin to lead away from the exclusively vision-
ary realm of Blake and the partially visionary realm of Runge.
Already in the 1830s, Palmer, like many of his Romantic
contemporaries, trod more and more often on *terra firma*, and
by the mid-nineteenth century his landscapes often shared the
objectively described topographies of younger Victorian
generations.

Still, in his youth, Palmer's sense of a holy immanence in
nature pervaded all his work; and until the early 1830s his art
stands comparison with the most mystical of the older
German Romantic masters. In fact, Palmer's new interpreta-
tions of divinity in landscape are constantly paralleled in the
work of Friedrich and Runge. Thus, his search for sacred
symbols in secular guise can be demonstrated in a curious
67 study from the 1824 Ivimy Sketchbook, in which we see a
shepherd leading his flock in some dreamlike, pastoral
Arcadia. Yet it is clear that this is not to be understood as
simply a genre scene of rural life. For one thing, the sym-

67 SAMUEL PALMER
Study for Shepherd and Flock
1824

metrical ordering of the composition, vertically bisected by
a tree, suggests, as in Friedrich's work, a heraldic symbol,
which is further underscored by the presence of the sun and
the moon on each side of the tree, an echo perhaps of the
simultaneous appearance of these two heavenly bodies in
traditional Crucifixion iconography. But even stranger as a
fusion of the sacred and the secular, the pagan and the
Christian, is the odd placement of the disc of the sun directly
behind the shepherd's head, so that it becomes, as it were, a
natural halo. Is it, then, an image not of just a shepherd but
rather of the Good Shepherd? And is the Christian conviction
of this work all the more persuasive because it avoids an
explicit traditional symbolism in favor of a more ambiguous
evocation of divinity within the realm of secular life, especi-
ally that of rural communities? It was a question that did not
die with Palmer and Friedrich, but was asked again and again
in the nineteenth century, whether by Millet's peasants or by
their progeny in Vincent van Gogh.

Another work by Palmer, *Coming from Evening Church*, 68
again shows parallels with Friedrich. Like Friedrich's images
of monastic burials in wintry Gothic ruins, Palmer's vision of
Christian ritual belongs to the new Romantic domain of
spectator Christianity, where genre scenes of communal
piety replace traditional Christian subject matter. Here we see
a dream of some archaic moment in the history of the
Christian religion in the British Isles, a dream that recalls the
firm and simple faith of those worshippers imagined in
Blake's Vision of Jerusalem in the preface to *Milton*:

> And did those feet in ancient time
> Walk upon England's mountains green?
> And was the Holy Lamb of God
> On England's pleasant pastures seen?

Already in the Ivimy Sketchbook Palmer had shown how

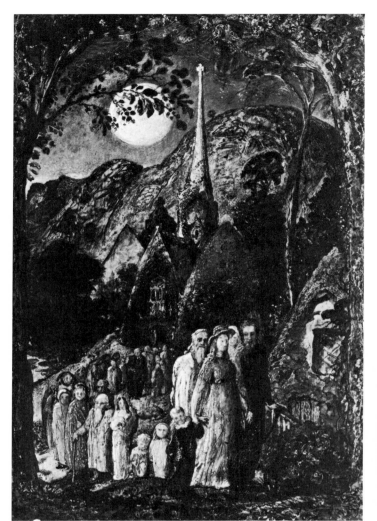

68 SAMUEL PALMER
Coming from Evening Church
1830

69 JAN AND HUBERT VAN EYCK
Hermits and Pilgrims (from the
Ghent Altarpiece)
completed 1432

profound an effect the *Ghent Altarpiece* had had on him. Here, appropriate to his growing preference for scenes of secularized Christianity, he chooses for inspiration the section from 69 the Van Eyck polyptych that represents not the Adoration of the Lamb itself, but rather the procession of bare-footed pilgrims and hermits who move worshipfully toward the Lamb. Palmer's own rural believers, unshaken in their faith and dressed in timeless robes, are seen leaving a village church that, like so many Romantic views of Gothic architecture, is almost totally camouflaged by the similarly Gothic patterns of the thatched primitive cottages and the ambient landscape. It is no surprise to find Palmer writing, among his many comments on his feelings toward nature: 'These leaves were a Gothic window, but sometimes trees are seen as men.'[16] In fact, just as the primitive Gothic buildings here seem to merge

70 SAMUEL PALMER
Moonlit Landscape
c. 1829–30

with a natural environment, so too does the primitive rural congregation seem to be at one with nature. It is a vision of a vanishing world of faithful flocks, untainted by the harsh realities of early nineteenth-century urban and industrial change, by what Blake called 'satanic mills.'

Palmer, like Friedrich, can suggest religious ritual even without reference to specific Christian rites. Thus, in the *Moonlit Landscape* of *c.* 1829–30, two figures, a man and a 70 woman, stand mesmerized by the spectacle of a moon rising above the gentle hills of a village indicated, in the extreme distance at the left, by the spiky Gothic spire of a church, a detail that adds a quiet reverberation of religious sanctity to this nominally secular scene. Like Friedrich's figures who contemplate moonrises and sunsets, Palmer's stand with their faces averted from us, their whole beings poised on the brink of what would seem to be some mystical revelation in nature. Often, in fact, the vehicle of that revelation is a heavenly orb, whose strange glowing light can become so intense, so all-pervasive that in Palmer's work, as in Friedrich's, there is frequent difficulty in distinguishing between moons and suns. What we feel rather is some presiding, almost pagan deity in the heavens, a symbolic celestial body that, defying astronomical identification, seems the source of a magic spell cast on earth. At times, these orbs reach a magnitude that, as in the *Harvest Moon* of 1830–31, thoroughly dwarfs the scale of the 71 human agricultural activities below. Overwhelming not only in its sheer size and luminosity but also in its fixed centrality, this blazing harvest moon seems to have usurped the role of a golden halo in medieval art. And, as we shall see, such

71 SAMUEL PALMER
The Harvest Moon
c. 1830–31

iconic moons and suns will have many more worshippers in the later history of modern painting, from Van Gogh and Munch to Ernst and Gottlieb.

72 Even without such heavenly, crypto-Christian deities, Palmer's landscapes seem saturated with an aura of divinity. Thus, a little painting of an English horse-chestnut tree becomes a rhapsodic outburst of the miracle of fertility, a foaming bounty of blossoms in sweet accord with the gentle shepherd who, like the shepherd in Friedrich's study of a single tree, seems not only to humanize the tree but to suggest indivisible harmony between rural man and nature. No less

73 passionate is Palmer's *Pear Tree Blossoming in a Walled Garden* of *c.* 1829, yet another demonstration of the Romantics' astonishing empathy with natural forces that might provide testimony to the presence of divinity. Palmer's attitudes toward deity in nature had, in fact, often been verbalized, as in a letter to John Linnell of December 1828, which captures the spirit of this little picture:

Terrestrial spring showers, blossoms and odours in profusion, which, at some moments, 'Breathe on earth the air of Paradise': indeed sometimes, when the spirits are in Heav'n, earth itself, as in emulation, blooms again into Eden. . . .[17]

Nature for Palmer, like Niagara Falls for Thomas Moore, could obliterate the doubts of the nineteenth-century atheist. The pear tree here, like the sunflower plant in Runge's

60 *Hülsenbeck Children*, seems to be alive with magical sap and vitality, almost quivering before our eyes in its fructifying

72 SAMUEL PALMER
Pastoral with Horsechestnut
1831–32

73 SAMUEL PALMER
*Pear Tree Blossoming in a Walled
Garden*
c. 1829

energies. So fervent an empathy with the visible forces of organic growth would not be found again until the work of Van Gogh.

Like other Romantics, especially Runge, Palmer also poses here an intense contrast of the near and the far, of the imminent and the distant. The abrupt jump from the microcosm of nature contained within the garden wall and the suggestion of an infinite, expanding bounty beyond is like that in the *Hülsenbeck Children*, where our eye must suddenly leap from the close confrontation of nature's forces on the near side of the picket fence to a remote vista that must contain an infinite number of nature's miracles. Such a polarity in Romantic art between the finite and the infinite, the microcosm and the macrocosm, might perhaps be considered a reflection of the period's restless and disturbing awareness of the individual pitted against the universe, whether in terms of a single human spirit that searches for its place in a mysterious totality, or of a single manifestation of nature that can offer a key to the unlocking of a cosmic whole.

But such verbal formulations, which might continue to accommodate the dilemmas of many later artists, must remain very abstract and metaphysical beside the emotional truths instantaneously conveyed by the self-portraits of many of the Romantic artists we have been concerned with here. Already by the 1780s, Carstens revealed in a self-portrait drawing the uncommon intensity of a hypnotic, wide-eyed

74 ASMUS JAKOB CARSTENS
Self-Portrait
c. 1784

75 CASPAR DAVID FRIEDRICH
Self-Portrait
c. 1810

74

76 SAMUEL PALMER
Self-Portrait
c. 1826

77 SAMUEL PALMER
Portrait of the Artist as Christ
c. 1833

78 SCHOOL OF JAN VAN EYCK
The Holy Face

stare that confronts the spectator with an earnestness and privacy alien to earlier eighteenth-century portraiture. The same kind of self-scrutiny can be found in Runge's self-portraits, weighty and brooding in their psychological charge; or, even more disquietingly, in a self-portrait drawing by 75 Friedrich. Seen against an abstract ground that locates him in the private world of his own feeling, Friedrich stares out at himself, and at us, from an unfamiliar vantage point that lies considerably below the eye-level of traditional portraiture and that, as a result, takes us almost by surprise in the askew but totally fixed gaze.

The mood of Friedrich's self-portrait might be described, perhaps exaggeratedly, as monastic, but in the case of Palmer's self-portraits the religious metaphor was made 76 totally explicit. In one early self-portrait of *c.* 1826, the head-on confrontation with a spirit of extraordinary fervor and mystery is as haunting as in any of the German self-portraits, even if the objective appearances of costume and physiognomy are perhaps more precisely recorded. But in another, later self-portrait of *c.* 1833, Palmer accomplished a truly 77 extraordinary transformation, combining his own features with an image of Christ.[18] It is probable that he was inspired by a painting, *The Holy Face*, in a British collection, a painting 78 then attributed to Jan van Eyck,[19] an artist Palmer had passionately admired; and it may well be that he had in mind not the potentially blasphemous idea of painting himself in

the role of Christ, but rather the more humble idea of using
his own, now bearded features as the practical means of help-
ing himself to recreate in painting the physiognomy of the
Holy Face. But whatever his intention, the remarkable fact
is his very ability to identify himself at all with the frontal,
hieratic head of a Christ by a Flemish primitive, translating
its impersonal features into a portrait of private suffering, the
eyes wet with tears, the gaze obsessive in its search for a world
of spirit.

Palmer's capacity to relocate his secular experience in the
realm of the sacred was a telling symptom of the curious dis-
placements of religious feeling among the Romantics. But it
was hardly to end with Palmer's generation. When, in
79 September 1889, Van Gogh painted a free copy of Delacroix's
Pietà, he did virtually the same thing. In paraphrasing the
head of Delacroix's martyred Christ, he seems to have sub-
stituted, consciously or not, his own red-haired portrait, as
revealed by comparison with those self-portraits he executed
80 at the same time. Indeed, Van Gogh, as we shall see, continues
to confront almost every Romantic dilemma posed to a
Friedrich or a Palmer, for he, too, was an artist who thought
of his painting not primarily as an aesthetic activity but as a
means of communicating with those supernatural mysteries
which lay concealed somewhere beneath the surfaces of the
materialistic nineteenth-century world.

79 VINCENT VAN GOGH
Pietà (after Delacroix)
September 1889

80 VINCENT VAN GOGH
Self-Portrait
September 1889

Part II Romantic survival and revival in the late nineteenth century

3 Van Gogh

IN MOST histories of modern art, especially those which are Paris-based, the death of Romanticism is placed in the mid-nineteenth century, to be replaced by a countermovement, Realism, which presumably undermined once and for all the Romantics' search for spirit, feeling, and symbol behind the objective data of the material world. Turner and Friedrich could still see angels in their visions of natural phenomena, but Courbet could not; and even Monet, in his most other-worldly interpretations of worldly light and atmosphere, could never have painted a supernatural creature. Even outside France, Romanticism, by the mid-years of the century, appears to have lost its original power to evoke the spirit of divinity and mystery, whether in ostensibly prosaic or imaginative subjects. Just as a long-lived artist like Samuel Palmer seems, by mid-century, to have lost the visionary aura that sanctified his early landscapes, so too do the great Romantic images of the early nineteenth-century masters, Runge and Friedrich, lose much of their original intensity in the art of later generations. It is revealing, for example, to see how even the high seriousness of Runge's private cosmogonies could be translated into less ponderous terms. Thus, the project for *Night* could become the basis for an illustration 81 to Clemens Brentano's fairy tales, *Gockel, Hinkel, und* 82 *Gackeleia*, in the 1838 edition, a charming children's world of flower- and air-borne creatures who are concerned not with

81 PHILIPP OTTO RUNGE
Night
1803

82 CLEMENS BRENTANO
Illustration to Fairy Tale 'Gockel, Hinkel und Gackeleia'
1838

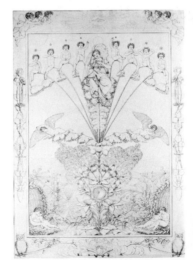

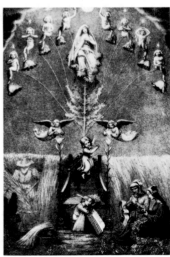

Runge's ultimate verities but rather with the delights of childhood fantasy.

The great images of Friedrich, in particular, were also slowly emptied of their transcendental implications. One

33 might usefully reconsider his *Woman at a Window* in the context of a later, Biedermeier master's interpretation of

83 the same theme, Moritz von Schwind's *Morgenstunde (Morning Hour)*, painted sometime after 1858. In terms of objective catalogue description, Schwind's painting might be itemized in the same way as Friedrich's: a woman, her back to us, stands before the open window of a middle-class interior, and looks out at a view just fragmentarily visible to us. Yet the subjective description would have to be vastly different. Friedrich's woman looks at something that instantly turns into evocation and symbol; Schwind's sees nothing more than the cheerful prospect of a sunny morning in the mountains. Viewed obliquely, standing off center, Schwind's woman suddenly belongs to the realm of casually observed experience, not to the secular shrine in which Friedrich's woman, in silent privacy, contemplates unnamed mysteries and longings.

In the same way, a painting like Friedrich's view of the

84 Watzmann in the Alps (a mountain he knew only from a watercolor) would have to be classified objectively as belonging to the same topographical realm as the Austrian Ferdinand

85 Waldmüller's later view of another section of the Alps, a view of the Hallstättersee from Hütteneckalm; yet once more the feelings emanated contradict the common denominator of the

83 MORITZ VON SCHWIND
Morning Hour
after 1858

84 CASPAR DAVID FRIEDRICH
The Watzmann
1824–25

85 FERDINAND WALDMÜLLER
*View of Hallstattersee from
Hütteneckalm*
1838

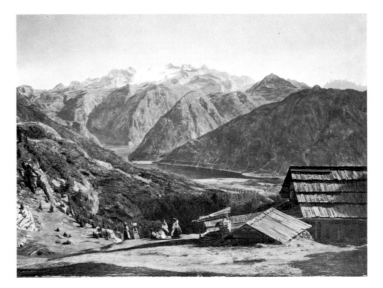

subject. Friedrich's mountain landscape is totally unpopulated, and the stark contrast between the verdant foreground and the unattainable purity of the distant, white peaks produces a polarity that invites symbolic speculation.[1] Waldmüller, on the contrary, relegates such scenery to the domain of a tourist holiday: the picturesque disposition of the wooden houses, the strolling vacationers, the seeming accessibility of the mountains themselves all suggest the easy, temperate pleasures of nature tamed to middle-class needs. No mystery, no divinity resides here.

Indeed, even when artists of a more philosophic persuasion

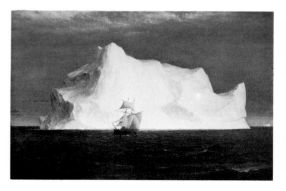 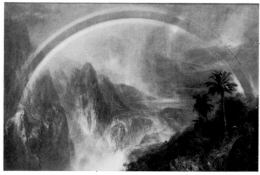

86 FREDERIC EDWIN CHURCH
Iceberg
1891

87 FREDERIC EDWIN CHURCH
Rainy Season in the Tropics
1866

continued to explore the symbolic motifs first defined by Friedrich, they inevitably diminished the stark force of his ability to transform natural fact into a timeless symbol of destiny. A case in point is the American, Frederic Edwin Church, who, like such other American landscape painters of the later nineteenth century as Albert Bierstadt and Thomas Moran, perpetuated the sublime landscape tradition of Friedrich. Yet even though Church's attitude toward nature was sufficiently mystical to permit him to execute paintings of a sunrise in the wilderness and a moonrise over the ocean as allegories of the death of his two children from diphtheria in 1865,[2] his sublime landscapes can often be mistaken, unlike Friedrich's, for thrilling travelogue views that simply docu-

86 ment strange, natural wonders. His painting of an iceberg (1891), for instance, may bear some symbolic message, but its

36 meaning is obscure by comparison with Friedrich's *The Polar Sea*, where all is instantly converted into an emblem of death and man's fate. Church's much earlier view of a breathtaking

87 rainbow that emerges after a rainstorm in a tropical paradise that seems half-Andean and half-Jamaican (1866) may bear some reference to visions of an unspoiled Garden of Eden and to images of hope,[3] yet by comparison with Friedrich's view

51 of a rainbow that also spans the entire painting and crowns a mountain, its symbolic message could easily be suppressed in the sheer spectacle of an exotic paradise recorded here on earth.

It is, in fact, difficult to discern objectively the difference between the emotional and symbolic aura conveyed by the same motif as used by, on the one hand, a master like Friedrich and, on the other, a less inspired Romantic contemporary or a later nineteenth-century master. The difference, however, is something that we immediately discern in subjective terms. In this light, too, it is worth noting how Paris-oriented art of the nineteenth century could often use the very motifs through which a Friedrich could convey transcendental mysteries, but produce thoroughly unlike results. Thus, the

1 cosmic, quasi-religious meditation of Friedrich's *Monk by the*

88 GUSTAVE COURBET
The Artist on the Seashore at Palavas
1854

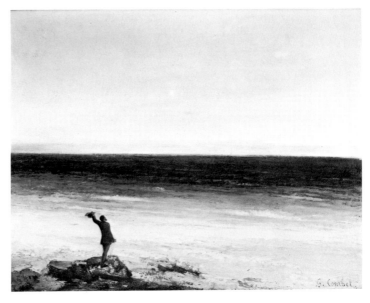

89 JAMES ABBOTT MCNEILL
WHISTLER
Courbet at Trouville (Harmony in Blue and Silver)
1865

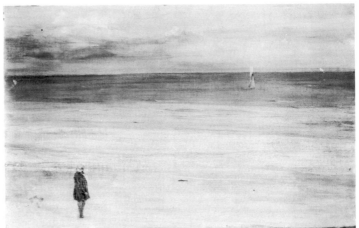

Sea is created by precisely the same components found in, say, Courbet's egotistical self-portrait of 1854, in which the 88 artist is seen at the beach at Palavas, near Montpellier, standing with his back to the spectator and facing an expanse of sea that stretches across an uninterrupted horizon. Yet far from suggesting silent absorption into some spiritual beyond, the figure appears strangely earthy and self-assertive. It is no surprise to read Courbet's comments on this self-portrait: 'Oh, sea! your voice is tremendous, but it will never succeed in drowning out the voice of fame as it shouts my name to the whole world!'[4]

Eleven years later, in 1865, Whistler, by then thoroughly steeped in the *art pour l'art* ambience of Paris, also painted a 89 picture of Courbet, who now stands on the beach at Trouville,

once more turned to the unbroken stretch of sand and sea.[5] This time, Courbet's swollen ego has vanished in favor of a ghost of a figure, hardly discernible as anyone at all. Yet if the presence of this lone figure as the only human element on a deserted beach can evoke some whisper of mood, the painting nevertheless imposes itself primarily as an exquisite *tour de force* of muted tonalities arranged in horizontal tiers. It is no surprise to find that Whistler entitled the painting *Harmony in Blue and Silver*, suppressing both the components of portraiture and of a meditation on nature's mysteries in order to stress a reading that would focus on aesthetic sensibility alone.

Or consider an Impressionist painting of 1872 by Monet, a view of the riverbank along the Seine at Argenteuil. The picture includes almost every motif from which Friedrich extracted such portentous symbols—figures standing quietly on the edge of a body of water; boats that move across the horizon; a distant vista of a building's Gothic silhouette, enframed by almost a nave of trees; and even a rather abrupt jump from the extremities of near and far. Yet somehow, though the painting conveys a gentle, contemplative mood, it also insists on the casual record of particular facts at a particular time and place. The clouds will shift, the figures will move, the trees will rustle in the breeze, the boats will pass. That quality of the momentary, of the random, of the specifically observed, thoroughly counters Friedrich's solemn and emblematic interpretation of the same motifs.

It is, in fact, much rarer to find in the domain of French painting than in the domain of Northern painting that quality which Thomas Carlyle spoke of in *Sartor Resartus* as 'Natural Supernaturalism,'[6] a phrase that has recently been used by M. H. Abrams as the title of a study in literary history which deals with many of the problems that have concerned us here: the search among Romantic writers and philosophers, especially in Protestant England and Germany, for some immanent mystery in natural experience that could replace the crumbling orthodoxies of Christianity.[7] As Abrams put it, these Northern Romantics tended 'to naturalize the supernatural and to humanize the divine.'[8]

To be sure, this Romantic reconstruction of the heavenly in the earthly could pertain to any number of national and religious traditions in the nineteenth and, as we shall see, twentieth centuries, among artists working both in the Protestant North and in the Catholic South. Pious peasants, country churches, rural innocence, natural Gardens of Eden, unspoiled commonplaces of nature, awesome sunsets, sublime mountains, could be found anywhere in nineteenth-century painting, whether in Spain and Italy or in Norway and Holland. Yet, measured by the intensity of the results, the artists who by and large pursued these Romantic goals most

90 CLAUDE MONET
Les Bords de la Seine, Argenteuil
1872

passionately, even desperately, were artists of Northern and especially Northern Protestant origin,[9] artists who seemed to work, like Friedrich, Blake, and Runge, not in the art-for-art's-sake ambience of Paris but in the art-for-life's-sake ambience of a private world in which the making of art was a means of communicating with the kinds of mystery that, before the Romantics, were located within the public confines of religion. And especially if one looks outside Paris, the usual locus for the history of nineteenth- and twentieth-century painting, one discovers that the Romantic pursuit of natural supernaturalism, of divinity in nature, did not expire in the mid-nineteenth-century, but in fact continued with renewed passion in the later nineteenth century and then into our own.

There is no better example of this survival, or perhaps revival, of the Northern Romantic dilemma into the later, post-Impressionist nineteenth century than the art of Vincent van Gogh. The very fact that his art was so inextricably related to his own non-artistic experiences—his search for religious values, his efforts to penetrate with his eyes and his feelings the mysteries of the commonplace, whether people, things, or nature—separates him from his French contemporaries. Even Gauguin, whose art was also closely interwoven with the values of his life and who constantly tried to evoke symbolist mysteries beneath the surface of things, remains, by comparison with Van Gogh, an artist who finally gave priority to the aesthetic, to the independence of art from life. The quasi-religious questions he meant to pose in his masterpiece of 1897—*Where do we come from? What are we? Where are we going?*—are posed almost more in the title than in the luxuriant, decorative splendor of the picture itself.

91 VINCENT VAN GOGH
The Old Tower in the Fields
early August 1884

With Van Gogh, however, we feel anew the kind of passionate search for religious truths in the world of empirical observation that characterizes so many of the Northern Romantics, in general, and Friedrich, in particular. One might begin by looking at a modest little painting of August 1884, which represents nothing more than a humble view outside the Dutch town of Nuenen. In it we see an old church tower, a setting sun, and a lone peasant standing in the fields. Such components could be found together in thousands of paintings of the nineteenth century, either in Van Gogh's native Holland or anywhere else in Europe or America; yet here, suddenly, there is once again a sense that these simple data of rural life and landscape have been carefully selected by the artist to express an idea or a feeling that far transcends the ubiquitous appearance of these motifs in nineteenth-century art. Unlike Monet's view of the Seine at Argenteuil, where there is no temptation to read beyond the momentary appearances of figures, landscape, architecture, Van Gogh's painting begins to suggest some symbolic connections among the starkly isolated components of this humble village scene—the silhouette of the church tower against the darkening sky, the disc of the sun overhead, and the solitary peasant who stands silhouetted against the earth, her head just rising above the continuity of the horizon. Although it could hardly be decoded in a conscious symbolic program, the painting seems to say something about the profound, unchanging relationships of religion to humble toil, to the daily cycles of work and nature.

In the years 1884—85 Van Gogh painted again and again this old church tower at Nuenen, examining it from different vantage points and recording it during different seasons, from spring to winter. Monet, of course, was to do something of

the same when in 1892—94 he painted a series of records of the façade of Rouen Cathedral as its craggy stone surface changed under the ephemeral chromatic and luminary conditions of the passage from dawn to sunset; yet by comparison, Van Gogh's record of a village church tower is less a statement about perception than about an idea. The very centrality of the church tower in some of the views of 1884—85 gives it a kind of symbolic status that we may recognize again from Friedrich's interpretation of those church ruins at Eldena to which he so constantly returned for inspiration; and once more, like Friedrich's view of these Gothic ruins in a wintry landscape, Van Gogh's record of the tower at Nuenen in the dead of winter conjures up religious speculation about man, nature, and death that are all the more strongly underlined by the presence of snow-covered cemetery crosses and hum- 92 ble cottages clustered protectively around the looming monumentality of the church tower.

92 VINCENT VAN GOGH
Country Cemetery at Nuenen in the Snow
January 1885

93 VINCENT VAN GOGH
Old Church Tower at Nuenen
May 1885

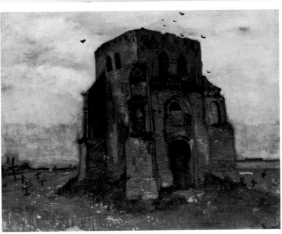

Fortunately, we need not depend entirely upon our own responses to these pictures to understand Van Gogh's intentions. Just as Philipp Otto Runge wrote copiously to his brother Daniel about his own artistic goals, and about his translations of fact to symbol, so too did Van Gogh write to his brother Theo about his responses to the prosaic data of the world around him and about the ideas he hoped to evoke in his choice of subject. Thus, when by May 1885 the church tower at Nuenen had begun to fall into ruins, Van Gogh not only newly recorded it without its former steeple and with the close observation of spring flowers growing among the crosses of the surrounding graveyard, but he also made explicit in a letter to Theo the religious implications that might only be guessed at from the pictures themselves:

93

> I wanted to express how these ruins show that *for ages* the peasants have been laid to rest in the very fields which they dug up when alive. . . . I wanted to express what a simple thing death and burial is, just as simple as the falling of an autumn leaf—just a bit of earth dug up—a wooden cross. The fields around, where the grass of the churchyard ends, beyond the little wall, form a last line against the horizon—like the horizon of the sea. And now these ruins tell me how a faith and a religion moldered away—strongly founded though they were—but how the life and the death of the peasants remain forever the same, budding and withering regularly, like the grass and the flowers growing there in that churchyard.
>
> *Les religions passent, Dieu demeure* [religions come and go, but God remains] is a saying of Victor Hugo's, whom they also brought to rest recently.[10]

And with these words, Van Gogh modestly and fervently restated not only the very questions inherited from the Romantics—how to express religious experience, the mysteries of death and resurrection, outside the canons of a moldering Christianity—but the very images explored by Friedrich and his contemporaries: Gothic ruins, cemeteries and burials, the cycle of the seasons, the mysteries of the horizon.

Van Gogh's own life could be considered a surrogate religious experience. He had begun as a lay preacher, unsuccessfully proselytizing the Gospel to peasants and coalminers with a passion that bewildered his congregation, and then rechanneling this evangelical fervor into his art. It should be no surprise then to find that he so frequently continued to explore the very motifs that the Romantics had translated into a new kind of religious art for a secularized century. Again and again, his search for the supernatural in the natural, for the symbol in the fact, meant that he would duplicate, in most cases quite unconsciously, the imagery of

much Northern Romantic art and often, especially in his later work, even the psychological charge evoked by many of the new spatial structures of Northern Romantic painting.

Already in his early, pre-French work, Van Gogh had implicitly raised the question of the proper boundaries of religious art, just as Friedrich or Palmer had done before him. The church tower at Nuenen, surrounded by the peasants' graveyard, could become for Van Gogh what the ruins at Eldena had become for Friedrich: the language of a new religious expression in which Christian architecture usurps the place of Christian narrative. Elsewhere, too, Van Gogh participated in this mode of spectator Christianity. His painting of the little Gothic chapel at Nuenen, viewed behind 94 a screen of trees, and separated from the foreground by a continuous hedge, tells us not only about this relic of Christian architecture but about its role in the religious life of those peasants who are seen leaving its sanctified walls. In its own, downtrodden way—for it represents with poignant honesty the simplicity of the chapel and its peasant congregation and the leaden bleakness of a wintry Dutch sky—it is only a variant upon a work like Palmer's *Coming from Evening* 68

94 VINCENT VAN GOGH
Coming out of Church at Nuenen
January 1884

Church, in which, despite the evocation of some imaginary, verdant Arcadia in ancient Britain, the message is also about the virtues of simple, rural piety, and the indivisible harmony of Christian architecture, nature, and an agricultural community.

The same Romantic question—can this properly be considered a religious painting?—is posed by Van Gogh's painting of the Bible open to a page in Isaiah, accompanied by two candlesticks and a yellow paperbound French novel, Zola's *Joie de Vivre*. To be sure, still-life painting, as in many seventeenth-century examples from Van Gogh's own native Dutch tradition, had often conveyed in disguised terms some symbolic message about world and spirit, and the idea of representing the Bible itself could also be found in seventeenth-century Holland. Yet these earlier works belong to a public domain of symbolic interpretation that, in Van Gogh's case, becomes a private world of meditation upon death and religion. It has been proposed, most convincingly, that Van Gogh's choice of a page from Isaiah and a burnt-out candle refers to the death of his father a half-year earlier, and that Zola's novel, juxtaposed with the Bible, provokes a symbolic contrast between the secular modernity of the late nineteenth century and the religious traditions embodied in the time-honored text of the Bible, which presides over the still-life with such a ponderous, inviolable density and magnitude.[11] We may never know the exact meaning of this choice of objects, but we can at least be certain that they represented for Van Gogh the kind of question about death and faith, the modern world and the Christian past, that belonged to the domain of religious experience.

Before he left for Paris, Van Gogh also proved himself a passionate heir to the tradition we have referred to as the

95 VINCENT VAN GOGH
*Still-Life with Open Bible,
Extinguished Candle and Zola's
'Joie de Vivre'*
October 1885

96 VINCENT VAN GOGH
Study of a Tree
April 1882

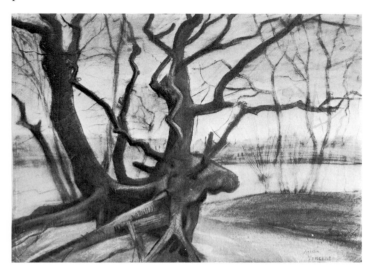

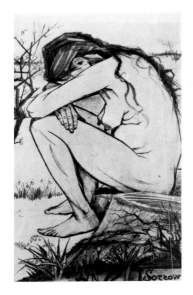

97 VINCENT VAN GOGH
Sorrow
April 1882

98 FRANCIS DANBY
Disappointed Love
1821

99 CASPAR DAVID FRIEDRICH
Woman with the Cobweb
1803–04

'pathetic fallacy'. The words he used in a letter of 1882—'I see in nature, for example, in trees, expression and, as it were a soul'[12]—could hardly define in a more simple and heartfelt way the Romantic viewpoint of Friedrich, Constable, Cole, and Palmer, among others. We noted at the end of Chapter I that Van Gogh's drawing of gnarled trees (April 1882) 96 belonged to the same emotional world as Friedrich's trees, conveying a sense of near-human suffering in the painful network of twisted roots and branches, and translating the very leaflessness of the trees into a metaphor of inner emotions brutally exposed. The human analogy could not have been made clearer, for Van Gogh, in fact, thought of this drawing as the counterpart to the explicitly human emotions revealed in his drawing *Sorrow*, which he then recreated in a lithograph. 97 Representing a despondent, crouching figure—directly inspired by the miserable prostitute, Christien, for whom Van Gogh felt infinite compassion—the drawing parallels this state of human despair with a small study of a tree below the sorrowing woman which reveals the same patterns of form and discharges of feeling. In this close echoing of human emotions with those of trees and landscape, Van Gogh again can be located in a Romantic ancestral table, which might be exemplified by such works as Francis Danby's *Disappointed* 98 *Love*, a painting of 1821, in which all of nature droops with the melancholic heroine and even the thorns, wrapped around the leaves in the foreground, echo the rejected woman's emotional stings;[13] or, on a somewhat more elusive symbolic level, a woodcut based on an early drawing by Friedrich (and 99 executed by his brother Christian), in which the interior, man-made environment of Dürer's *Melancholia* is replaced

100 VINCENT VAN GOGH
Orchard in Blossom, Arles
between 14 April and 10 May
1888

101 VINCENT VAN GOGH
Olive Trees, Yellow Sky with Sun
1889

by a melancholic nature that reflects, in the leafless trees and thistles, the despondency of a woman whose emotions seem to flow directly into the ambient landscape.[14]

Van Gogh's passionate empathy with nature, as almost a direct extension of human emotions, was far more closely related to his native Northern than to alien French traditions.[15] It is telling, then, as a demonstration of the countertraditions of French art that Van Gogh, on first attempting to absorb the brilliant newness of French Impressionist landscape painting, often seemed to suppress, in the interest of greater objectivity and decorative cohesion, his instinctive identification with the passions of nature, only to permit them to re-emerge with all the greater energy in the final years of his short life. A comparison between, say, the peach trees that 100 bloom in an orchard painted in Arles in the spring of 1888 and the olive trees that writhe in the rocky Provençal land- 101 scape painted near St. Rémy in the fall of 1889 may suggest how Van Gogh first adopted, however clumsily at times, the all-embracing shimmer of French Impressionism which tended to muffle the identity of individual parts of nature, and then once again, in his late work, revitalized, beneath this Impressionist surface, his commitment to a fervent identification with every palpable object or being he painted.

From his beginnings, in fact, he demonstrated the kind of passionate scrutiny of nature's most humble but most wondrous facts that we have already found in so much Northern Romantic art. There are, for example, his early paintings of birds' nests, in which he examines with close-up 102 intensity the womblike mysteries of these simple natural structures. The very choice of these commonplace subjects probably depends upon a Romantic tradition that was most popularized in England in the work of William Henry Hunt 103

102 VINCENT VAN GOGH
Three Birds' Nests
September 1885

103 WILLIAM HENRY HUNT
Hawthorn and Bird's Nest
1850–60

(known as 'Bird's Nest Hunt,' undoubtedly to distinguish him from his illustrious Pre-Raphaelite contemporary, William Holman Hunt). Hunt's many pictures of birds' nests continue, into the more objective language of mid-nine-teenth-century naturalism, that Romantic immersion in the microcosm of nature, looking at its data with little or no reference to the scale of man. Van Gogh apparently was already acutely aware in these early works of the difference between the phenomena of nature observed, as it were, *in situ* as opposed to in an artificial setting, for he comments on the fact that these three birds' nests have been removed from their natural surroundings and painted against a black back-ground.[16]

Indeed, throughout his career, Van Gogh seems to alternate between, say, an arrangement of flowers carefully composed in a vase and observed primarily as aesthetic objects and the same flowers viewed as living objects in their natural setting. 104 Thus, on the one hand, there is a still-life such as a vase of irises, of May 1890, in which the flowers' blooming and drooping silhouettes are decoratively patterned against two

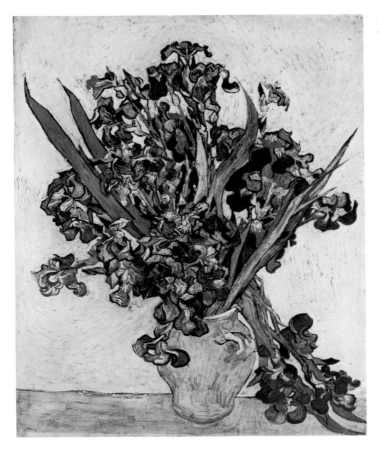

104 VINCENT VAN GOGH
Still-Life, Vase with Irises against Yellow Background
1890

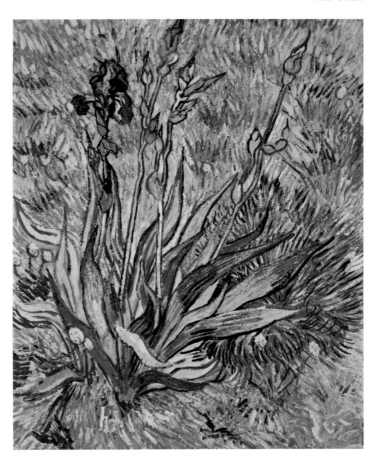

105 VINCENT VAN GOGH
Iris
April 1889

bands of flattened color which harmonize with the green of
the leaves and the creamy tone of the vase itself. But there are
also irises, like those of April 1889, which are seen growing 105
wild, burgeoning before our eyes with the kind of tough,
irrepressible energy that Runge had seized in his plants and
flowers, and which can make us believe once again that a
simple flower, an iris, can have the same magical aura as, say,
the symbolic irises in such a late medieval Northern painting
as Hugo van der Goes' *Portinari Altarpiece*. Moreover, Van
Gogh has here inherited from the Romantics that strange,
anti-Renaissance sense of a scale unrelated to human hierar-
chies. His iris plant looms as large as a tree, its energies ignit-
ing, flame-like, a background of blossoming greens and spring
flowers that seem to exist in a world of primal intensity
unrelated to human dimensions or calibrations.

Such a view of flowers growing in nature, as opposed to
being transplanted to the aestheticized human environment of
an interior still-life, is once again a tradition whose ancestry
is traceable through the Northern Romantics. Although

81

some nineteenth-century French masters, like Millet, on occasion painted flowers scrutinized closely in a setting that bore little or no mark of human intervention, it was a tradition more common in the North. American painters like Martin Johnson Heade often painted, into the late nineteenth century, close-up views of flowers, usually exotic, in a natural setting populated by birds rather than men, which produces the Alice in Wonderland magic of things that simultaneously seem uncommonly large and uncommonly small. It was a tradition that encompassed the humblest of flowers as well as the exotic splendor of Heade's tropical orchids: Samuel Palmer himself often painted or drew the simplest dandelions bursting like giants from the commonest corner of nature.[17]

Ultimately, the Romantic tradition of painting flowers *in situ*, viewed through the mysterious lens of microcosm and macrocosm (the flowers strangely enlarged, the background strangely diminished), finds its most memorable and widely circulated definition in the fantastic colored plates by Philip Reinagle and other British artists illustrating Robert John

106 MARTIN JOHNSON HEADE
Orchids and Hummingbirds
1872

107 Mezzotint by
RICHARD DUNKARTON
after
PHILIP REINAGLE AND
ABRAHAM PETHER
The Night-Blowing Cereus,
illustration in Robert John
Thornton, *Temple of Flora*

108 VINCENT VAN GOGH
Flowering Garden with Path
July 1888

Thornton's *Temple of Flora*, which appeared between 1797 and 1807. Here we find the first full-scale statement of, so to speak, the Romantic flower, in which, as in Runge, botanical data as well as the strange radiance of cosmic mysteries are conveyed through close-up scrutiny of individual blossoms. Engorged with swelling vitality, they expand to gigantic scale before our eyes and thereby diminish, as in the plate of the *Night-Blowing Cereus*, the works of man (a Gothic church 107 in the upper left) to minuscule dimensions.[18]

Van Gogh's flowers, to be sure, are usually more common in species than either those illustrated by exotic painter-travelers like Martin Johnson Heade or by compilers of botanical treatises like Thornton. But the telling fact again is that the individual species can usually be exactly identified in Van Gogh's works, at least in those where he seems to assert most fully his counter-French conception of nature. In the most French-influenced paintings of flowering earth, like one painted in Arles in July 1888, it is almost impossible to dis- 108 tinguish one flower from the other, for their individual identities are submerged under the even speckling of Impressionist flecks of unmodulated color. But this decorative, tapestry-like effect often appears to be a kind of aesthetic discipline alien to Van Gogh's instinctual nature which, like that of a Northern painter of the late Middle Ages or, for that matter, of the Romantic era, was attuned to the mystical individuality of things, even at the sacrifice of a cohesive decorative unity that might diminish the wonder of the specific data of things observed. In Van Gogh's late work, this instinct, so prominent in the early, pre-French years, is again dominant, so that in a view of a corner of Dr. Paul 109

109 VINCENT VAN GOGH
Dr Gachet's Garden
May 1890

110 PHILIPP OTTO RUNGE
Flower Silhouettes

Gachet's garden in Auvers, painted in May 1890, the Impressionist dabs of color no longer veil the uniqueness of separate species. In reading Van Gogh's letter describing the southern plants that he observed in Gachet's northern garden we can easily identify in the painting the aloes, the cypresses, the marigolds that he enumerates one by one.[19] The magic of nature's variety, scrutinized in its individual manifestations, has been resurrected from under the homogeneous, decorative surfaces of Impressionist color that the artist borrowed from his French contemporaries.

Van Gogh's late records of botanical fact may often be compared, on many levels, with Northern Romantic precedents. His drawing of feather hyacinth stalks, for instance, belongs to the same world as Runge's flower silhouettes, not

111 VINCENT VAN GOGH
Branches of Feather Hyacinth
May–June 1890

112 VINCENT VAN GOGH
Branch of an Almond Tree in Blossom
February 1890

only in its microscopic attention to botanical detail but in its curious scale which, because of the elimination of any reference to human size, magnifies the subject to unexpected importance. The sense of organic vitality so conspicuous in these Van Gogh flower studies is, again, another heritage from the Romantics. Thus, in a late painting of a blooming almond branch in St. Rémy, silhouetted against a clear blue 112 sky and separated, characteristically, from a world of human scale, we stare upward, far above the horizon, at the miracle of a blossoming tree, a nexus of young growing life that expands exuberantly to all four of the painting's borders. It is an experience that belongs to the world of Palmer's or Runge's own sense of the frothing bounty and energy of nature, and one which, like theirs, is easily translated into a symbol of human growth and vitality. It is no surprise to discover that Van Gogh painted this canvas as a gift for an infant close to him, his brother Theo's son, who had just been born in Paris, on 31 January 1890, at a time when Van Gogh could watch the stirrings of new botanical life in the more clement Provençal winter at St. Rémy and associate this early coming of spring with the birth of his nephew.[20]

Van Gogh's ability to empathize with the life of flowers and to find in them some mysterious metaphor of the supernatural in nature is nowhere more emphatic than in his many studies of sunflowers. It is worth noting that, in writing about these pictures, Van Gogh almost always mentions specifically the number of flowers—three, twelve, fourteen—as if each one counted as an individual, feeling thing, a separate miracle of nature.[21] Thus, even at their most decorative, as in the Gauguinesque arrangement of a bunch of sunflowers in a

113 simple cream-and-yellow pot of August 1888, Van Gogh's
sunflowers are conceptually and emotionally different from,
114 say, such a French sunflower still-life of the 1880s as that by
Monet. In Van Gogh's still-life we somehow feel the miracu-
lous vitality of each individualized stem and blossom, as if

113 VINCENT VAN GOGH
Still-Life, Vase with Fourteen
Sunflowers
August 1888

114 CLAUDE MONET
Sunflowers
1881

115 VINCENT VAN GOGH
Sunflowers
late summer 1887

every flower were seized at some moment of a mysterious life-cycle which reaches its vital climax in the radiant blossoms at the top and which expires with the drooping ones that hang over the side of the vase. In Monet's sunflowers we see rather a collective whole, where the individuality of the flowers is submerged in a decorative shimmer that fuses the reflections from both a natural source (the daylight of an unseen window) and an artificial one (the warm red of the table covering). Monet's still-life is above all an object of aesthetic delectation, where the natural is finally subordinated to the artificial; Van Gogh's finally subordinates the artifice of the decorative patterns to the overwhelming sense of tough and vital natural energies conveyed through the individual lives of these flowers.

Elsewhere, in other sunflower studies, Van Gogh's empathy 115 with their biological mysteries is even more conspicuous, as in those intensely close-up studies of two or three living and dying blossoms so expansive in size that we have almost a bee's-eye view of the organic vitality—sometimes passionately radiant, sometimes pathetically flagging—transmitted by every quivering detail of sepal, petal, stamen, pollen. For Van Gogh these flowers, as earthbound metaphors for the miracle of the sun's energy, must have had a particularly religious connotation. How else could he have referred to them, when planning a triptych, as 'illuminating candelabras'?[22] And for Van Gogh, these flowers, in their special toughness and energy, must have had associations with the kind of mysterious natural vitality that Runge had already expressed in his own association of sunflowers with growing infants in the portrait of the *Hülsenbeck Children*. 60

Van Gogh's occasional paintings of children also belong to this Romantic heritage. They bear special analogies to Runge's children in their indifference to prettified and sentimentalized images of infants and in their awareness rather of the child as the container of primal organic forces that might be perceived as directly as the tough energies of the hardiest of sunflowers. Thus, Van Gogh's painting of Mme. Roulin (the wife of the Arlésien postman Joseph), and 116 her baby, Marcelle, is grotesque by comparison, say, with the standards set by a Renoir, just as Runge's portrait of his wife 117 and infant son, Otto Sigismund, is a startling rejection of the sentimental mother-and-child portrait types created by a Greuze or a Vigée-Lebrun. In both Van Gogh and Runge, the child looms before us with frightening size and vitality, forcing the mother into a subordinate role, the old, weak tree from which a new and stronger branch has grown. Indeed, in the case of the Runge, the child is actually silhouetted against a growing young tree that rises higher than the tree associated, at the left, with his mother. The energies are those

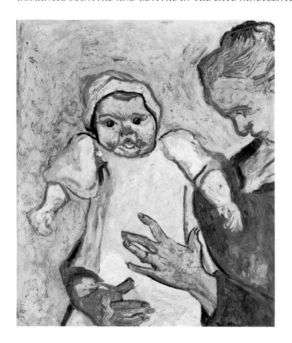
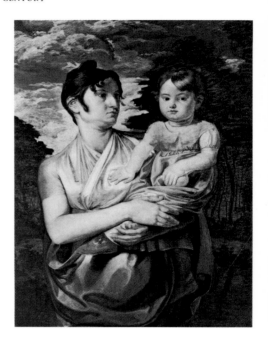

of an infant Siegfried or Hercules—tough, irrepressible, infringing upon the ambient space and figures.

In another, even more intensely focused portrait of the
118 Roulin baby, Marcelle, Van Gogh again perpetuates Runge's
119 child image. Like Runge's portrait of his son, Otto Sigismund, perched in a highchair that seems barely capable of containing the infant's rapidly swelling flesh and energy, Van Gogh's infant is all mysterious plasm, expanding, like that of a young giant, beyond the cramped confines of the picture's rectangle. And again, as in their flower paintings, both Runge and Van Gogh move to the scale of their subject, in this case an infant's world; for they stare at these strange, humanoid creatures not from adult height above, but rather from an infant's-eye view that confronts with disquieting directness and intensity the phenomenon of a baby's pudgy flesh and glassy gaze. No more winsome as a painting of a child is Van Gogh's record
120 of the young blonde daughter of a carpenter in Auvers, M. Levert. The child again looms large before us; seated in a verdant, flowered landscape that radiates the coarse energy of her red cheeks and long blonde hair, she grasps a large orange with hands that share the prehensile strength of the infant in
60 Runge's *Hülsenbeck Children*. Neither Van Gogh nor Runge associated children and flowers with the pretty, the decorative, the sentimental, but looked upon them as unspoiled vessels that, here on earth, convey mysterious, God-given energies.

Following in so many ways a Romantic search for a new

116 VINCENT VAN GOGH
Mother Roulin with her Baby
November–December 1888

117 PHILIPP OTTO RUNGE
Artist's Wife and Son
1807

118 VINCENT VAN GOGH
The Baby Marcelle Roulin
November–December 1888

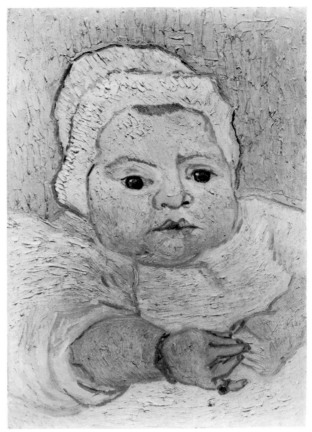

119 PHILIPP OTTO RUNGE
*The Artist's Son, Otto Sigismund,
in Highchair*
1805

120 VINCENT VAN GOGH
Levert's Daughter with Orange
June 1890

121 VINCENT VAN GOGH
The Sower
June 1888

kind of religion in the scrutiny of nature, Van Gogh inevitably perpetuated in his own art many metaphors of divinity that were first invented in the visionary landscapes of Friedrich, Runge, and Palmer. There is, for instance, Van Gogh's recurrent image of the sun as something almost sacred, a connotation that can often become explicit. Even in a
121 thoroughly secular scene like that painted in Arles in June 1888 of a sower in a wheat field, the sun, blazing on the horizon, has an almost supernatural power. Its location, in exact center and just over a high horizon, is that which, in earlier art, one might have associated with a symbolic representation of an omnipotent deity; and its form and color, a pure disc of golden yellow from whose clearly incised circular periphery radiate symmetrically ordered spokes of golden light, suggest that this is, in effect, the pantheist's equivalent of a gilded halo. The supernatural aura of this centralized sun, which has usurped some holy presence, is precisely that which we feel in, say, a painting by Friedrich, another symmetrical
122 sunset where the glowing, heavenly orb takes on almost iconic stature, an inaccessible, luminous presence framed by willow trees in the foreground. We shall often see such heavenly deities, solar and lunar, in another Northern artist of Van Gogh's generation, Munch.

It was characteristic, too, of Van Gogh's perpetuation of the Romantics' sense of divinity in landscape that he was constantly drawn to the image of peasants tilling the soil, as if such idyls of simple agricultural life could recall an elemental, Old Testament harmony of man in nature. In Van Gogh's case, such imagery probably derived mainly from

122 CASPAR DAVID FRIEDRICH
Willow Bushes with Sun
c. 1825–30

123 VINCENT VAN GOGH
The Sower
Autumn 1888

Millet's solemn idealizations of pious peasants, yet the results strike a far more familiar chord in the non-French ancestry of Palmer and Friedrich, where peasants and shepherds seem to inhabit an enchanted landscape of almost symbolic purity, magically vitalized by blazing golden suns or silvery crescent moons. In such an ambience, a solitary reaper could easily take on a quasi-religious metaphor, as when Van Gogh, writing about his painting of a wheat field behind the asylum at St. Rémy, thinks of the lone reaper as an image of death in the sense that the wheat he reaps might be a symbol of humanity.[23] A lone reaper by Palmer could provoke exactly the same kind of symbolic interpretation, for his records of agricultural activity, like Van Gogh's, also seem to place the natural on the threshold of the supernatural.

In this light, it is worth noting that Palmer's secularized but 67 haloed 'Good Shepherd' also finds his counterpart in Van Gogh. Thus, in the autumn 1888 painting of a sower, we find 123 that the enormous disc of the setting sun is located directly over the head of a solitary peasant who sows seed upon the earth with his outstretched hand. Like Palmer's drawing of a shepherd who stands in front of the huge aureole of the sun, Van Gogh's painting translates such traditional crowns of divinity as a golden nimbus into a setting sun that virtually sanctifies the lone peasant. For all the indebtedness of this painting to the style of Gauguin and of Japanese prints, its spirit belongs more to the world of Palmer and Friedrich.

Van Gogh's search for the supernatural in the world of the natural gave his interpretation of light, whether solar, lunar, or artificial, an aura of mystery that seems to have more to do

124 VINCENT VAN GOGH
Night: the Watch (after Millet)
October 1889

125 VINCENT VAN GOGH
Figure of an Angel
November 1889

with the magical light of Friedrich and Turner than the empirically examined light of the French Realists and Impressionists. It is worth noting that when he copied a print by Millet which represented a humble peasant family sitting around the light of a candle, he so magnified the yellow 124 radiance of the candle's small flame that the simple interior is bathed in a light which, one feels, would be equally suitable for the representation of a Holy Family. Van Gogh must have learned much about the divinity of light from his great Dutch pictorial ancestor Rembrandt, who also blurred so movingly the distinction between the natural and the supernatural.

126 VINCENT VAN GOGH
Raising of Lazarus
May 1890

127 REMBRANDT
The Raising of Lazarus

When Van Gogh copied Rembrandt, it was above all the Baroque master's light that seemed to haunt him. In his copy of a head of an angel, then ascribed to Rembrandt, Van Gogh translates the luminous halo into the very image of radiant 125 spokes that he often uses for the sun. More telling still is Van Gogh's free copy of Rembrandt's print of the *Raising of* 126 *Lazarus*, where he included only three of Rembrandt's figures and, most remarkably, excluded the miracle-working Christ, 127 for whom he substituted, as it were, the golden ball of the sun, which becomes the supernatural agent that effects the miraculous resurrection.[24]

To paint the head of a Christian angel, the Raising of Lazarus, or the Pietà, Van Gogh needed the support of the old masters; however much he could believe in these Christian truths, he could not reinvent them in any but naturalistic terms. His complaint about Émile Bernard's *Christ in the Garden of Olives*—that it would be better simply to paint real olive trees[25]—is a clear avowal not only of Van Gogh's personal dilemma but of that of so many artists who inherited the problems of those Northern Romantics who tried to create, consciously or unconsciously, a religious sentiment in things observed that would be far more truthful to their personal experience of the supernatural than the perpetuation of traditional Christian iconography.

For Van Gogh, as for so many Romantics, the night sky could provide one of the most passionate metaphors of the mysteries of the universe. As he explained to his brother Theo, after commenting on how it did him good to attempt difficult pictures, taken, like the scenes in Flaubert and Zola, from real life: 'That does not prevent me from having a terrible need

of—shall I say the word?—of religion. Then I go out at night
128 to paint the stars. . . .'[26] He was referring to a painting he
executed in September 1888 of a star-filled sky over the
Rhône River, a painting that may well be inspired in part by
129 an earlier picture of a starry night by Millet, that French
artist who so often sparked Van Gogh's imagination. But
again, by comparison, Millet's record of a comet-streaked
night in a Northern wood seems prosaic and literal—indeed,
it has recently been called 'the most accurate description of a
night sky painted in the nineteenth century,'[27] whereas Van
Gogh's becomes a visionary blaze that sets the sky and water
on fire and curves the horizon with its pulsating energies. A

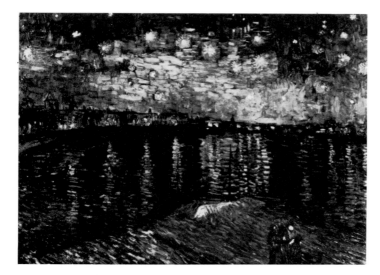

128 VINCENT VAN GOGH
The Starry Night
September 1888

129 JEAN-FRANÇOIS MILLET
The Starry Night
1850–51, retouched in 1865

130 VINCENT VAN GOGH
Starry Night
June 1889

131 CARL GUSTAV CARUS
Gothic Church and Tree Tops in the Moonlight
c. 1820

man and a woman in the right foreground take their place, like Friedrich's silent observers of moonlit skies, as witnesses to this stellar and lunar magic, anonymous figures submerged and diminished in the sheer breadth and intensity of the natural wonder above. One is reminded of Diogenes Teufelsdroeckh, Carlyle's spiritual alter ego in *Sartor Resartus*, who wished to disclose, 'were it in the meanest province . . . the star-domed city of God.'[28]

130 Van Gogh's most famous disclosure of that 'star-domed city of God' is, of course, his later painting of a heavenly blaze, the *Starry Night*, executed at St. Rémy in June 1889, a painting that for twentieth-century spectators has become one of the most famous modern symbols of a visionary, quasi-mystical translation of the data of the empirical world. Never did Van Gogh go further than this in transforming observed fact into ecstatic spirit, where palpable substance becomes flame-like energy. The undulant contours of the rising cypress and of the distant foothills are of the same impalpable stuff as the gyrating blaze in the sky that merges the crescent moon and the individual stars into an apocalyptic whole. It is a vision that ultimately belongs more to the realm of religious revelation than to astronomical observations.

Although the writhing momentum of this image is Van Gogh's own, it is worth noting that the painting has Northern Romantic precedents in spirit and subject. Thus, in a work by
131 Friedrich's disciple, Carl Gustav Carus, we are already located, as in Van Gogh, before a mysterious night sky illuminated by stars and a crescent moon, screened from the spectator by the strong dark silhouettes of Gothic church spire and treetops. In neither picture do we have a foothold, but float rather before some distant vision of nocturnal splendor that lies beyond our grasp, on the near side of the objects that block us in the foreground. It is significant, too, that some of the capacity of Van Gogh's painting to cross the threshold of the natural must depend upon his inclusion, in the enchanted valley, of a church whose fantastically high Gothic spire, echoing the acute angle of the foreground cypress, is the only man-made element that rises above the radiant little village into the heavenly zone above. It is the kind of visionary image of religious architecture in a landscape often found in Friedrich and Palmer, and that can now translate Van Gogh's earlier, more earthbound studies of the Gothic church at Nuenen into a new kind of symbolic image that here literally provides a point of contact between the terrestrial and the heavenly. As in Friedrich's paintings, the expression of some mystical divinity is so strong that it is hard to resist specific symbolic readings. Does this cypress connote, as in its traditional symbolism, death, and if this is the case, is the sky a symbol of an apocalyptic resurrection? Does the tiny, in-

habited village clustered quietly about the church spire suggest the diminutive power of man against the tumultuous heavens? Yet again as in Friedrich, such readings must be hesitant and speculative. The genius of both masters is one of evocation, not the invention of a specific symbolic code that may be deciphered like a Baroque allegory based upon Ripa's *Iconologia*.[29]

Van Gogh, in fact, provides a remarkable number of parallels with Friedrich, even though the chances of his ever having seen a work of Friedrich's, either in the original or in reproduction, are almost nil. Like the Romantic master, he also painted window views that, unlike their French counterparts, become personal metaphors of an enclosed private world that is abruptly separated from something that lies beyond. Thus, Van Gogh's view of a window in the mental hospital, St. Paul's, at St. Rémy, where he so often sought refuge in 1889, could hardly be confused, despite its sunlit atmosphere, with the cheerful window views of French painters from Monet to Matisse, but becomes rather a poignant record of a private experience, in which every detail —the bottles in front of the window, the pictures on the wall —seems a projection of the artist's personality rather than a decorative component. It is like Friedrich's angle view of his studio window which, even without a human presence, seems, like Van Gogh's, to be saturated with the artist's personality, even to the point where it might be interpreted as a symbolic self-portrait.[30]

Van Gogh resurrects Friedrich's spirit, too, in his last paintings, those bleak, lonely views of landscape in which the broad sweep of the horizon is so panoramic and engulfing that the individual's potential for functioning within it dwindles to a fearful insignificance. That tragic mood of a terrible loneliness and an almost menacing power in a simple landscape was first explored by Friedrich in such a picture as the *Large Enclosure Near Dresden*, where so much of the earth seems to expand with so infinite an extension that it actually produces a curvature which one of Friedrich's engravers, Philipp Veith, corrected in his print,[31] substituting perspectival accuracy for emotional authenticity. Had an engraver copied Van Gogh's *Field Under Thunder Clouds*, painted in the last weeks of his life, he, too, might well have made the same kind of perspectival correction, for Van Gogh also shows so passionately broad a sweep of the horizon that the earth again swells in a curvature that has more to do with subjective experience than the rules of one-point perspective. Van Gogh's words to describe this and two other paintings of wheat fields could well pertain, in their emotional confession, to Friedrich's painting: 'I have painted three more big canvases . . . fields of wheat under troubled skies, and I did

132

133

134

135

132 VINCENT VAN GOGH
Window of Vincent's Studio at St Paul's Hospital
May–June 1889

133 CASPAR DAVID FRIEDRICH
Studio Window
1805

not need to go out of my way to express sadness and extreme loneliness.'[32] For all their record of specific observation—wheat fields near Auvers, an enclosure near Dresden—both Van Gogh's and Friedrich's paintings are projections of a terrible isolation, in which the extremities of a space that stretches swiftly from foreground to an almost unattainable horizon, are charged with such power that the artist, and hence the spectator, feels humbled and finally paralyzed before the forces of nature.

How far Van Gogh had traveled in terms of redefining his perceptions in the interest of molding them to correspond to his emotional needs may be suggested by considering together an early Dutch work—a window view from the artist's attic room in The Hague, of July 1882—and the late *Crows over Wheat Fields*, painted just a few weeks the artist took his life on 27 July 1890. In the earlier picture, Van Gogh used, with student-like perseverance, a perspective frame, a traditional device in which geometric grids of crossed strings secured the illusions of one-point perspective

136
137

136 VINCENT VAN GOGH
Roofs seen from the Artist's Attic Window
July 1882

134 CASPAR DAVID FRIEDRICH
The Large Enclosure near Dresden
c. 1832

135 VINCENT VAN GOGH
Field under Thunder Clouds
before 9 July 1890

137 VINCENT VAN GOGH
Crows over Wheatfields
before 9 July 1890

138 CASPAR DAVID FRIEDRICH
Hill and Ploughed Field near Dresden
c. 1824

with all orthogonals converging on the horizon. The vista of Dutch roofs and flying birds flees swiftly away from the foreground to some point in the distance with an impersonal predictability which reflects closely the mechanical method that achieved this facsimile of the distance between the perception of a nearest and a farthest point. But in the late painting, this traditional perspective device, inherited from the Renaissance, is inverted, turned inside out, so that the rush of orthogonals (the three roads) across the distance from near to far suddenly converges upon the viewer, rather than upon the horizon. It is a three-pronged force that, as Meyer Schapiro has described so unforgettably,[33] turns not so much outward, toward the now inaccessible horizon, but inward, toward the beholder. This profound change from a construction that would objectify the space of the outer world to one that translates it into a language of personal anxiety pertains even to the birds in these two works. In a letter describing The Hague roofs, Van Gogh comments that the flying birds are signs of the beginning of a new day;[34] in the *Crows over Wheat Fields*, the flock of crows hardly needs the artist's words to explain their import, for these black creatures, traditionally associated with death, surge over the horizon and invade the foreground, menacing omens of some undefined, but imminent disaster.

Remarkably, Friedrich too painted a landscape of black ravens flying over a field and at a time—the mid-1820s—when he, like Van Gogh, was suffering not only professional discouragement but both mental and physical illness. In Friedrich's view of a plowed field near Dresden we see, as in Van Gogh's, that strange inversion of perspective which turns the space of the painting upon the beholder. Here, the distant vista of only the very tops of a few of the city's highest spires is blocked from us by the foreground landscape, whose horizon seems to swell around us in an imprisoning enclosure. And like Van Gogh's fields, Friedrich's have been invaded by a flock of black birds which have flown from beyond the horizon into the constricting space of the spectator. The subjective intensity of both Friedrich's and Van Gogh's paintings compels us to experience them in a new way, as images of anxiety, of the contrast between an inaccessible beyond and the private universe of the artist's experience. In this, as in so many other ways, Van Gogh can be considered an heir to the Northern Romantics.

138

4 Munch and Hodler

IN THE context of late nineteenth-century French painting, Van Gogh's passionate empathy with things seen, his search for a quasi-religious meaning in anything from a sunset to a sunflower, from a shepherd to a newborn child, strike a note as alien as his willingness to let his art serve, even at the expense of decorative cohesion, as the most direct vehicle for the release of anxieties about his relation to the world around him and to life's ultimate mysteries. By comparison, even Gauguin's efforts to evoke moods of Christian piety among Breton peasants, to ask transcendental questions about the meanings of birth, love, and death seem programmatic and literary, their would-be disquieting content more often concealed than revealed under surfaces of sumptuous aesthetic harmony. But if Van Gogh's art is looked at in the context of late nineteenth-century painting in Northern Europe, it can find companionship in the work of other artists who also found themselves the heirs to a Romantic belief in art-for-life's sake and who also perpetuated a Romantic pantheism that could find in the mysteries of landscape a surrogate for traditional religious art.

Only a glimpse of the self-portraits of the two artists who will concern us here—the Norwegian Edvard Munch and the 140 Swiss Ferdinand Hodler—can relocate us in the psychological 139 world of Northern Romantic self-portraiture. The wide-eyed stares of Carstens, Friedrich, and Palmer are the emotional ancestors of these artists who, in the late nineteenth century, continue to confront themselves with a close-to-frontality that, as is explicitly the case in Munch's lithograph, with its lower border of a bone, poses questions about the relation of the artist to the mysteries of his inner self and to the great unknowns beyond. They are self-portraits that record the artist not in the present tense of realism, but rather in the timeless realm of eternity. In fact, we shall find again and again that these ultimate questions are asked by Northern artists long after the presumed demise of Romanticism in the mid-nineteenth century. Are masters like Van Gogh, Munch, and Hodler to be considered the spearhead of a revival of Romantic attitudes? If the history of nineteenth-century art is measured by the timetable of Parisian developments, then these Northern artists seem to belong to a post-Impressionist generation that is preceded by decades of anti-Romantic art

which insisted, from the 1840s through the 1870s, from Cour-
bet to the Impressionists, on grasping the empirical facts of
the here and now. Yet if these Northern masters, rather than
being grafted onto a foreign French tradition, are considered
as the successors to the more provincial traditions of their own
countries, their art can often be seen as a more direct, almost
uninterrupted continuation of the Romantic premises that
obtained so long into the nineteenth century in Northern,
and especially Northern Protestant countries. They may well
be as much examples of survival as of revival. The fact that so
much of their mature style was dependent upon a pictorial
language developed first by French masters tends to deceive
us into clocking them by Paris time.

Thus, in Munch's Scandinavia, Northern Romantic land-
scape traditions, with their sublime scenes of chasms, torren-
tial cataracts, and storms, were maintained well beyond the
mid-years of the nineteenth century. Already in the late
eighteenth century, the Swedish artist Elias Martin painted
141 scenes of windswept pine trees in vast and foggy mountain

139 FERDINAND HODLER
Self-Portrait
1912

140 EDVARD MUNCH
Self-Portrait
1895

passes that for sublimity could rival anything in the British tradition, which Martin had absorbed first-hand during his two English sojourns; and in the early nineteenth century, close connections with the art of Friedrich were made by the Norwegian, Johan Christian Claussen Dahl, whose blasted, 41 agonizing birch tree of 1849 we have already considered as a particularly potent as well as belated example of the pathetic fallacy. Indeed, such Romantic landscape traditions continued in Scandinavian art well past the year 1848, so critical for the history of French painting. The dramatic canvases of the Swede, Markus Larsson, are cases in point, perpetuating as they do scenes of wild, virgin forests or 142 moonlit storms at sea well into the third quarter of the nineteenth century. To be sure, these engrained Romantic attitudes were challenged in the 1870s and 1880s by younger, more Paris-oriented artists who attempted a Realist revolution; but the native traditions of Romantic landscape were so

141 ELIAS MARTIN
Romantic Landscape
1768–80

142 MARKUS LARSSON
Cascade at Småland
1856

dominant that an artist like Munch, for all his early allegiance to a Realist aesthetic, might as easily be thought of as merely extending rather than resurrecting the moods, the goals, the forms of Romantic art.

Such questions may be more semantic than historical. What is clearer is that, survival or revival, Munch's work, from the 1880s on, reveals growing affinities with the great archetypal Romantic images of Friedrich and Runge. Like Van Gogh, Munch changed drastically the surface appearance of his painting by absorbing the newest artistic vocabularies that he could study during his frequent sojourns in France that began in 1885; and like Van Gogh, Munch could almost always mold this foreign vocabulary to his own emotional needs. It is

143 worth looking at a quasi-Impressionist painting of 1891, which shows a well-dressed, middle-class woman seated in a blond, dappled landscape that evokes the mood of Sunday afternoon leisure and country outings so common to the French paintings Munch had been able to see first-hand. Yet confronted with an example by, say, Monet of the same kind

144 of subject—a well-dressed, bonneted woman so immersed in nature that she is almost camouflaged by the speckled landscape around her—Munch's painting strikes a totally foreign psychological note. The relation of the figure to the landscape is, by French standards, disquieting: the figure seems more to be isolated than absorbed by the sunlit lawns around her, and even though her face is shielded from us by a wide-brimmed hat, we sense through her posture and separateness what is almost a kind of antagonism rather than harmony between her and a setting that looks more appropriate for contemplation than for picnicking. The disquieting psychology of a figure who, when located in a natural setting, emanates an aura of internal tension rather than external

143 EDVARD MUNCH
Outdoor Scene
1891

144 CLAUDE MONET
Woman Reading
1876

145 CASPAR DAVID FRIEDRICH
The Source of the Elbe
c. 1810

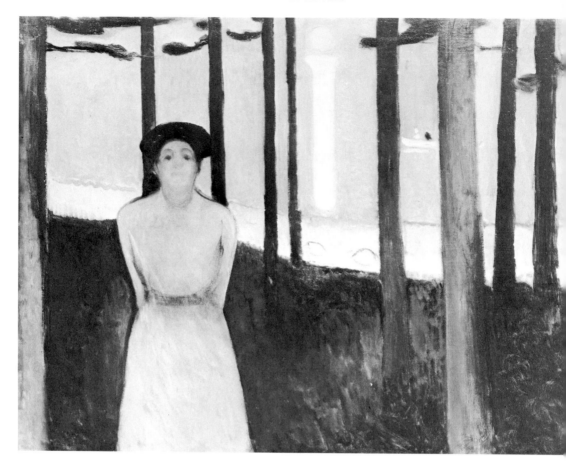

146 EDVARD MUNCH
The Voice
1893

relaxation is one that can be abundantly duplicated in Friedrich's work. Thus, even in an ostensibly peaceful view by Friedrich of a mountain meadow, the presence of a lone figure with a walking stick becomes, thanks to its unexpected position, disturbing. The wanderer is too large to be an insignificant speck in nature, and his surprising position of facing away from the view and out, past the lateral edge of the picture, similarly isolates him from his surroundings, underlining the sense of a lonely, meditative ego that opposes its own private sensations to those of the ambient landscape.

By the early 1890s, the sensation of a figure caught in an intense emotional dialogue with nature, both yielding and resisting, became even more emphatic than in those pictures which, like so many of Van Gogh's from 1886 to 1888, paid more superficial homage to French precedent. Often, the figure is placed in explicit tension with nature, as in *The Voice* (originally called *Summer Night's Dream*) of 1893, where the psychology of a painting like Friedrich's *Woman in Morning Light* is curiously perpetuated, though, to be sure, with a new

inflection. Like Friedrich's woman, Munch's stands upright, a strong vertical element that, embodying a silent, lone human presence, immediately establishes a psychological tug against the surrounding landscape. Friedrich's woman, facing the sunrise, seems to be immersing, losing herself in nature; Munch's, facing the spectator, seems to sense a strange magnetism from the trees, the water, the near-centralized heavenly orb that fuses midnight sun and moon and casts a mysterious reflection that parallels her own rigid verticality. Even without contemporary comments on this painting, written with Munch's approval,[1] we would probably intuit that in the case of Munch's young woman the forces of nature are sexual in character. The repressed yet giving posture of the figure in a virginal white dress who both withdraws her arms and extends her face and breasts, the tiny boat on the lake, with its male and female occupants symbolically polarized in dabs of black and white, the irresistible compulsion of the orb and reflection—all suggest a kind of Scandinavian *Sacre du Printemps*, an awakening of sexuality that is fearful and even destructive, its energies so powerful that human will is annihilated.

The motif of a figure in a tense, internal dialogue with nature was one that Munch resurrected from Romantic imagery, and it may be seen throughout his *œuvre*, especially in the 1890s, the decade in which he first found the artistic means to project his melancholic concepts of man in nature. In a print of two figures who stand, their backs to us, before 147 the infinite expanses of a body of water no longer even delimited by a horizon, we have a remarkable reprise of the very motif invented by Friedrich, as in his early painting of two men, again turned away from the spectator and toward 19

147 EDVARD MUNCH
Two People
1895

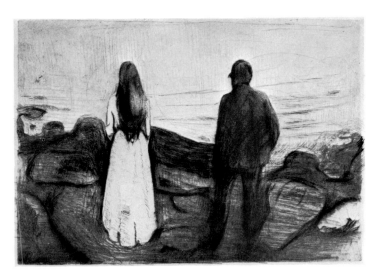

the phenomena of nature, in this case a mysterious sunset over the sea. Not only does Munch repeat Friedrich's psychologically charged back view of a silent, contemplative figure, but also the starkness of his symmetrical structure, which once more transforms surface into symbol, the random into the eternal. Again, Munch's figures yield a sexual overtone foreign to Friedrich: the lonely pair who face the sea are male and female, forcefully contrasted in their opposition of black and white as in their basic compositional duality, and the tensions generated now eroticize those natural forces which, in Friedrich, had not yet acquired the sexual charge so conspicuous in many late nineteenth-century interpretations of nature.

Given the frequent recurrence of Friedrich's imagery and structure in Munch's work, one cannot help asking whether, in fact, Munch might not have known first-hand the art of Friedrich and his circle. Here the answer may be more positive than in the case, say, of Van Gogh, for the Norwegian art historian Andreas Aubert not only owned works by Friedrich in Oslo (then Kristiania), but began to write about him in the 1890s. Moreover, even if Munch did not know Friedrich, he must have known the work of his Norwegian disciple Dahl, who was honored in Kristiania in 1888 with a retrospective exhibition celebrating the hundredth anniversary of his birth.[2] And other Norwegian masters of the early nineteenth century preserved Friedrich's spirit and themes. Thus, in a characteristic painting by Thomas Fearnley, a Norwegian painter of English family origin, we see two tiny figures standing, their backs to us, in silent meditation before the boundless, virgin mysteries of the Norwegian landscape, here a burial mound on the Sognefjord at Slinde.[3] Repeating Friedrich's evocative contrast of near and far, of the material and the spiritual, the foreground, with its enormous birch

148

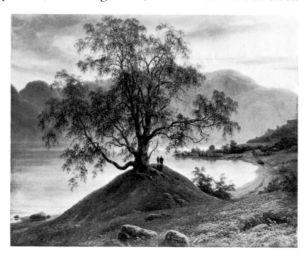

148 THOMAS FEARNLEY
Birch Tree at Slinde
1839

149 EDVARD MUNCH
Dance of Life
1899–1900

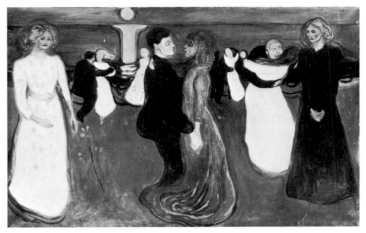

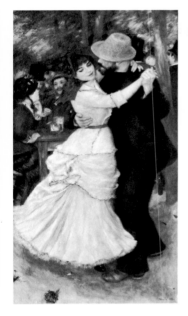

150 PIERRE-AUGUSTE RENOIR
Dance at Bougival
1883

tree, is delineated with a crystalline purity that defines every animate leaf and branch; but beyond this material brink, the near coastline of the fjord, all is haze and infinity, expanding outward to uncharted territories.

But as with Van Gogh, one feels that Munch, even without knowledge of such Friedrichian prototypes in Scandinavian painting, would have arrived at the same results, for his sense of man tragically pitted against a natural world that mirrored a supernatural power was profoundly close to Friedrich's conception. Thus, Munch, in the *Dance of Life*, his most famous variation on the theme of the ages of man, translated, as Friedrich had done before him, a secular motif into a transcendental symbol. For Friedrich, the stages of life could 34 be expressed through the mysterious movement of ships from the inaccessible distance of the horizon to the proximity of the shore. For Munch, this same awareness of a human 149 biological cycle was communicated through an equally secular activity, a spring dance that takes place, like so many of Friedrich's paintings, on the edge of the water and under a sky dominated by a single heavenly orb, sun or moon. It is as if man and woman were in fullest confrontation with their destinies when farthest away from the nineteenth-century city, located rather at the very fringe of unspoiled nature— sea, coast, moon.

Munch's conception of human destiny is conveyed here through the theme of the three ages of woman, who moves from a state of virgin purity (white), to one of sexual con- summation (red), and finally to ashen fulfillment (black) at the completion of her biological goal. It need hardly be said that Munch's interpretation of the motif of people dancing is grimly unlike that of such a contemporary French work as Renoir's *Dance at Bougival* (1883), in which a dancing couple 150 suggests nothing but the pleasures of a leisure afternoon in the

Parisian suburbs and the background offers a setting of cheerful conviviality among men and women who talk, drink, and smoke. For Munch, the motif of the dance was translated into a terrifying biological pantomime, a three-part cycle in which the female protagonist first stirs with a sexual desire that animates her virgin-white purity in unison with the growth, by her side, of spring flowers; then consummates this literally flame-like passion in the dance where she holds and consumes her partner in a stiff, robot-like embrace; and finally stands, spent in the fulfillment of her biological fate, her hands clasped at her sex, her figure black and ashen. The demonic dancing couples of the background, their sexual magnetism of male and female polarized in the stark contrasts of sinister black and virgin white, contribute the frightening momentum to a composition that, in its elemental, tripartite structure, resurrects the kind of symbolic symmetry so common in Friedrich. And the presence of the strange orb over the horizon, a combination of sun and moon, casts the spell of a pagan deity that controls the lives of these puppet-humans on earth, much as the glowing suns and moons in Friedrich appear to be the source of the heavenly mysteries that animate the earthbound landscape.

It is important, however, to recognize the new inflection Munch gives to the Romantic sense of the pitiful insignificance of man in the face of nature's terrifying powers. For him, as for so many other artists, writers, and thinkers of the late nineteenth century, especially in Germanic and Scandinavian countries, these powers often become eroticized, so that the malevolent destinies of Romantic avalanches and storms or the exhilarating terror of isolation in a boundless landscape could be translated into an awareness of some overwhelming sexual force, emanating from nature, which dominated human behavior and reduced man to helplessness. But for all the change of inflection, from the sexual innocence of many Northern Romantics to the sexual knowledge of their late nineteenth-century heirs, the search for some powerful, quasi-religious destiny in nature remained the same, and the pictorial language through which these ideas were conveyed inevitably perpetuated many Romantic innovations.

Thus, in his own way, Munch attempted the kind of modern religious icon that had already been attempted by
151 Runge in his *Times of Day*. His *Madonna* lithograph of 1895 might be thought of as a post-Darwinian interpretation of
152 the very theme and structure of Runge's project for *Noon* in his four-part series, insofar as both works attempt to symbolize the basic concept of human fertility in a biological context. Runge's, to be sure, offers a childlike innocence in his transla-

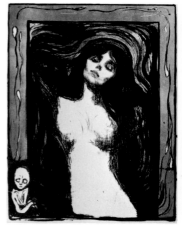

151 EDVARD MUNCH
Madonna
1895–1902

tion of a Christian Madonna into a purified symbol of maternity and fertility, abounding in sprouting wheat, flowers, and plants. Munch's, by contrast, expresses his own and his generation's Strindbergian morbidity and pessimism about woman as a monstrous pawn of nature, a post-Darwinian *femme fatale* whose irresistible sexual magnetism perpetuates the species. Yet both Runge and Munch confront the same problem, that of reinterpreting the traditional Madonna and Child image for the modern world, and both arrive at a curiously analogous iconic structure, where the central symbolic figure is surrounded by an equally symbolic margin, rather like the format of a medieval manuscript page. But for Munch and his generation, Runge's blossoming *putti* and plants become equally vitalistic images of the flow of spermatozoa and, at the lower left, a shriveled, almost skeletal creature, a human embryo. It is an image of the fusion of death and life which, like that of the comparably sexless figure who dominates Munch's *Scream*, may in good part be inspired by the primitive truth of a Peruvian mummy that, exhibited at the Paris World's Fair of 1889, had so stimulated Gauguin's own search for a means of symbolizing these biological concepts.[4]

Like Runge and Friedrich, Munch was obsessed with the goal of finding artistic means to convey his sense of the eternal verities of nature, and of the mysteries that lay beyond the world of the here and now. His range was polarized between

the specific observation of middle-class realities and the creation of a highly personal symbolic structure, much as his friends and fellow Scandinavians, the great dramatists Ibsen and Strindberg, could also move from the realm of bourgeois domestic tragedy to otherworldly allegories, from *A Doll's House* to *When We Dead Awaken*, from *The Father* to *The Dream Play*. Thus, in dealing with the theme of death, which, thanks in part to early family tragedy, haunted him as much as it did Friedrich, Munch could at times experience this ultimate mystery in terms of the claustrophobic confines of a late nineteenth-century middle-class interior where those

153 who attend the last moments of a dying girl—a reminiscence of Munch's sister Sophia's death when he was thirteen—are seen in frozen and emotionally disconnected profile and frontal views that underscore each mourner's state of private grief. But he could also interpret death in the symbolic,

154 universal terms of an immense mountain of tumbling corpses and rising spirits who together bear, at their apex, a coffin perched on the brink of an undefined landscape of Romantic remoteness and infinity.

Friedrich, too, shared these curious polarities, inhabiting both a middle-class world of domestic interiors, as in the

33 *Woman at a Window* or in the views of his studio, and a world of overtly symbolic intentions that, like Munch's, often attempt to convey the unknowns of death. His grotesque

155 drawing of *Skeletons in the Stalactite Cave* is indeed a prophecy of Munch's morbid pyre of bone and spirit: two human skeletons are glimpsed through the dark silhouettes of an equally skeletal grotto, their bones facing, like Munch's coffin, an evocative void. The pathos of Friedrich's spatial construction —figures in the immediate foreground confronting an

153 EDVARD MUNCH
The Death Chamber
1896

154 EDVARD MUNCH
Funeral March
1897

155 CASPAR DAVID FRIEDRICH
Skeletons in the Stalactite Cave
c. 1834

156 CASPAR DAVID FRIEDRICH
Spring
1826

immeasurable abyss—is resurrected in Munch's interpretation of the enigma of the afterlife.

In his search to tap the most elemental mysteries of man's relation to the outer world and to himself, Munch inevitably explored experiences that had already been confronted by the Northern Romantics. If he was concerned with death, he was also concerned with its counterparts, love, life, growth. In his symbolic cycles, Friedrich, too, showed human beings as participating unconsciously in the primal forces of nature, in harmony with the passing of the seasons. His drawing of *Spring*, for example, depicts two children who reach out for 156 two butterflies in a landscape of such virgin purity that it seems to be newly born before our eyes. The harmony of these newborn human creatures with nature is like that of Runge's infant in *Morning*; their sunlit bodies and out- 53 stretched arms partake fully of the sense of organic resurrection in a spring landscape.

Munch, too, often expressed this Romantic sense of an organic unity between man and nature, but characteristic for his generation, in terms that seem to be as conscious of

157 EDVARD MUNCH
Bathing Boys
c. 1904

Darwinian evolution and biological sciences as the sperm-
151 and-embryo border of his *Madonna*. Thus, in a painting of
157 *Bathing Boys*, Munch takes what might have begun as a factual
record of a group of nude males swimming in natural waters
—a subject common at the turn of the century from Eakins
and Cézanne through the German Expressionists—and meta-
morphoses it into a strange, symbolic retrogression of the
human species to some premammalian state that seems as
much at home in water as on land. As the nude figures become
more deeply immersed in the clear blue waters, they take on
bizarre anatomical configurations that recall frog-like swim-
ming creatures with green flesh, flattened featureless heads,
and amphibian legs. Munch's awareness of man's prehuman
roots is, to be sure, more scientifically sophisticated than
Friedrich's efforts to equate children with butterflies and
burgeoning trees, but it is telling that both artists are pre-
occupied with the same question.

Again, the drawing that follows Friedrich's *Spring*, his
158 symbolic vision of *Summer*, can be closely paralleled in
159 Munch's œuvre. A woodcut of 1898, *Fertility*, provides a more
biologically knowing interpretation of Friedrich's motif of
two innocent lovers who hold hands beneath a crowning
canopy of paired trees and whose erotic awakening is echoed
by the billing doves in the foreground. Like Friedrich, Munch
strips this human experience to its emotional and structural
essentials: he also places male and female on both sides of a
central axis, resuming that elemental symmetry which so
often conveyed the Romantics' search for symbol in reality.
But again, typical of the late nineteenth century, the mood
is one of disquieting, primitive sexuality, more like D. H.
Lawrence's *Lady Chatterley's Lover* than Goethe's *Hermann
and Dorothea*. The farmer suddenly seems to be aware of the
farm girl as a temptress who stands, like a modern Eve, on
blossoming soil beneath a spreading tree, symbols in a land-
scape of the human fertility promised by this sexual encounter.

Munch's efforts to find symbolic visual equivalents to the

158 CASPAR DAVID FRIEDRICH
Summer
1826

159 EDVARD MUNCH
Fertility
1898

instinctual life of man had many precedents in Northern Romantic art, even to the point where one of his most intensely complex psychological themes—the emotions of three intertwined lives—can find an early nineteenth-century counterpart. In his *Jealousy* of *c.* 1895, Munch attempted to 160 express sexual jealousy by translating into symbolic terms the turbulent emotions generated in the novelist, Stanislaw Przybyszewski, as his Norwegian wife, Dagny, in the role of a temptress, is courted by a man to be psychologically identified either with Munch himself or with Strindberg, both of whom were in love with her. This eternal triangle is here reduced to those archetypes of symbol and feeling soon to be explored by Jung and Freud. The temptation scene at the left takes us all the way back to the primal seduction in the Garden of Eden and to the consuming sexual energies that unite these three psyches; for this modern Eve actually extends her arm to an apple whose redness corresponds to the flame-like garment of passion that envelops her, ignites her suitor's and her husband's contours, and glows in the pubic shape of her husband's beard.

It was a Romantic, Runge, who also attempted the difficult visual task of projecting the interlocking emotions of three passionate people—himself, his wife, and his brother. Such is the achievement of that memorable triple portrait, *Wir Drei* 161 *(We Three)*. Runge's painting is again innocent by late nineteenth-century standards, but its goals survive in Munch. The artist has tried to show the emotional continuities of marital love and family fidelity by linking the bodies and the feelings of this intense trio. And the landscape, like Munch's, resonates with the interplay of human emotions: Runge's brother Daniel stands beside a sturdy oak tree that reflects his steadfastness, while a pair of trees in the central distance echo the postures and feelings of the wife who leans dependently

160 EDVARD MUNCH
Jealousy
c. 1895

161 PHILIPP OTTO RUNGE
We Three
1805

and lovingly upon her husband. It is a painted image of family love and devotion of brother to brother, husband to wife, and wife to brother-in-law that Van Gogh himself might have attempted with his own brother Theo and sister-in-law Jo, and one that he, too, might well have located in a landscape of symbolic inflection. Munch, to be sure, introduces the morbid motifs of sin and sexual jealousy foreign to the emotional domain of Runge's triple portrait, but the very fact that he tried to disclose the psychological relationships among three figures in a symbolic setting is a testimony to the continuity of Romantic innovations in artistic generations of the later nineteenth century.

The same thing might be said about Munch's paintings of children, which, like Van Gogh's, often seem to be the direct heirs of Runge's new awareness of the child's mysterious biological vitality. In a painting of three generations of women—daughter, mother, and grandmother—seen on a Norwegian country road, Munch takes up the theme of Runge's portrait of his parents with their grandchildren: the child is father of the man, or in Munch's case, mother of the woman. In this dour family trio, Munch virtually restates the three ages of woman; and as with Runge's infants, it is the staring blonde child in the foreground who displays most compellingly those primal mysteries of nature that will then be tamed by society. With the prehensile strength and urge of children, she reaches up forcefully to the seemingly weaker hand of her mother, while in the other hand she grasps, with almost destructive power, a small doll, as if in prophecy of the biological destiny of love, procreation, and death that is hers.

In other paintings, Munch offers that head-on confrontation with a child's world that was first created by Runge in the *Hülsenbeck Children*. In his record of four standing and staring country girls at Aasgaardstrand, we sense, as in Runge's

162 EDVARD MUNCH
Family on Country Road
1903

163 EDVARD MUNCH
Four Little Girls in Aasgaardstrand
1905

164 EDVARD MUNCH
Girls on a Bridge
1901

165 CHRISTIAN KØBKE
Entrance to Castle
1834

three children, the tough energy of a child's growth. Their varying ages, the differing points in a biological evolution, are made explicit by the step-like progression of their height; and their repressive confinement, as with Runge's children, to a narrow man-made space before a house, is set in opposition to the suggestion of a natural environment—the border of green grass that curls behind their legs and upwards at the left—that would express their truer nature. Elsewhere, these young girls become more overtly magnetized by natural forces beyond the stifling proprieties of a Norwegian town. In his *Girls on a Bridge*, Munch offers a reprise of a genre theme that could be found in early nineteenth-century Scandinavian painting—in, for instance, the Dane Christian Købke's view of young boys looking over a bridge outside the entrance to a castle—but turns it into the kind of yearning and mysterious motif that reawakens the mood of Friedrich's figures meditating in nature. Here, the three young girls cluster together, united in age and desire, and look silently beyond the restricting confines of bridge and village. At the upper left, just above the horizon, we see the yellow orb of the sun which, as in *The Voice*, begins to take on a magnetic power toward which these adolescent girls are drawn. As in Friedrich, the precise reading of these emotions and natural

164

165

146

forces is usually impossible and hence all the more evocative; what we sense, rather, is some moment of awakening in these three girls to the mysteries that reside in an omnipotent nature, an awareness of a destiny that lies far beyond the confining railing of the bridge. And often, judging from the context of Munch's work, this destiny is biological and sexual, involving the submission of human will to the natural forces that are evoked by celestial orbs, sun and moon, or bleak, boundless landscapes and night skies.

Thus, Munch's landscapes and seascapes, whether totally uninhabited or contemplated by lonely figures, perpetuate Friedrich's sense of landscape as a metaphor of an experience 167 that can border on the religious. The bleak coastal regions of Norway provided Munch with the same kind of Northern European landscape that Friedrich had earlier used as the 1 stark setting for his Capuchin monk meditating upon the infinities of water, horizon, and sky at the very fringe of the terrestrial world. Munch's forests, like those of Friedrich and other Northern Romantics, are virgin. Following the tradition of mid-nineteenth-century Norwegian painters like 166 August Cappelen, Munch represented the strange vertical silhouettes of upright pines and birches in a landscape where, one feels, no man has been before. Here, in nature's purity, the night sky often looms large, sometimes glowing with the enchanted silvery light of the moon, sometimes twinkling with the radiance of stars that inevitably recall Van Gogh's views of a starlit dome of heaven. Such landscapes, though still part of the world of empirical observation, attest to the power of that Romantic tradition which would turn to

166 AUGUST CAPPELEN
Forest
1850

167 EDVARD MUNCH
Coast at Aasgaard
1906–07

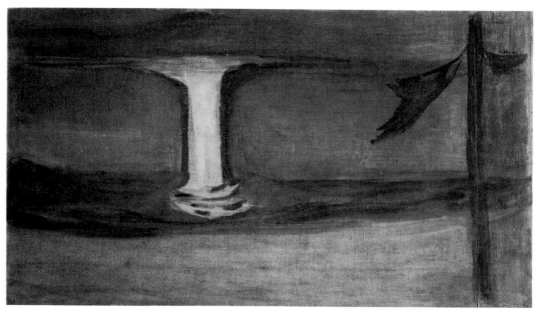

unspoiled nature as a metaphor of the supernatural. No
French Impressionist picnics or strolls could take place in
these sanctified Northern landscapes; they are, rather, the
shrines where nature's ultimate mysteries are contemplated.

Munch's sensibility to the power of nature was surely
underlined by his Scandinavian origins and long residence in
his native Norway; for there, in the northernmost regions of
Europe, the extremes of nature's forces—first the extinction
of light in the long, dark, and cold winter, and then the
dramatic resurrection of the sun which reigns, during the
summer months, deep into the night—are far more awesome
than in Southern Europe. With the coming of the white
nights, when nature is freshly irradiated by the magic of both
sunlight and moonlight, the intensity of nature's strength is
immeasurably heightened. It inaugurates a period of spring
rites that in Munch's art, as in Scandinavian life, represents
human immersion in the great pagan forces—awakening of
sexual desire and loss of virginity, nude bathing in crystal-
clear waters, contemplation of primeval forests.

It was, above all, the light of the sun that could symbolize
for Munch, as for Van Gogh, these overwhelming energies
in nature; and although throughout his career he painted sun
and moon as pagan symbols that dominated human destiny
on earth, he on one occasion painted the sun in a setting that
truly converted it into a deity. This was in the Aula (or the 168
Great Hall) of the University of Oslo, for whose mural
decoration Munch won in 1911 a competition announced in
the previous year.[5] The major allegorical murals on the side
walls representing History and Alma Mater are still figural
paintings that rephrase traditional Western iconographic
motifs, but the mural (or, so to speak, the high altar) on the
far wall is of a startling originality in so traditional a setting
as a university assembly hall: a blazing, centralized image of 169
the sun, rising over the horizon of the sea, which exactly
bisects the painting's height. It is, indeed, a powerful restate-
ment of that image of the creation of light which had
obsessed so many Northern Romantic artists and which
Friedrich himself had envisioned in a drawing constructed 21
with exactly the same stark symmetry as Munch's mural.
Munch's sun has usurped the place of a holy image in the
halls of the University, realizing perhaps most explicitly his
early, manifesto-like journal entry of 1889, where he stated
that henceforth he wished to paint a kind of art whose sacred-
ness would make men 'take off their hats as though they were
in church.'[6]

This golden aura of light, radiating just above the horizon,
becomes the source of new and pure energies, a concept of
primal life forces that was shared by many other thinkers and
even musicians of the later nineteenth century who were

119

smitten by these cosmic speculations. It is related to the thought and ambitions that produced Nietzsche's generative ideas of *Urlicht* and *Urleben*,[7] or primordial light and primordial life (the German prefix *ur* so often expressing these late Romantic efforts at reaching the elemental verities), or to such musical cosmologies as those by Gustav Mahler, whose *Resurrection Symphony* employs in its descriptive notes the phrase *Urlicht*, and by Munch's close friend, Frederick Delius, whose equally megalomaniac *Mass of Life* is also connected with the Nietzschean allegories propagated in *Thus Spake Zarathustra*.

Munch's sun is also like Van Gogh's suns, suggesting as it does the very symbol of nature's omnipotence, a supernatural halo made natural. And in its efforts to cast a spell of sublime religious mystery in the program of a building that lay outside the confines of traditional Christian function, Munch is the heir of Runge's own ambitions for a chapel to house his symbolic *Tageszeiten* or, for that matter, the ancestor of a similar enterprise we shall later discuss, the Rothko Chapel at Houston.

Munch's position as an artist of the late nineteenth century, who seems to reactivate with new inflections the Northern Romantics' search for divinity in nature, was shared not only by such lesser Scandinavian contemporaries of his as the Dane, Jens Ferdinand Willumsen, but by such other major Continental artists as Van Gogh and Ferdinand Hodler. Hodler's life and art, in fact, bear many close parallels to Munch's and Van Gogh's. He was an exact contemporary of Van Gogh, having also been born in 1853, and like him, he also had had, in his youth, strong religious ambitions. About 1880, he went through a personal religious crisis, attending meetings of a Swiss religious sect, the Stündeler, and planning to become a pastor. But as in the case of Van Gogh, Hodler's aspirations to find spiritual experience in religion were redirected to his art, which so often deals, explicitly and implicitly, with the basic questions of life, love, and death. Like Munch, Hodler

168 EDVARD MUNCH
The Aula at the University of Oslo
1909–11

169 EDVARD MUNCH
The Sun
1909–11

was the heir to a local pictorial tradition that vigorously continued the Romantic veneration of sublimity in landscape into the mid-nineteenth century. Just as in Scandinavia, late eighteenth-century painters quickly adapted the aesthetic of the Sublime to the depiction of their own, spectacular native landscape, so too in Hodler's Switzerland did artists like Caspar Wolf and Heinrich Wuest begin to paint the Alps in 13 the mid-eighteenth century. And the tradition continued with Swiss painters like Alexandre Calame and François Diday, whose paintings of sublime mountain sites, roaring Alpine cataracts, and devastating storms were known intimately by Hodler, who, as a young art student in the 1870s, had copied many of them to earn money. But Hodler's interpretations of these and other Romantic traditions were eventually to offer the obverse side of the Romantic coin—stillness, spareness, and purity were to replace the windswept complexities of these belated Romantic landscape formulas.

By the early 1880s Hodler, then working within the premises of mid-nineteenth-century Realism, resumed another Romantic tradition that found its traces in so much painting of the period: the representation of simple, pious 170 people observed in acts of religious ritual. Around 1880, when Hodler was drawn to the possibilities of a religious vocation, he painted pictures of humble Swiss congregations at prayer. These works are the close counterparts to such well-known German Realist interpretations of piety as Wilhelm Leibl's

170 FERDINAND HODLER
Prayer in Bern
1880–81

171 WILHELM LEIBL
Three Women in Church
1878–82

171 *Three Women in Church*, of 1878—82, in which the mood is
also one of a withdrawn, Northern privacy and stillness in
the act of religious worship. This aura of inwardness, of silent
communication with the Deity is one that belongs more to
the Protestant North, to the hushed meditations of a Fried-
rich, than to Catholic Europe, a point that might be supported
by an earlier French painting of a similar subject, Schnetz's
172 *Vow to the Madonna*, where equally pious peasants gesticulate
their suffering and faith with an overt physical passion alien
to the atmosphere of Nordic piety.

The growing sense of silence and stillness in Hodler's art
carried with it a growing veneration of those mysteries—
birth, love, death, the cycles of nature—which so preoccupied
the Northern Romantics. In a painting of 1888 that records
173 the artist's mistress, Augustine Dupin, and their newborn
child, Hector, we feel once again that sense of awe which
Runge and then Van Gogh and Munch experienced before
the phenomenon of an infant. Here the mother presents her
fat and tough baby as if it were a holy object, a new Christ,
117 much as Runge, in painting his wife and son, represented the
infant as towering before us with almost uncanny energy. The
opposition of the mother's slight twisting in space to the

172 VICTOR SCHNETZ
Vow to the Madonna
Salon of 1831

absolute profile position of the child again underscores the sense of some symbolic mystery in this strange creature, whose nakedness in this domestic environment also bears with it a charge of elemental truth.

By the 1890s Hodler, like Munch, could depart from the Realist premises still so insistent here and could represent these primal mysteries of birth and growth in more overtly symbolic fashion. In *The Chosen One* of 1893—94, we again see the artist's son Hector, this time kneeling in prayer before a small square plot in which a tree has been planted. Above, six angels, arranged in a pattern of pure symmetry, hover protectively over the child. The setting is one of a virgin landscape in spring, a symbol of nature that becomes even more generalized in the slight curve of the horizon, which, as in many of Hodler's other symbolic works, takes on literally global and universal connotations. It is a painting that shares profoundly those Romantic concepts of children in nature which are best exemplified in Runge, whose symbolic infant in *Morning* prophesies, both in its iconic centrality and profile posture and in its intense communion with the verdant new growth of nature, Hodler's ambition to extract the metaphor of the relation of childhood's innocence to nature's purity. Like Runge, Hodler revives a structure of stark and simple symmetry, a hieratic ordering of forms that would translate empirical observation into symbol and that often produces in both masters a strange duality between passages of intensely literal description and an overall pattern of emblematic abstraction. It is a duality that, in the case of, say, Hodler's angels, as in the case of Runge's floating *putti*, often causes the modern spectator a certain discomfort in the collision of the

174

53

173 FERDINAND HODLER
Mother and Child
1888

174 FERDINAND HODLER
The Chosen One
1893–94

real and the abstract, a discomfort seldom experienced in Friedrich or Van Gogh, who work more consistently within the domain of the empirical, or in Munch, who in his own more overtly allegorical canvases of the 1890s, works more consistently within the domain of the abstract.

Alternating as he does between these extremes of fact and symbol, Hodler often seems to stand in an intermediate position between Van Gogh and Munch. Thus, in its Romantic efforts to parallel the growth of a child with the growth of trees or flowers, *The Chosen One* provides a symbolic counter-

112 part to Van Gogh's painting of a blooming almond branch that, we learn only from letters,[8] was meant to commemorate the birth of his nephew, just as, relatively speaking, it provides a more naturalistically rendered counterpart to Munch's frequent juxtaposition 'of highly abstracted figures and flowers, which can convey immediately, without literary intervention, the sense of, say, the unity of the coming of spring in nature with the first awakening of sexual desire in the pubescent girl who begins the 'dance of life'.

Still, even at his most painstakingly descriptive, Hodler could instill this mood of communion with nature, as in his

175 picture of a young boy, dressed in the most precisely rendered clothing, who holds two spring flowers in a boundless meadow. The mood is again close to Runge's children, who communicate with landscape as if their premature point in a human life cycle granted them special empathy with nature. Hodler could also represent the opposite extreme, of expres-

176 sion as well as of style, as in his *Look into the Beyond*, a later allegorical painting that turns the child in nature into a kind of naked, abstract superman, an adolescent standing on a mountain top, his head above the horizon, the earth below obscured by clouds. In concept, as well as in style, these alternations between the empirical and the symbolic, between a figure silently immersed in nature and a figure heroically dominating it, also hark back to Romantic prece-

148 dents. If Thomas Fearnley in 1839 could show us two figures who almost lose their identity in their submersion into a

177 breathtaking Norwegian landscape, John Martin, at almost the same time, 1837, could locate a Byronic hero, Manfred, with his companion, gesticulating heroically on the top of the Jungfrau. In his acute awareness of a tragic polarity between the individual and nature, the Romantic artist, and with him, Hodler, could turn his figures silently and passively inward, or assertively and defiantly outward.

Hodler inherited, too, the Romantic search for new icono-graphical systems that could translate the Book of Genesis into a fresh experience of cosmogony. In the 1880s he already planned a series of paintings based on the theme of the Times of Day,[9] an enterprise which inevitably recalls Runge's

175 FERDINAND HODLER
Standing Boy with Flowers
1893

176 FERDINAND HODLER
Look into the Beyond
1905

177 JOHN MARTIN
Manfred on the Jungfrau
1837

lifetime project. Hodler's series, though never realized in its original form, bore fruit in many paintings of the 1890s, of which *Night* and *Day* offer the most remarkable parallels 178 with Runge's forms and intentions. In both these works—the 179 earlier of the two, *Night* (1890), being executed in the more naturalistic style—Hodler attempted, like Runge, to create profound harmonies of figures and landscape that could communicate the mysterious cyclical patterns that dominate both man and nature. And like Runge in his *Times of Day*, Hodler evolved a pictorial structure of absolute symmetry, a system that he actually defined as 'parallelism,'[10] the formal counterpart to the concept, so Romantic in origin, of translating the diversity of nature into a frozen emblem that stresses rather its ultimate unity. Thus, the symmetrical structure of *Night* and *Day*, like that of Runge's *Times of Day* or even of many of Friedrich's less explicitly symbolic works, makes it clear that we are in a symbolic realm. The coming of death, like the coming of dawn, takes on a heraldic character, metamorphosing figures in a landscape into timeless icons of eternal truths. It is a goal and a pictorial structure shared as well by Munch in such pictures as the *Dance of Life*. 149

From *Night* of 1890 to *Day* of 1900, Hodler's style grew increasingly abstract and elemental, so that these cosmic implications could ring all the more true. In *Night*, the figures still suggest specific models and their nudity seems a temporary condition. In *Day*, all five women appear to be the same, mirror images caught at different moments of awakening, and their nudity is a permanent state that unites them

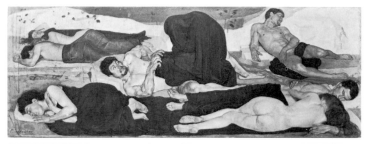

178 FERDINAND HODLER
Night
1890

179 FERDINAND HODLER
Day
1900

indivisibly with nature. Like the movements of the modern dance as practiced by such students of Rudolph von Laban as Mary Wigman,[11] these figures seem to throb with the very life forces of reborn nature, much as Runge's personification 53 of day, the Aurora figure in *Morning*, seems to be a humanoid embodiment of some cosmic emanation from beyond the 174 horizon. And in *Day*, too, as in *The Chosen One*, the horizon and distant clouds curve, evoking some symbolic plateau at the very peak of a universe no longer scaled to human dimensions.

These visions of elemental nature could be expressed by Hodler not only in the symbolic terms of figural composition but in the more empirical ones of his native Swiss landscape. In his many late landscapes he translated the already sublime scenery of Alpine mountains and lakes into images of numbing simplicity, in which we are located at the literal and symbolic brink of a breathtaking vista of pristine nature, untainted by the presence of man. Often these images are closely paralleled in the work of Munch. Thus, Hodler's view 180 of Lake Geneva from a mountain height near Caux places us, 181 as does Munch's view of the waters from a Norwegian shore, at the very fringe of the earth, surveying the pure and boundless blue of ether and water ordered upon the most elemental vertical and horizontal axes. Such fearful symmetries and confrontations with the void hark back to Friedrich's meditations upon the vast expanses of sea and sky and upon the infinite extension of the horizon, and approach as well the comparable sensations that will be reawakened in abstract terms in the art of Rothko and Newman.

180 FERDINAND HODLER
Landscape near Caux with Rising Clouds
1917

181 EDVARD MUNCH
Summer Night at the Coast
c. 1902

In Hodler's paintings of mountain summits, we find the same search for a symbol of absolute stillness, purity, and sanctity, a search that can also be paralleled in the work of lesser late nineteenth-century Northern painters such as a Norwegian follower of Dahl, Peder Balke, whose mountain view of the 1880s prophesies the Hodlerian format of a distant, symmetrical vista of a towering mountain peak, inaccessible to earth dwellers. This image obsessed Hodler throughout his later work. In his record of the *Dents du Midi Seen from Chesières*, we seem finally to have left far below the terrestrial realms inhabited by man, and contemplate instead, from an unspecified vantage point, a looming vision of

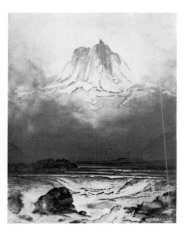

182 PEDER BALKE
Landscape Study from Nordland
before 1887

183 FERDINAND HODLER
Dents du Midi seen from Chesières
1912

184 PAUL CÉZANNE
Mont Sainte Victoire
c. 1904–06

majesty that, like some Olympian or Christian deity, floats on a bank of clouds, indifferent to the pull of gravity. Unlike such native Swiss precedents as the late eighteenth-century mountain paintings of Wolf, or the early nineteenth-century ones of Calame and Diday, Hodler's Alpine vistas always eliminate the traces of man and centralize their mountain peaks so that they become frozen, timeless symbols, fixed for eternity far above the invisible plane of the earth. For Hodler, whose tubercular son was confined to a mountain sanatorium near Montana, in Switzerland, these Alpine summits and purified altitudes must also have had an intensely personal meaning, associated, like Thomas Mann's *Magic Mountain*, with a strange world, remote from earthly time and society, where ultimate questions about human destiny can be asked.

Hodler's recurrent images of Swiss mountain tops have often been compared to Cézanne's multiple records of the mountain that obsessed him throughout his life, the Mont Sainte-Victoire, and indeed, the comparison can be compelling.[12] Cézanne's Provençal mountain often ascends before us to lofty heights, a distant deity in nature crowned by the deep blue of the southern sky. Yet Cézanne's mountain views still seem earthbound by comparison with Hodler's. The land below establishes contact with man and his activities, the soil seems cultivated, and human presence is usually made explicit by the inclusion of small houses. Moreover, for all the stability and grandeur of the mountain, we sense the ephemera of nature, a change in light and atmosphere, a movement of winds. But in Hodler the earthly, the human, the transitory have all been obliterated. We are, in fact, in the same mountain realm as Friedrich's view of the Watzmann, a realm that lets us gaze at but never scale an impossibly remote, icy blue divinity whose timeless power is underscored by the compositional push toward a centralized, symmetrical emblem.

Confronted with the haunting, otherworldly character of these uninhabited, almost supernaturally pure mountain summits of Hodler, we can understand the phrase *paysages planétaires* (planetary landscapes) which Hodler applied to them.[13] But, tellingly for Hodler's position between the Romantic landscape tradition of the early nineteenth century and that of the twentieth century, it is also a phrase that could apply as well to many landscapes by Friedrich or, as we shall later see, by Max Ernst.[14]

Part III Romantic survival and revival in the twentieth century

5 The pastoral and the apocalyptic: Nolde, Marc, Kandinsky

IN considering the art of Van Gogh, Munch, and Hodler, it is often difficult to know whether we are dealing simply with an unbroken survival of Romantic traditions into the later nineteenth century or with almost a conscious revival of them, after their destruction or temporary eclipse in the mid-nineteenth century. The question is the same in dealing with many twentieth-century artists, some of whom are thoroughly aware that they are paying homage to the great Romantic masters, but most of whom perpetuate Romantic motifs and emotions without any awareness of historical precedent.

There are even such specific and self-conscious cases as, say, those of recent German painters like Paul Wunderlich, who in 1964 painted an *Aurora*, a conscious tribute to Runge's 185 *Morning* that speaks of the twentieth-century artist's fascina- 53 tion with a search for strange, primitivizing symbols and hieroglyphs that would replace the moribund symbolism of the Christian and classical traditions; or, like Gerhard Richter, of whom a characteristic landscape offers an almost equally conscious reprise of Friedrich's recurrent image of a 186 lonely figure, dwarfed beneath the leaden sky and low horizon of a bleak Northern European plain.[1] But there are infinitely more examples where the new concepts, emotions, and structures of Romantic art have penetrated quite unconsciously into the repertory of countless twentieth-century artists, both major and minor, esoteric and popular. Thus, one

185 PAUL WUNDERLICH
Aurora (Hommage à Runge)
1964

186 GERHARD RICHTER
Evening Landscape
1970

might find that almost any of the new ideas and images evolved by Friedrich and his Northern contemporaries have an afterlife well into our century. For instance, in a painting
187 of a fallen tree executed in 1970 by the American, Gandy Brodie, we can see that what we have called the pathetic fallacy is still very much alive. Like Friedrich's painting of a
188 tree that, as a result of an avalanche, has fallen at a precarious angle across a mountain gorge, Brodie's image of a fallen tree demands the kind of empathy one would expect only in a human situation. From the lower left to upper right-hand corner, the tree's extension is, like that in the Friedrich, a taut and painful one, in which the viewer must experience, almost kinesthetically, the tree's uprooted suffering.

The poignant spatial structure of Friedrich and other Romantics is also explored, in terms of the American scene,
189 by an artist like Edward Hopper, who constantly restates— and undoubtedly with no direct knowledge at all of such prototypes—the evocative polarity created by a shallow fore- ground that obliges us to stop suddenly at a near brink and from there to contemplate a vista of vast, empty spaces more accessible by feeling than by foot.[2] It is a polarity evident as well in a gouache by another painter of the American scene,
190 John Button, who also offers a reprise of another Friedrichian theme, the melancholy affinity of Gothic architecture—in this case, the tall and narrow neo-Gothic bell tower at Clothier Hall, Swarthmore College—with a screen of leafless trees, whose sharply delineated contours in the fore- ground define the cut-off point from which we glimpse the impalpable tonal silhouettes of the ghostly buildings beyond the horizon.

Such analogies exist quite as fully on the level of popular
191 art, witness only the scene from Walt Disney's *Fantasia* (1940), in which, to the music of Schubert's *Ave Maria*, we saw a low, earthbound procession of nuns against the exalting background of a Northern forest whose tall, skeletal trees

187 GANDY BRODIE
Fallen Tree
1970

188 CASPAR DAVID FRIEDRICH
Rocky Landscape in Elbsandstein Mountains
c. 1823

189 EDWARD HOPPER
Railroad Sunset
1929

190 JOHN BUTTON
Swarthmore College
1970

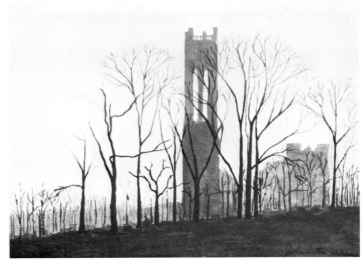

191 WALT DISNEY
Ave Maria scene from 'Fantasia'
1940

metamorphose before our eyes into what looks like the prototype of a Gothic nave, its vaulting branches so heaven-borne that they disappear above the frame. Disney's metaphor of a forest of trees as Gothic architecture and his placing of religious experience not only in nature but in the spectacle of a somber movement of nuns through patches of fog that would turn matter into spirit are almost literal restatements of Friedrich's scene of monks in a funeral procession that
29 leads to a ruined Gothic abbey in a wintry oak forest. It is a token of how ubiquitous Romantic imagery and ideas have become in our time, as well as of how difficult it is, in the more exclusive domain of high art, to speak of the precise influence of Friedrich when, in fact, his ideas could also have been disseminated by Walt Disney or on picture postcards.

In the same way, one might reconsider Friedrich's painting of the mariner's cross silhouetted against a setting sun at
26 Rügen, a work we have talked about as an early example of those Romantic surrogate religious paintings in which the rituals and artifacts of Christianity usurp traditional Christian subject matter. Such an image was obviously so profoundly related to essential changes of religious attitudes in the modern world that it can be found in twentieth-century imagery on everything from a painting of 1932 by Georgia
192 O'Keeffe, which depicts a rude cross in Canada that confronts, with absolute cruciform symmetry, the remoteness of the sea and the low, distant horizon, to a souvenir postcard which records another rude cross seen against a sun setting on the
193 horizon off the Brittany coast at Saint-Samson.

Because Romantic images were disseminated so thoroughly in high art and low art of the nineteenth and twentieth centuries, it is more often than not futile to attempt to pinpoint specific sources. It would be more than surprising, that is, if either O'Keeffe or the Breton photographer knew the picture by Friedrich which is, in fact, the first statement of their idea. Still, there are many twentieth-century artists whose own cultural milieu was so steeped in the traditions founded by the thought and art of the Northern Romantics that we can speak of them more confidently as heirs to the legacy of a Friedrich or a Runge. This is, of course, especially true in Germany.

There is, for one, the art of Emil Nolde, who, from his earliest works, seemed to perpetuate that Romantic search for a viable religious art, either through passionate records of the miracles of nature or through efforts actually to resurrect Christian subject matter. Already in the 1890s, when he was in his twenties, Nolde demonstrated a pantheistic awe before the most primal spectacles of nature. In a little watercolor of
194 a sunset, painted in Switzerland about 1894, he recorded the scorching orb of the sun viewed in a centralized composition

192 GEORGIA O'KEEFFE
Cross by the Sea, Canada
1932

193 Picture Post Card
Sunset on Cross, Saint Samson, Brittany

194 EMIL NOLDE
Before Sunrise
c. 1894

195 EMIL NOLDE
The Matterhorn Smiles
c. 1894

that bears comparison not only with Van Gogh's and Munch's images of solar worship but with later restatements of this theme among both German Expressionists like Ernst Ludwig Kirchner and American nature abstractionists like Arthur Dove. Here again, the sun becomes almost a holy icon, framed by the foreground slopes of trees but located behind clouds in a distant zone that remains inaccessible.

Nolde's sense of the natural as the vehicle to the supernatural found in 1894 a literal application in his illustrations of famous Alpine mountains that are metamorphosed into gigantic humanoid creatures of mythic cast. In *The Matterhorn* 195 *Smiles*, we see, albeit on a level that approaches Romantic *kitsch*, yet another example of the pathetic fallacy, in which, quite literally, a mountain takes on a human physiognomy and expression. But although these illustrations were easily turned into a successful commercial enterprise—a printing of 100,000 postcards made from them was quickly sold[3]—they nevertheless reveal Nolde's capacity to identify the awesome facts of nature with strange images of the Deity Nolde, in fact, frequently conceived of nature in human terms, and when he admired the works of Hodler, especially *Night*, 179 which he saw in Munich in 1896, he was convinced that the painting's 'sinuous, pushing, wiry bodies are part of the character of the mountain folk, just as the firs on the mountain slopes are gnarled and grown oddly.'[4] In this regard, it is worth mentioning that Nolde's anthropomorphized mountain views sometimes belong to the same realm as those painted by Hodler. Popular tradition and nomenclature gave these Alpine heights human and even Christian connotations

196 FERDINAND HODLER
The Jungfrau from Schynige Platte
1908

197 EMIL NOLDE
Marsh Landscape (Evening)
1916

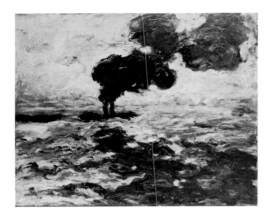

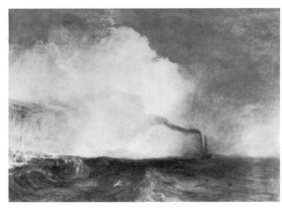

198 EMIL NOLDE
Steam Tug on the Elbe
1910

199 JOSEPH MALLORD WILLIAM
TURNER
Staffa, Fingal's Cave
1832

—the very names of the Jungfrau (the Virgin) and the Mönch (the Monk) attest to this—and, in at least one case, Hodler, in 196 painting the Jungfrau, seems to suggest in the cloud forms below its peak the configuration of the Madonna and Child, a curious double image that both humanizes and sanctifies these miracles of nature. But even without such explicit metamorphoses of nature into humanoid deities, Nolde's, like Hodler's, interpretation of landscape motifs is saturated with a sense of the transcendental that borders on the religious.

It is no surprise, then, to find how often Nolde's paintings of his native Schleswig-Holstein—the bleak flat plains, the low horizon, the foggy skies of this coastal region in Northern Germany—seem to resume traditions of Romantic landscape and marine painting in Northern Europe. In *Marsh Landscape* 197 of 1916, we feel reimmersed in those melancholic, lonely plains that Friedrich had first explored a century before, landscapes that exclude human habitation and bring the beholder before the infinite extension of earth, sky, horizon. Nolde's seascapes, too, strike familiar chords in the history of Northern Romantic painting, especially in the art of Turner, whose more liquid paint techniques are particularly prophetic of Nolde's molten palette and brushwork, where light, color, cloud, and sea fuse into an indivisible whole of glowing, impalpable energy.[5] Thus, in Nolde's view of a little tugboat 198 on the Elbe River, he offers a virtual reprise of a late Turner seascape such as the foggy vista of the waters at Staffa, near 199 Fingal's Cave, in which a tiny, distant steamship is just discernible as the only man-made element in a dark and strange natural world. In both works, all parts—the choppy waves, the shifting clouds of an overcast sky, the diffused light of a hidden sun—merge into a fluent, all-pervasive ambience that glows with a somber mystery.

Just as Nolde's bleak landscapes and luminous seascapes

perpetuate the vision of Friedrich and Turner, so too do his flower studies convey the same sense of mystical energy in growing plants that was first felt so passionately by the Northern Romantics. His flowers, like those of Palmer, Runge and, later, of Van Gogh, tend to grow in a natural setting, blooming before us with a kind of supernatural vigor. Even his earliest, most domesticated paintings of gardens contain flowers whose bursting vitality is more like Palmer than Monet; and in many of his later flower studies, as in the work of Van Gogh, the stems and blossoms are seen from below, freed from the earthbound world of man and united with the burning color of a glowing sky above. That Romantic dissociation of the scale of man from the scale of nature is again operative here: Nolde's flowers often loom like giants against the sky, their dimensions related to heaven rather than earth.

Like so many of his Northern Romantic ancestors, Nolde could move quite literally from the world of the natural to that of the supernatural, for he also attempted, with a success particularly rare in the twentieth century, the resurrection of traditional Christian subject matter. In his large polyptych, the *Life of Christ* of 1911—12, Nolde realized, as it were, Samuel Palmer's youthful dream of a late medieval altarpiece that, through the sheer passion of the artist's faith, could be revitalized in a world of modern religious doubt. Although the stark and crude images and drama of Nolde's neo-Christian altarpiece were as offensive to conventional standards of early twentieth-century religious art as Palmer's probably would have been for the early nineteenth century— so offensive, in fact, that because of protest from the Catholic Church, the work had to be removed from an international exhibition of religious art at Brussels in 1912[6]—it is exactly this almost naïve fervor that accounts for the success, to modern eyes and emotions, of Nolde's own belated contribution to the Gothic revival in painting. Using a pictorial vocabulary like Matisse's of 1905—06, Nolde transformed the French art-for-art's sake hedonism of Fauve color and brushwork into a vehicle for rekindling the religious fire of a North German late medieval altarpiece.

Capable as he was of such an achievement, Nolde could touch with an aura of religious mystery almost any subject he experienced, so that, at times, the threshold between a secular and sacred work is as blurred as it is in Friedrich or Van Gogh. Thus, in Nolde's painting of a family—an infant son, a mother, a father, and a sunflower—it is hard not to consider the group a Holy Family, despite the vagueness of any specific Christian symbolism. The golden glow of the infant himself is of a supernatural cast, reflected in the radiant yellow of the mother's face and the sunflower which seem to bend in

200 EMIL NOLDE
Sunflowers
1932

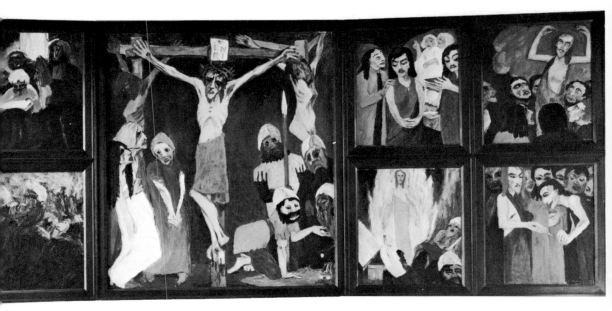

201 EMIL NOLDE
Life of Christ
1911–12

202 EMIL NOLDE
The Family
1931

adoring homage; and the peripheral role played by the father evokes Joseph. Again, as in Van Gogh, the sunflower becomes a metaphor of special God-given energy, a source of heavenly light that here is almost transformed into a halo that sanctifies mother and child. Moreover, Nolde's awareness of a mysterious vitality in nature and in children is particularly apparent in the analogy between the child and the sunflower.

In many ways, the painting can be considered a twentieth-century restatement of the mystical Holy Family in a landscape envisioned in 1805 by Runge, a master whose works, 58 like those of Friedrich, were rediscovered in Germany in 1906 at the Berlin National Gallery exhibition of a century of German art, 1775—1875,[7] and then became particularly accessible to a North German like Nolde, thanks to their presence in the collection of the Kunsthalle in Hamburg. But again, as in the case of Van Gogh, Nolde, one feels, would have arrived at the same expression of divinity with or without the support of Romantic precedent, for his very attitudes toward nature closely perpetuated those of the early nineteenth century. For him, nature was saturated with the spirit of a supernatural deity, revealed in the passionate glow that emanates from his flowers, landscapes, and seascapes. And at other times, that deity was revealed not only through the resurrection of the moribund *dramatis personae* of Christian art, but through the folkloric channels of popular legends. Just as in 1894 Nolde could illustrate Alpine mountains transformed into the giant deities of some pre-Christian religion, so too as late as 1940 could he illustrate, with almost childlike

137

203 EMIL NOLDE
The Great Gardener
1940

wonder and piety, the popular concept of a *lieber Gott*, the
203 Good Lord seen here as a divine gardener, a luminous old man
in the heavens who, with infinite power, love, and tenderness,
brings to incandescent life the flowers that rise toward him
from the earth. Nolde's pictorial vocabulary may be that of
an early twentieth-century artist, but his imagery and feeling
evoke the early nineteenth-century belief that nature, in its
goodness and purity, provides the most direct communication
with the mysteries of religion.

Like Nolde, many other artists of the early twentieth
century continued that Romantic pursuit of innocence, of a
childlike simplicity of feeling and expression. German artists,
in particular, seemed to feel the oppression and hypocrisy of
the middle-class materialism that dominated Europe on the
eve of the First World War and some of them reached extra-
ordinary extremes in their search for a state of being that
could unite them most closely with the primal truths of the
natural and the supernatural. Of these, the most unusual case
may be offered by the short-lived Franz Marc, who, after
trying to find an image for the spiritual apocalypse of the

modern world, was ironically to meet his death at Verdun on 4 March 1916, during the terrestrial apocalypse of the war.

In almost every way, Marc perpetuated traditions that stemmed from the Romantics. Not only an artist but a student of theology who had visited Mount Athos in 1906, Marc was, from the beginning, immersed in matters of the spirit. He considered the creation of art a vehicle for the expression of ultimate truths that were quasi-religious in character. For Marc, however, the primary metaphor of these spiritual disclosures was not landscape or the human figure, as it had been for Munch, Hodler, and Van Gogh, or for Friedrich, Runge, and Blake, but rather the animal, a symbol that he thought could provide another sentient creature through which man might once again recapture his lost contact with the forces of a God-given nature, almost reversing the direction of Darwin's theory of evolution.

It is telling that even in one of those relatively rare paintings where Marc repeats a traditional nineteenth-century figural motif—a nude female model in the studio—he includes an unexpected narrative focus; for here, the figure's attention, like ours, is entirely directed toward the feeding of a yellow 204 cat from a bowl of milk, a sentimental intrusion that would be unthinkable in the Fauve paintings of Matisse which ultimately inspired the rainbow palette explored here by Marc for the modeling of the figure, the animal, and the setting. It was characteristic that, for Marc, none of these aesthetic innovations of French origin was ever an end in itself, but always a means that might provide yet another way to reveal those abstractions—spirit, feeling, empathy, soul, idea—which, as the goals of an artistic program, usually sound so much less persuasive in English translation than in the original German.

But it was in fact such goals that Marc pursued, for he believed that art was to create 'symbols for the altar of a new spiritual religion,'[8] a belief that was virtually identical with that of almost every Northern artist we have considered so far. And for him, too, any pictorial vocabulary available could be used to promote his search. Thus, even when, in 1909, he painted still within the premises of a belated and 205 provincial French Impressionism, he used the camouflaging effects of a light, overall tonality and dappled brushwork, not to create primarily a cohesive and beautiful surface but rather to symbolize the unity of animals in nature, a unity so intense that our eye must search carefully for the presence of gentle deer grazing in these unspoiled woods. Three years later, in 1912, Marc studied closely first in Munich and then in Paris Robert Delaunay's precocious new experiments in the weaving of a bright spectrum of colors into the overlapping scaffolding of Cubist planes. It was an experience that altered

204 FRANZ MARC
Model and Cat
1910

205 FRANZ MARC
Deer in Forest
1909

206 FRANZ MARC
Deer in Forest, II
1913–14

drastically Marc's own pictorial vocabulary, yet he used this abstract language, which Apollinaire had named Orphism, for essentially the same purpose as before. Thus, in a painting of deer in a forest of 1913—14, the ends are the same as in the 206 painting of 1909. These gentle creatures are again camouflaged in an image of peaceful harmony with nature, except that here the fusion of animal and landscape is attained through the means of French Orphism rather than French Impressionism.

Marc's fascination with animals not seen in zoos, as other German artists like Max Liebermann and August Macke had painted them, but in a natural state, was in itself an extension of Romantic attitudes that had their origins in the late eighteenth century, especially in England, where artists like George Stubbs[9] at times could represent horses not only as a gentleman's property but as gentle, free creatures inhabiting a pastoral landscape, and could begin as well to explore the look and the emotions of other, stranger beasts, like lions, tigers, monkeys. That Romantic empathy into the lives of dumb animals, which increasingly humanized them and made ideologically possible not only the foundation of early nineteenth-century societies to protect them from human abuse but ultimately the entire animal mythology of Walt Disney, found its most remarkable extreme in Marc's ambitions, which he clearly articulated:

Is there a more mysterious idea for an artist than the conception of how nature is mirrored in the eyes of an animal? How does a horse see the world, or an eagle, or a doe, or a dog? How wretched and soulless is our convention of placing animals in a landscape which belongs to our eyes, instead of submerging ourselves in the soul of the animal in order to imagine how it sees.[10]

In trying to communicate with the experiences of these subhuman and hence truer and purer states of being, Marc extended the pathetic fallacy from the domain of botany to the domain of zoology. In such pictures as *Horse in a Landscape* 207 (1910) or *Dog before the World* (1912), we have virtually an 208 animal transposition of Friedrich's archetypal *Woman in* 18 *Morning Light*. In both these cases we see an animal—horse or dog—from behind, a vantage point which, so often in these Romantic meditations, permits the fullest empathy with the depicted being; and presumably we contemplate with the eyes and soul of horse or dog the mysterious landscape vista beyond, a landscape which, thanks to Marc's exposure to the chromatic liberties of Parisian painting, becomes less and less literal, substituting the rainbow colors of the spirit and the imagination for the descriptive local colors of perceived, material surfaces. Although this *reductio*, perhaps *ad absurdum*, of Romantic premises may be more persuasive in the abstract

207 FRANZ MARC
Horse in a Landscape
1910

208 FRANZ MARC
Dog before the World
1912

terms of Gustav Mahler's musical conception in the *Third Symphony's* second and third movements of 'What the flowers in the meadows tell me' and 'What the animals in the woods tell me,' Marc's effort to inhabit the very soul of these subhuman creatures is at the very least a vivid testimony to the passionate extremes to which the Romantic search for contact with unspoiled, God-given being could lead.

The mood of Marc's animal paintings tended to be polarized between two extremes, the pastoral and the apocalyptic, much as Stubbs before him could alternate between the depiction of, say, horses quietly grazing in a pasture and a horse savagely attacked by a lion in a stormy, sublime landscape. To be sure, Marc's view of animal life was on another plane of symbolism from that of an early Romantic animal painter; it chose to deal with those cosmological ultimates—genesis and destruction—that were the domain, rather, of landscape masters like Friedrich and Turner. At times, Marc, in his search for pure natural origins, envisioned a symbolic zoo worthy of Noah's Ark. The very titles of his paintings, 'The First Animals' and 'The World Cow,' bear this out. But in those works executed just before the First World War, the apocalyptic mode began to dominate, translating into art that German Expressionist awareness of imminent world catastrophe which was seized in Jakob van Hoddis' brief but historically telling poem of 1911, *Weltende (The End of the World)*.

Marc had virtually prophesied in his art the holocaust that was to follow. In the spring of 1915, he received at the front a postcard reproduction of his *Fate of the Animals*, sent to him by a friend, Bernard Koehler, and was astonished at how accurately this painting of 1913 had predicted the shattering events in which his own life was to end at Verdun.[11] In many ways this work can be seen as a transposition to the animal world of those images of apocalyptic destruction that had obsessed the imagination of so many Romantic artists, especially in Northern Europe and America. It represents, in the words of a revealing recent analysis, 'a plea for apocalypse; the expression of a longing for the destruction of the present world of corruption, evil, and degeneration, and its replacement with a world of innocence, goodness, and purity.'[12] Like the compilation of disparate iconographical sources, both well known and esoteric, which lie behind the private cosmogonies of Blake and Runge, the literary origins of Marc's *Fate of the Animals* are also personal and complex, involving themes from the *Eddas*, the *Nibelungenlied*, Flaubert's *La Légende de St. Julien l'hospitalier*, Wagner's *Götterdämmerung*, and Nietzsche's *Birth of Tragedy*, not to mention Marc's own animal symbolism. Still, its impact is immediate in the image of torrential, shattering forces, an otherworldly

209

209 FRANZ MARC
Fate of the Animals
1913

destructive power that becomes a spiritual earthquake in a forest of suffering animals.

Again, Marc has borrowed pictorial languages invented elsewhere in order to convey as vividly as possible his spiritual message. For one, the transparency of Analytic Cubist planar dissection is used to illustrate the theme of the painting's original title, *The Trees Show their Rings, the Animals their Veins*, that is, that at the moment of destiny, the very inside of matter is revealed. For another, the Futurist and Rayonnist lines of force, invented by Italians and Russians to communicate the kinetic sensations of a modern, mechanized world, are transformed by Marc into bolts of spiritual lightning that wreak havoc on a primal universe of landscape and animals. And similarly, the intense juxtaposition of complementary colors (e.g., red rays of destruction and green horses) translates the chromatic theory and practice of French Neo-Impressionism and Orphism into violent collisions of emotional forces. These modern pictorial means are all molded by Marc to the spiritual ends stated in the painting's subtitle, 'And all being is flaming suffering,' a phrase whose cosmic

implications might also qualify it for the programmatic title of a Mahler symphonic movement.

This 'flaming suffering' is seen throughout. At the upper left, green horses shriek with pain, the modern metaphysical restatement of Stubbs's horses attacked by lions; in the lower left, purple boars agonize quietly; in the center, a blue deer stretches its head back in a final death throe; and at the lower right (in that area of the painting which, together with the inscribed subtitle, was damaged, ironically, by a fire in November 1916 and was restored by an artist who would also explore the souls of animals, Paul Klee), there is a group of

210 FRANZ MARC
Tyrol
1913–14

four deer who escape this divine fury in a quiet area of refuge. Indestructible, too, is the central tree, now identified as the mythical Yggdrasil, the world-ash tree from Nordic cosmology, which, with the four deer at the right, will survive and provide the hope for the resurrection of a new, cleansed race after this apocalypse.[13]

Such terrible but purifying immolations offered to Marc a catharsis through art that could in some way combat, with the passion of an evangelical reformer, the corruption of the materialistic world in which he felt he lived. It was a spiritual purge that was to be repeated, with more explicitly Christian imagery, in his next apocalyptic work, *Tyrol*. Painted first in 210 1913, during a sojourn in the Bavarian village, Sindelsdorf, it was then considerably repainted in the following year when Marc was on leave from his first experience of military service in the Great War. Originally the painting depicted only a sublime catastrophe, a scene of Alpine devastation set against the dramatic spectacle of the interplay of light and shadow on the mountain at sunset. In the foreground, an enormous tree 188 seems to have been struck down by a cataclysmic earthquake, becoming as pitiful a protagonist as that in a comparable example by Friedrich of the pathetic fallacy, the tree that painfully bridges a mountain gorge after an avalanche.

But Marc's painting resembles even more closely a painting that Turner exhibited in 1810, *Fall of an Avalanche in the* 211 *Grisons*, in which, as in Marc's painting, the work of man, symbolized in the tiny, earthbound cottage in the foreground, is threatened by the catastrophic forces of nature. Turner himself had written about such natural disasters in terms of how man's hopes and labors were crushed along with forests of pines, but he may also have been thinking of a passage in the Book of Job (XIV, 18–19): 'But the mountain falls and crumbles away, and the rock is removed from its place; the waters wear away the stones; the torrents wash away the soil of the earth; so thou destroyest the hope of man....'[14] In Marc's cataclysm, however, such biblical allusions became explicit, for when he asked for the painting back in 1914, he added at the apex of the mountain a radiant image of the Virgin and Child that is closely related to representations of the vision of the Virgin to St. John as described in the Book of Revelation (John, XII, 1) 'a woman clothed with the sun, and the moon under her feet.' In effect, the original natural phenomenon of shadow intersecting light on a mountain peak is now metamorphosed into a supernatural one: a biblical revelation of the Queen of the Heavens in whom sun and moon join ecliptically in blinding halos of natural and supernatural light. Moreover, the scythe-like form of the foreground tree would also appear to refer, in Marc's work, to the biblical image of death as a reaper[15]—an

211 JOSEPH MALLORD WILLIAM TURNER
Fall of an Avalanche in the Grisons
1810

image, incidentally, to which Van Gogh himself had alluded
in a description of his recurrent theme of a lone sower in a
wheat field.[16] Once again, Marc has resurrected many of the
agonizing dilemmas of Northern Romantic artists—the
translation of the natural into the supernatural, the creation
of a convincing new image of supernatural forces that can
nevertheless recall a Christian past. And it might be said, too,
that the relation of Marc's sublime, apocalyptic visions to
both his subjective anxieties and their objective corollary in
the premonitions and realizations of the First World War
bears analogies to the Romantics' use of the sublime as a
subjective response to the overwhelming revolutions, both
spiritual and political, of the late eighteenth and early nine-
teenth centuries.

The sense of apocalyptic upheaval alternating with dreams
of pastoral innocence and purity was not unique to Marc in
the years just preceding the war. Vasily Kandinsky, Marc's
close associate in the formation of the Blue Rider group in
Munich, shared with him these ultimately Romantic visions
of primal harmony and primal chaos. Indeed, much as Marc,
209 in 1915, became aware that his *Fate of the Animals* of 1913 was
a premonition of the war, Kandinsky also later, in 1914
213 recognized that in his *Improvisation No. 30* of 1913 (which he
himself had subtitled 'Cannons') the presence of these instru-
ments of war and destruction, if not to be interpreted as
illustrative, nevertheless reflected the mood of imminent
international disaster so pervasive in Europe in the months
212 and years before Sarajevo.[17] But like Marc, whose *Fighting
Forms* of 1914 conveys only metaphorically some cosmic
collision of opposing forces, Kandinsky generally envisioned
his apocalypses in terms less specifically contemporary than
210 modern cannons. Just as Marc, in his repainting of *Tyrol* in
1914, recreated the vision of the Virgin in the Book of
Revelation, so too did Kandinsky, from 1909 to 1913, turn
to the Bible for themes evoking such eschatological ultimates
as the Deluge, the Resurrection, the Last Judgment, and the
Horsemen of the Apocalypse.[18] In one of the most ambitious
214 of these apocalyptic fantasies, *Little Pleasures* (1913), Kandin-
sky, according to a recent elucidation,[19] was directly inspired
by the theosophist Rudolf Steiner's new interpretations of
the Book of Revelation, which, like Marc's paintings of
universal catastrophes, presented such destruction as a purify-
ing Wagnerian immolation, from which a more enlightened
state of experience would emerge.

Broadly speaking, Kandinsky's painting also offers a
remarkable resumption of many motifs first explored most
fully and with the richest symbolic resonance by the Roman-
tics. For one, there is the storm-tossed boat, visible at the right
of the central mountain, a motif that here, as in so much

212 FRANZ MARC
Fighting Forms
1914

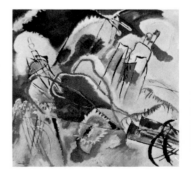

213 VASILY KANDINSKY
Improvisation No. 30, Cannons
1913

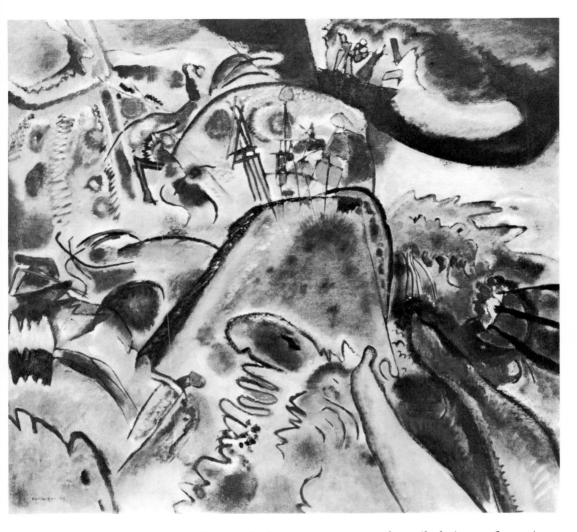

214 VASILY KANDINSKY
Little Pleasures
1913

Romantic imagery, suggests the tribulations of steering through physical or spiritual unrest. Moreover, there is the blazing sun in the upper left that suggests, as it had for so many artists in the Romantic tradition, a symbol of some omnipotent divinity or revelation, toward which man and nature can aspire. And, most conspicuously, there is the image of the Horsemen of the Apocalypse, which perpetuates a Romantic motif that, extending from Mortimer and West in the eighteenth century to Turner, Boecklin, and Ryder in the nineteenth, seizes a passage from the Scriptures that could inspire thoughts of ultimate destruction. Following Steiner, however, Kandinsky's horsemen present a more optimistic interpretation of this biblical immolation, for the fourth horseman, Death, who haunted Northern Romantic readings

of this theme, is eliminated, leaving only three riders who, almost absorbed by the molten light and color, ascend at the left from the chaos of stormy, darkening skies, to the radiant sun glowing at the upper corner. Thus, Kandinsky's *Little Pleasures*—a title that, with its reference to the leisurely aspects of the horseback riding and boating motifs in the painting, serves as an ironic foil to the true cosmic implications of these themes—takes its place with Marc's *Fate of the Animals* and *Tyrol* as one of the most telling examples of the survival, into our own century, of the Romantic obsession with the theme of the end of the world as well as the hope for its purified regeneration.

209
211

That purity was also seen in Kandinsky's work before the First World War, for he, like Marc, painted many scenes of a nature so simple and harmonious that it evoked some Garden of Eden, utterly remote from the grim realities of the modern industrial world. For Kandinsky, the objective point of departure for these Arcadian fantasies was the village of Murnau, in the Bavarian Alps, where he and Gabriele Münter bought a house in 1909. From this locale, where mountain sunrises and sunsets, verdant gardens, grazing animals, and village churches comprised the simple cosmos, Kandinsky extracted a vision of an enchanted, otherworldly community that harks back to the Romantics' dreams of some happy, primordial symbiosis of man and nature. Like Palmer, who, during a short but intense period of his long artistic career, transformed the rural facts of the Kentish town of Shoreham into a magical metaphor, Kandinsky, too, envisioned the landscape around Murnau as some sort of legendary, mystical community where the sun and the moon also burn with pagan force, where flowers grow with uncommon vitality and bounty, where village churches merge imperceptibly with the ambient landscape of swelling hills and valleys. For him the surfaces of nature were only the means to understanding the strange, spiritual forces below, forces that could carry us far away from the modern materialistic world in images that either warn us of terrible, impending doom and chaos, or comfort us in dreams of Arcadian simplicity and harmony. They are paintings that, like so many Romantic paintings before them, recreate the polarities of a fervent religious sermon, alternately inspiring terror and hope, nightmares of destruction and dreams of eternal peace.

215

215 VASILY KANDINSKY
Mountain Landscape with Church
1916

THE drastic rejection of the empirical world in Kandinsky's and Marc's work before the First World War is of such enormous consequence for the twentieth-century phenomenon of abstract art that it is easy to forget that their work also looks backward to Romantic traditions, then over a century old, in which spirit would triumph over matter and in which art would become the vehicle for communicating the quasi-religious experiences of childlike innocence or apocalyptic destruction, of the beginnings and ends of the universe, of the supernatural mysteries revealed in the world of nature. Such preoccupations, in fact, haunt the art of many other twentieth-century Northern masters, whose use of the fullest autonomy of line, color, and shape within the shallow spaces defined by Fauvism and Cubism has tended to make their formal means obscure their Romantic ends.

Such a master is Paul Klee. His aesthetic order, unlike Marc's, is on a sufficiently high level to compete successfully with the highest standards set by the School of Paris, but the universe he constructs is one that, in imagery and intentions, has little, if anything, to do with the masters of early twentieth-century French art. Associated as he was with the Blue Rider in 1911–12, Klee was closely aware of Marc's and Kandinsky's search for spiritual truths beneath the surfaces of nature; and his friendship with Marc actually had specific repercussions on both Marc's work and his own. It was Klee who suggested to Marc that he change the title of *The Trees Show Their Rings, the Animals Their Veins* to *The Fate of the Animals*, and 209 it was Klee who took the responsibility, after Marc's death, of restoring the lower right-hand corner of the painting, when it had been damaged by fire.[1] Klee, in fact, must have absorbed much of Marc's attitude toward animals as mysterious creatures through which humans could experience closer affinities with nature's secrets.

Thus, Klee's *With the Eagle* of 1918 continues Marc's search 216 for empathy with the experience of dumb animals, in this case providing the spectator with a vertiginous, literally bird's-eye view that, from a central aerial summit, surveys the panoramic vista below, with its fragmented glimpses of an Alpine cottage, a reindeer, and the pine trees and other flora that rise and fall on this mountainous topography. But if Klee's image still depends upon those premises of Romantic empathy with animals that dominated Marc's ambitions, his

reading of this subhuman world seems far less metaphysical in tone, marked rather by a more whimsical and pixillated atmosphere more appropriate to fairy tales than to philosophical speculation. The all-seeing eagle's eye itself is more of an ideograph than anything in Marc, conjuring up the kind of magic associated with, on the one hand, an Egyptian hieroglyph and, on the other, a child's drawing. Indeed, the parallels such a work offers with the conceptual style of children's art are ones Klee himself sought out in a characteristically Romantic pursuit of an uncorrupted purity of vision. Even as early as 1902, Klee virtually repeated Runge's sentiments of exactly a century before. He wished, he said, 'to be as though newborn, knowing absolutely nothing about Europe, ignoring poets and fashions, to be almost primitive.'[2] And he often found in the art of those untainted by decadent Western traditions, for example, the art of children and even of the insane, the means of reaching this purity.[3]

It was, in fact, Klee's particular genius to be able to take any number of the principal Romantic motifs and ambitions that, by the early twentieth century, had often swollen into grotesquely Wagnerian dimensions, and to translate them into a language appropriate to the diminutive scale of a child's enchanted world. For Klee, the megalomaniac and the spiritual are suddenly viewed, as it were, through the other side of the magnifying glass, disclosing a tiny cosmos that mirrors with fresh magic the grandiose mysteries dreamed of by the Romantics. Thus, it was characteristic of him that when he, as a Swiss, inevitably painted one of the same Alpine heights that Hodler had painted before him, *The* 217, 218 *Niesen*, he viewed it not as some sublime, Olympian pinnacle of nature's majesty, beyond man's reach yet still in the natural world, but rather as a fantastic, fairy-tale construction,

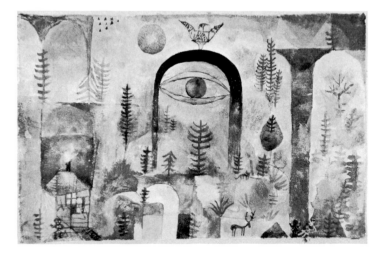

216 PAUL KLEE
With the Eagle
1918

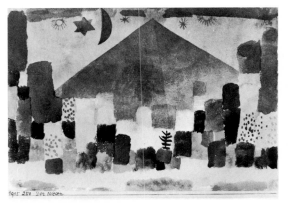

217 PAUL KLEE
The Niesen
1915

218 FERDINAND HODLER
The Niesen
1910

more pyramid than mountain, and accompanied by twink-ling ideographs for stars, moon, and sun that might have been conjured up by a magician. The mood is more like E. T. A. Hoffmann than Nietzsche.

Throughout Klee's work, Romantic themes abound. Not only did he seek to evoke the mysterious experiences of animals—the way an eagle surveys the terrain below, the way a cat stalks a bird, the way a fish starts at a baited hook—but he wished, as so many Romantics had before him, to pene-trate into the secret lives and feelings of trees and flowers, to capture the miracles of organic growth and change, the blossoming of plants, the magical passage from one season to another. In an essay published in 1920, '*Schöpferische Kon-fession*' (generally translated as 'Creative Credo'), he articu-lated once again ideas that had been voiced by many Roman-tics, claiming that the making of art was a metaphor of the Creation, that it mirrored divinity the way the terrestrial mirrors the cosmic, that it could serve to assist mankind in experiencing the mysteries of religion and of God.[4]

Given Klee's fervent search for these quasi-religious secrets of nature, it is no surprise to find in his art among the richest twentieth-century demonstrations of the survival of the pathetic fallacy. In *Mountain in Winter*, for example, he effectively resurrects the very emotion we experience before Friedrich's leafless trees in a wintry mountain setting. Here, in the foreground, a lone tree, set in a position of iconic centrality, is poignantly silhouetted against a snow-covered mountain landscape, whose icy planar intersections are as impalpably translucent as the rays of cold light that might emanate from the dim, remote winter sun in the foggy sky. As in Friedrich, we feel not only the skeletal chill of death, but the promise of life in the quivering branches of the tree, which, like a human being, seems dramatically pitted against this harsh, deathly environment.

219

40

151

Like a deity, it is the sun and its heat that so often provide in Klee's art the supernatural forces which control the phenomena of nature here on earth and which give the cycles of the seasons an almost sacramental magic in their extinction and then resurrection of life. In *Before the Snow*, we again focus on a single sentient creature, a tree that responds to the slow, but irrevocable coming of winter. The very colors begin to bleach away the vital greens at the tree's core, in favor of an autumnal rust that in turn harbors the chilly white of the winter ahead; and the fluid, irregular web of lines conveys the image of a vital organism that is withering and flaking before our eyes. It is a visual metaphor that realizes Klee's wish to make 'a cosmos of forms which is so similar to the Creation that only the slightest breath is needed to transform religious feeling, religion into fact,'[5] and it is a visual metaphor that also translates Friedrich and Runge's scrutiny of the palpitant, God-given life of trees and flowers into the more overtly symbolic language of twentieth-century organic abstraction.

The same veneration of the powers of heat and light can be seen in Klee's *Arctic Thaw*, which again attempts to find a visual equivalent of the energies of the sun as they begin to work their warming and melting effect upon a landscape as frozen as that of Friedrich's *The Polar Sea*. A glowing yellow solar orb and its reflections seem to generate the miraculous force which finally releases the life imprisoned in a landscape of frozen white blocks that slowly liquefy before our eyes. It is an image of a quiet miracle on earth that, in more abstract terms, fulfills the ambitions of Friedrich's disciple Carl Gustav Carus, who, in his letters on landscape painting of 1815—24,[6] envisioned a new kind of art, an *Erdlebenbildkunst*

219 PAUL KLEE
Mountain in Winter
1925

220 PAUL KLEE
Before the Snow
1929

221 PAUL KLEE
Arctic Thaw
1920

(that is, 'pictorial art of the Life of Earth'). By this, Carus meant a close and passionate scrutiny of natural phenomena imbued with a sense of the supernatural mysteries that lay beyond the changing surfaces of the most humble terrestrial events: the blossoming of flowers, the slow changes of

153

natural light, the movement of clouds, the cycle of the seasons.

For Klee, perhaps the most intense revelation of these mysteries could be found in the world of plants, trees, and flowers, which provided, as they had for so many Romantics, metaphors of the secrets of life. For example, one of his pictorial ideas is 'an apple tree in blossom, its roots, the rising sap, its seeds, the cross-section of its trunk with annual rings, its sexual functions, the fruit, the core with its kernels.'[7] It is a description that, in its combination of botanical exactness and a sense of the miracle of organic growth, corresponds to a recurrent Romantic attitude that can be traced from Runge and Palmer through Van Gogh, Nolde, and, as we shall see, even Mondrian; and it is also a description that corresponds closely to Klee's genius for fusing what seems almost an objective translation of these natural data into a language of uncanny magic.

222 PAUL KLEE
Spiral Blossoms
1926

223 PAUL KLEE
Flower Face
1922

In *Spiral Blossoms*, as in so many Romantic paintings of 222
flowers, we leave the scale of the human world in order to
study at closest range the organic swell and curl of blossoms
which, in response to solar light and heat, appear to be
expanding in unwinding coils and in radiant, intensifying
colors. Again, as in Romantic flower paintings, the particu-
larity of each blossom becomes a symbol of a universal life
force. So saturated are Klee's botanical images with a kind
of animistic power that, at times, they even metamorphose
into humanoid creatures, as in *Flower Face*, where Runge's 223
capacity to transform growing plants into otherworldly
cherubs, symbolic of unseen mysteries, is rejuvenated in a

masklike double image that not only relates the organic configurations of a flower to human physiognomy but creates a new deity, a flower god, in the Romantic pantheon of 'natural supernaturalism'.

Although it was primarily the metaphors of nature— animals, plant growth, the changes of the seasons—through which Klee perpetuated in a new language so many Romantic images and ambitions that would seize, in a microcosmic blade of grass, the mysteries of the cosmos, he also revitalized many other Romantic motifs, from Gothic architecture to the endlessly evocative theme of a maritime journey. In his 224 *Departure of the Boats*, he resumes Friedrich's motif of out-225 ward-bound ships that move slowly toward undefined spaces and destinies under the enchanted spell of a moonlit sky. Though the motif had become common coin in nineteenth-century art, Klee, as usual, was able to revitalize its potential mysteries by the power of his own symbolic language that here renders this nocturnal voyage all the more haunting by the inclusion of an arrow pointing to an unstated destination, and by the fusion of the night sky and sea into a continuous black plane that conceals the horizon and leaves us afloat in inky shadow.

Klee's ability to re-enchant such a Friedrichian motif as the movement of ships across a hazy sea was shared by his friend and close associate at the Bauhaus in the 1920s, Lyonel Feininger, who, despite his American birth, belongs more fully to a Germanic than to an American tradition of painting. Indeed, far more literally than Klee, Feininger often offers what may be considered almost conscious reinterpretations of Friedrich's seascapes.[8] The question of exactly when Feininger became aware of the specific inspiration of Friedrich is a thorny one, for the artist himself claimed that he was ignorant of the Romantic master's work until 1926, by which time he had already painted many overtly Friedrichian paintings.[9] But the more important fact is that, whether directly or indirectly, the motifs, the mood, the spaces of many of Friedrich's paintings were virtually reborn in Feininger's work, both before and after 1926. Again and again Feininger locates us, as Friedrich had done, on the very fringe of the sea, so that we can contemplate the soundless movements of ships that, like Flying Dutchmen, seem to be phantom vessels headed for ports that belong more to the geography of the spirit than of the earth. Even when he paints 226 a historical subject like the victory of the *Sloop Maria*, a New York yacht that won a race in the 1840s, the result looks more 34 like Friedrich's *Stages of Life* than like a boat race bound to a particular time and place. Characteristically Romantic, Feininger is more interested in emotional ends than pictorial means, for like Marc, he uses Cubist transparencies and

224 PAUL KLEE
The Departure of the Boats
1927

225 CASPAR DAVID FRIEDRICH
Moonlight and Ships on the Baltic
c. 1817

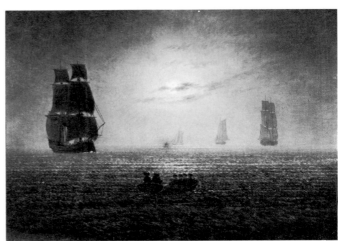

226 LYONEL FEININGER
The Glorious Victory of the Sloop
Maria
1926

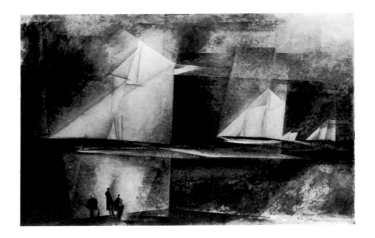

157

scaffoldings, not so much for the construction of an inde-
pendent aesthetic order but rather for the dematerialization
of objects into impalpable, translucent rays that evoke un-
worldly, spiritual realms. Even his penchant for the color
blue is determined not only by decorative preference but by
the belief, shared by so many Germanic artists from Friedrich
and Carus down to Kandinsky, Marc, and Klee, that blue was
a color associated with spiritual experience. Such a belief was
actually reflected not only in the name of the Blue Rider
group but in its later manifestation, the Blue Four, founded
in 1924 by Feininger himself, together with Kandinsky,
Klee, and Alexei von Jawlensky.

In Feininger's world, as in Friedrich's, the human figure is
most often reduced to diminutive size, awed and almost
absorbed by the engulfing and mysterious spectacle of hazy,
227 North German light and atmosphere. In the *Bird Cloud* of
1 1926, Feininger offers a virtual reprise of Friedrich's *Monk by
the Sea*, in which again a small, solitary figure stands on the
dunes before the vast, resonant expanse of a low, unbroken
horizon which separates a dark sea from a dense and trans-
lucent blue sky. Above, the shifting clouds, like those
scrupulously observed by so many northern Romantic
landscape artists—Constable, Carus, Dahl—take on a strange,
birdlike shape, a fugitive vision neither more nor less real than
the earthbound forms in Feininger's work. Indeed, Fein-
inger's use of Analytic Cubism's luminous, intersecting
planes provided him with a means of transforming all matter
into a strangely ethereal stuff, like beams of colored light that
have passed through stained glass.

Feininger, again like Friedrich, avoided traditional religious
subjects, yet conveyed in many of his works that aura of
sanctity and mystery which, beginning with the Romantics,
had been especially associated with Gothic architecture. He
was fascinated, as was Friedrich, with medieval German
architecture, which could become for him, too, both a
symbol of melancholy decay or triumphant, spiritual power.
There was, for instance, the Gothic church ruin in the
Pomeranian village of Hoff, on the Baltic Sea, which Fein-
inger, after first visiting the site in 1928, depicted again and
228 again and which his son Andreas also recorded in somber
photographs.[10] These weathered remains of a medieval past,
dramatically located on a bluff, overlooking the sea, provided
229 for Feininger, as the ruins of Eldena had for Friedrich, an
occasion to revitalize, in many paintings and watercolors,
that Romantic motif of the poignant contrast between an
omnipotent, even destructive nature and the works of pious
men from a distant era of faith, now recalled only by skeletal
relics.

Another Gothic monument Feininger viewed through

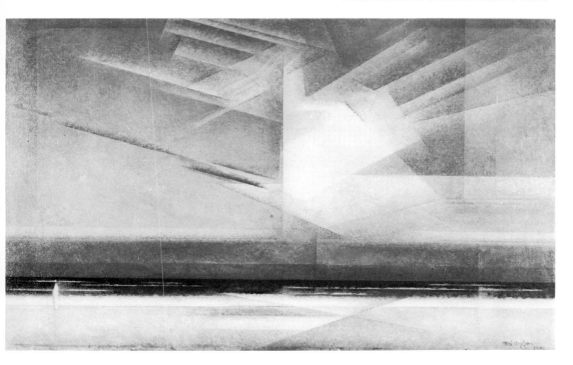

227 LYONEL FEININGER
Bird Cloud
1926

228 ANDREAS FEININGER
Photo of Ruin of Church at Hoff

229 LYONEL FEININGER
Ruin by the Sea, II
1934

belated Romantic eyes was the village church at Gelmeroda, 230
in Thuringia, whose acutely attenuated spire he drew, as early
as 1906, in close conjunction with an equally attenuated tree,
perpetuating that Romantic analogy between nature and
Gothic architecture so prevalent in the art of Friedrich and
his generation. Later Feininger often returned to the same
church, then viewing it, so to speak, through Cubist lenses 231
that translated the palpable, earthbound church into inter-
secting beams of filtered light which denied all sense of

159

matter. In this, Feininger's Cubist views of Gothic architecture are sharply differentiated from those of his French Cubist contemporaries in much the same way that, say, Friedrich's and Carus's are distinguished from Corot's. Thus, Albert
232 Gleizes' painting of Chartres Cathedral in 1912 is almost a
31 Cubist version of Corot's painting of the same monument in 1830. Despite the gravity-defiant language of Cubism, the architectural complex of the cathedral and of the adjacent clustering of houses remains earthbound, a picturesque ensemble of towers, sloping roofs, and masonry walls that seem to be glimpsed casually during a leisurely stroll on a sunny summer day. Feininger's Cubist Gothic, by contrast, veils the architecture in crystalline rays of light that elevate matter to the plane of spirit. It is an effect analogous to that of
233 Carus's view of a Gothic church, probably the Church of St. Mary at Halle, where the spiky Gothic attenuations, echoed even in the shape of the frame, combine with a hazy moonlit atmosphere to sanctify and dematerialize this heaven-borne architecture.
234 Feininger, too, had painted the Church of St. Mary at Halle, looking at it not in the French Cubist manner, as an essentially earthbound tourist spectacle of picturesque massing and complex structure, but rather as an unearthly symbol that, in its soaring height and grandeur, reduces the figures outside it to minuscule stature, and in its symmetrical disposition, takes on an emblematic character that recalls Feininger's woodcut frontispiece for the Bauhaus manifesto

230 LYONEL FEININGER
Church at Gelmeroda
1906

231 LYONEL FEININGER
Gelmeroda IX
1926

232 ALBERT GLEIZES
Chartres Cathedral
1912

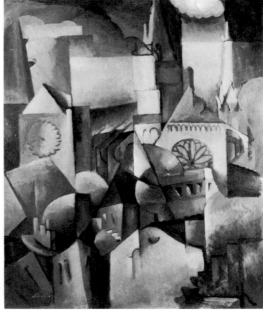

235 LYONEL FEININGER
Cathedral of Socialism
April 1919

234 LYONEL FEININGER
Church of St Mary in Halle
1930

233 CARL GUSTAV CARUS
Terrace by Moonlight
1836

236 AUGUSTUS WELBY
NORTHMORE PUGIN
A Medieval City (frontispiece to
*An Apology for the Revival of
Christian Architecture*, 1843)

237 CASPAR DAVID FRIEDRICH
The Cathedral
c. 1818

of 1919, the so-called *Cathedral of Socialism*. It is an illustration 235
that brings up to date a long Romantic lineage in which a
Gothic façade is seen in frontal symmetry as a symbol of
triumphant spirit and aspiration. Pugin's frontispiece to his
Apology for the Revival of Christian Architecture of 1843 creates 236
the same dream of a new utopian society with its lofty
proliferation of the most acutely Gothic spires; and Friedrich
himself, in works like his radiant re-creation of St. Mary,
Stralsund, a Gothic church near Greifswald, transforms these 237
monuments of religious architecture into transcendental
emblems, free from the laws of engineering and gravity, and
borne by heavenly light. The contrast between these nine-
teenth- and twentieth-century Nordic and French interpreta-
tions is like that between, say, Goethe's spiritual eulogy of
Strasbourg Cathedral and Viollet-le-Duc's technological
approach to Gothic structure. And it is a contrast that we shall
see again in the work of another early twentieth-century
Northern master who was also drawn to the symbolic
implications of Gothic architecture, Piet Mondrian.

In Feininger's work, as opposed to Klee's, we are often aware of what is almost a conscious historicism in the revival of such Romantic prototypes as those offered by Friedrich, as if the artist were trying to consolidate the new language of twentieth-century art—in this case the crystalline, intersecting facets of both Analytic Cubism and Futurism—with native Germanic traditions. A similar situation can be found in England, in the art of Graham Sutherland, who also can be thought of as translating native Romantic traditions into a more contemporary pictorial idiom. In the mid-1920s, at exactly the same time that Feininger, in Germany, seemed to be resurrecting the bleak and meditative images of Friedrich, Sutherland was studying and paraphrasing the art of Samuel Palmer,[11] almost as if, for the moment, the innovations of twentieth-century art had never taken place. Such an etching by Sutherland as *Pecken Wood*, of 1925, magically resurrects the mood, the imagery and the small-scale intensity of Palmer's prints. Rejecting, as Palmer himself had done, the complexities of the modern industrial world, Sutherland again escapes to an Arcadian dream of rural simplicity and harmony, where the landscape seems uncommonly fertile, where humble peasants, like the Suffolk farmer Willy Lott, whose house Constable painted, are rooted for the entirety of their peaceful lives to their soil, their work, their thatched cottages, and where the light of the sun, the moon, or the stars glows with an uncanny radiance that evokes a supernatural presence.

By the 1930s this revival, both intuitive and self-conscious, of a native British Romanticism had been molded into a more specifically contemporary language based on a freedom to intensify color and line in the interest of expressing a more overtly impassioned response to the mysteries of nature. These mysteries, however, were ones inherited from the Romantics. In a little watercolor, *Sun Setting Between Hills* of 1938. Sutherland brings up to date the mystical radiance of

238 GRAHAM SUTHERLAND
Pecken Wood
1925

239 SAMUEL PALMER
The Bellman
completed 1879

240 GRAHAM SUTHERLAND
Sun Setting Between Hills
1938

241 GRAHAM SUTHERLAND
Blasted Oak
1941

Palmer's own suns in an image where the sun's molten brilliance seems to spill over onto the pastoral landscape below, much as the solar and lunar orbs in the landscapes of Kandinsky, the German Expressionists, and even the American Arthur Dove become forces that almost dissolve the earthbound landscape with fluid, glowing colors.

Elsewhere, Sutherland becomes the heir to the tradition of the pathetic fallacy, as in a pen-and-wash drawing of 1941, 241 *Blasted Oak*. Even more than Dahl's pitiful birch tree, clinging 41 to a precipice in a storm, Sutherland's oak seems to scream with pain, its ruptured trunk transformed into an agonized mouth, its roots into a pathetically grasping hand. And its scale, too, continues Romantic traditions in the bizarre magnification of the tree into a prominence that demands the spectator's fullest empathy.

The change from landscape images of pastoral serenity to those of suffering and destruction—a polarity common in Romantic landscape—was clearly, in Sutherland's case, a metaphoric response to the brutal realities of the German aerial attacks upon England at the beginning of the Second

World War. If he could translate this experience of a male-volent, airborne force into the imagery of blasted trees, he could also record the devastation of man-made objects. Thus, in 1941, he depicted the remnants of cities after bombard-ments, creating desolate images in which the twisted, knotted shells of destroyed buildings—warped girders, ashen scraps of metal—are almost indistinguishable from the debris of a natural catastrophe in a landscape. Like his trees, these urban ruins are magnified to a scale that transcends human dimen-sions, making us sense both a specific fragment of pain and destruction and a generalized awareness of a terrible force that has left an agonizing trail of desolation on the works of man and nature. It hardly matters whether that force is specified as lightning or bombers; it becomes, rather, an ex-perience of cosmic evil that reduces the world to a primordial state.

Sutherland's ability to translate the literal apocalypse of the the Second World War into a metaphorical one was shared by another British artist, Paul Nash, whose most unfor-gettable image of virtually a cosmic catastrophe is the so-called *Totes Meer (The Dead Sea)*, of 1940—41, its German title referring to the fact that the site he depicted was a kind of graveyard near Cowley for the Nazi planes that had crashed there. In a letter of 11 March 1941, written to Kenneth Clark, Nash described the genesis of this haunting, end-of-the-world image:

The thing looked to me suddenly like a great inundating Sea. You might feel under certain influences—a moonlight night, for instance—this is a vast tide moving across the fields, the breakers rearing up and crashing on the plain. And then, no: nothing moves, it is not water or even ice, it is something static and dead. It is metal piled up, wreckage. It is hundreds and hundreds of flying creatures which invaded these shores. . . . By moonlight, this waning moon, one could swear they began to move and twist and turn as they did in the air. . . .[12]

242 GRAHAM SUTHERLAND
Devastation—City—Twisted Girders
1941

243 PAUL NASH
Totes Meer
1940–41

Nash's painting, like his description, perpetuates the Roman-
tic image of a waste land, where the work of man has been
absorbed into a desolate, chilly vista, a natural graveyard. Its
closest antecedent is Friedrich's image of the skeletal remnants
of a ship wrecked in an Arctic landscape as deathly and as 36
unbounded as Nash's; but its mood of a malevolent, almost
supernatural power that transforms a world of temporal
human activity to a landscape of barrenness and devastation
was one revived as well in much Surrealist imagery of the
early 1940s, especially in the paintings of Yves Tanguy and
Max Ernst executed in the United States just after their flight
from a war-torn Europe.

The Romantic fascination with visions of destruction
inspired by both the artist's subjective anxieties and the
objective facts of the most catastrophic of modern inter-
national wars (whether the Napoleonic Wars or the two
world wars of the first half of the twentieth century) was
usually combined with a religious temperament that, as in the
case of Friedrich and Turner or Nolde, Marc, and Kandinsky,
often produced images of more explicitly Christian reference.
Sutherland himself, after painting the agonies of the Battle of
Britain in the metaphorical terms of an airborne, almost
supernatural force of evil, was soon to be confronted with the
problem of translating these experiences into the more
traditional form of Christian iconography.

Commissioned in 1944 to paint an *Agony in the Garden* for
the church of St. Matthew's in Northampton, Sutherland,
characteristically for a twentieth-century artist, found the
challenge an immense one, and accepted it on condition that
he might change it to a *Crucifixion*. As a modern means to
these traditional ends, he again scrutinized the forms of nature
in a search for some organic metaphor that could provide him

165

244 with a vehicle for expressing the transcendental suffering that he felt should be embodied in a Crucifixion. He found this landscape corollary in thorns for, in his own words, 'while preserving their normal life in space, the thorns arranged themselves and became something else—a sort of paraphrase of the Crucifixion and the Crucified Head—the Cruelty.'[13] Indeed, in many paintings that followed the Northampton *Crucifixion*, completed in 1946, Sutherland invented thorn crosses, translating the image of the racked body of Christ on the Cross into the botanical equivalent of a cruciform inter-

245 weaving of spiky thorn branches that painfully impale the abstract, emblematic space around them. In trying to convey the human suffering of Christ through the vehicle of plant forms, Sutherland not only perpetuated the whole tradition of the pathetic fallacy, but also raised once more the Romantic problem of how to express supernatural experiences through natural means. For many modern spectators, Sutherland's personal, metaphorical re-creation of the Crucifixion in the botanical image of thorns arranged in icons of cruciform symmetry is far more compelling than his more orthodox interpretation of the corporeal Crucifixion of Christ. In the same way, those early nineteenth-century Romantic paint-ings that seek to convey religious, transcendental mysteries through scrutinizing the phenomena of nature are usually

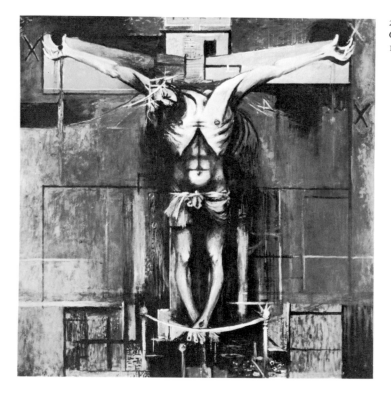

244 GRAHAM SUTHERLAND
Crucifixion
1946

245 GRAHAM SUTHERLAND
Thorn Cross
1954

246 MATHIAS GRÜNEWALD
Crucifixion (from the *Isenheim Altarpiece*)
1515–16

247 MAX ERNST
Crucifixion
1913

more persuasive than those which repeat traditional Christian iconography.

Nevertheless, such responses must remain, in our secular world, subjective; and for the religious commissions offered him by the Church, Sutherland was obliged to represent the idea of the Crucifixion not through the Romantic metaphor of an agonized nature, but through the traditional one of the agonized body of Christ. In creating these images of martyrdom for clerical, not secular, purposes, Sutherland leaned heavily for emotional and pictorial support upon a pre-Romantic interpretation of the Crucifixion, that by Matthias 246 Grünewald, which, for twentieth-century Northern artists and even for Picasso, seemed to provide one of the few traditional expressions of suffering potent enough to correspond to the spiritual and physical ordeals of the modern world.

It had done so already for the twenty-two-year-old Max Ernst, when in 1913 he painted a *Crucifixion*, whose image of 247 cosmic catastrophe and redemption, with a blackened sky, a blazing sun-and-moon image, and a rainbow presiding over a visionary panorama of Gothic ruins in a mountainous landscape, corresponds to that apocalyptic mood so common

167

in German art just before the outbreak of the First World War, especially in the work of Marc. But as in Sutherland's case, Ernst's occasional efforts to reinterpret traditional Christian subject matter—as in his later *Temptation of St. Anthony* (1945), again inspired by Grünewald—are less convincing than his reinterpretations of Romantic landscape traditions, which he often resurrected in fantasies of fresh and uncanny power. Long before the official birth of Surrealism,

248 Ernst, about 1909, painted landscapes of such unreality that
249 we already feel located far from earth. Above these strange terrains, heaving with the brilliant hues and thick brush strokes of the most advanced German and French painting of those years, there preside eerie celestial spheres whose colors are as unfamiliar as those of the unpopulated land below. They recall the iconic suns of Munch and Nolde, especially in their high, central position, but they move irrevocably from the observable phenomena of our own planet to some domain incalculably remote in time and space and accessible only to a mythic imagination. That imagination continued to expand during the high years of Surrealism's programmatic exploration of the irrational, and was to persist throughout Ernst's later career; but at all times it was deeply imbued with an imagery that was ultimately Romantic in origin.

The motif of a glowing orb, so conspicuous in these early works, is one that found infinite variations in Ernst's Sur-
250 realist work. In *The Entire City* of 1935—36, one of many paintings based on this theme, we again find ourselves on some extraterrestrial soil. Above, a cold yellow disc of a moon or sun presides over what appear to be the ruins of some long-lost civilization, a pyramidal structure of pre-Columbian inflection that, however, belongs to no earthly archaeological category. In the foreground, a wild jungle of equally unclassifiable plants appears to have grown around this desolate site, as if some uncanny vital force would soon cover the work of man. The mood of such a painting restates, through the liberated fantasy of Surrealist imagery, that Romantic obsession with cosmological images of destruction and resurrection, images in which civilizations fall in ruins or in which nature is reborn through the energies of some primal plasm. They evoke ultimate mysteries whose ideological sources are literally acknowledged in the very title
251 of a work of 1960, *The Almost Late Romanticism*, where Ernst again immerses the spectator in a primeval forest, this time dominated by a bizarrely elliptical orb whose yellow radiance can be defined as neither lunar nor solar.

In works like these, Ernst seems to present a curious stylistic duality that, in fact, characterizes the two extremes of his art. At times he paints passages, such as the forest in both

248 MAX ERNST
Landscape with Sun
c. 1909

249 MAX ERNST
Landscape with Sun
c. 1909

250 MAX ERNST
The Entire City
1935–36

251 MAX ERNST
The Almost Late Romanticism
1960

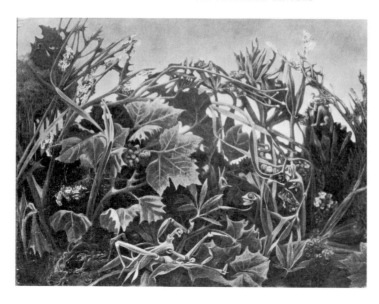

252 MAX ERNST
Joy of Living
1936

these pictures, that are executed with the most intensely naturalistic detail (though these plants may belong to no known botanical species), whereas quite as often he not only orders his paintings in terms of the most flat and emblematic structure—patterns of elemental symmetry—but cancels these naturalistic passages with, as in *The Entire City*, the abstract heraldry of a two-dimensional heavenly orb. Such a polarity between the most close-eyed view of nature in all its microscopic detail and the imposition of a starkly geometric structural order pertains equally to the greatest German Romantic artists, Friedrich and especially Runge, whose
53 *Morning*, for example, offers the same curious alternation between, as it were, a botanist's observation of naturalistic detail and an effort to fit a symbolic, patterned whole upon these particular revelations of nature's deepest mysteries. One would also have to look back to Runge's metamorphic
58 botany, as in *The Rest on the Flight into Egypt*, to find a precedent for the uncanny sense of organic growth that Ernst
252 can convey in works like the *Joy of Living* (1936), another primordial forest where we seem to be trapped in a post-Darwinian fantasy of the vital energies of plant life and even of insect life, perhaps again on a planet other than earth.

That Romantic sense of regressing to a mysterious virgin nature, as yet untouched by the hand of man and at times even located in the space-time coordinates of another planet or universe, is nowhere more explicit than in Ernst's series of *frottage* drawings (that is, drawings whose final form was inspired by the granular textures first produced by rubbings), the *Histoire Naturelle*, prepared in 1925 and published the following year. The series creates, in fact, a fantastic cos-

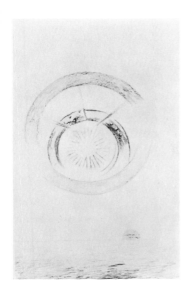

253 MAX ERNST
Histoire Naturelle: A Glance
1925–26

254 MAX ERNST
*Histoire Naturelle: the Habits of
Leaves*
1925–26

mogony, in which Book of Genesis images of primal sea, rain, earth, and heavenly orbs are gradually metamorphosed in a quasi-Darwinian evolution from which plant, insect, bird, and finally, strange, prehistoric mammalian forms emerge.

To be sure, this fascination with biological and cosmological origins characterized much Surrealist imagery of the mid-1920s, as in Miró's *Birth of the World* of 1925, which takes us back to primal sexual generation, or in Masson's many images of savage, prehistoric battles among marine creatures on sandy grounds. Yet Ernst's vision of natural origins distinguishes itself from such Spanish or French works in a way that proclaims its Germanic origins. Unlike, say, Miró's cosmogonies, which have a sun-drenched, Mediterranean look, pulsating with squirming shapes and brilliant colors that suggest the sexual origins of a more palpable physical world, Ernst's have a bleak, mysterious quality, a haunted landscape alien to human beings and more generative of spirit than of matter, of death than of life. In the earliest drawings of the *Histoire Naturelle* series, such as *A Glance*, the vision of a disc over the waters 253 recalls Friedrich's drawing of the beginning of the world, symbolized by a sun on the horizon, a world whose terrifying 21 voids are revived in Ernst's own landscapes. In some of the subsequent drawings, such as the *Habits of Leaves*, the strange 254 scale of Runge's botanical drawings is recalled, drawings in which, as in Ernst, these miraculous facts of nature are seen in a microcosmic perspective that magnifies their mystery and locates them in an environment remote from man's. Often here, as in so many Romantic views of landscape, the presence of man is banned. We are transported instead to some mythic realm of prehistory, where dreams of ultimate origins or ultimate destructions can be generated.

The aura of German Romantic art is pervasive in Ernst's work in the mysterious darkness and density of his imaginary forests, in the haunting presence of luminous discs dominating a dark sky, in the magical magnifications of his fantastic plants, in the frequent sense of desolation and death. That this is so may be in part an unconscious absorption of his native Germanic traditions, but it is doubtless also Ernst's conscious admiration for the great German Romantic painters, especially Friedrich, whose famous statement that the artist should close his outer eye in order to see his painting first with his inner, spiritual eye, was cited by Ernst's biographer, Patrick Waldberg, as an echo of Ernst's own attitudes.[14] Waldberg also tells us that, on the occasion of the Munich Glaspalast fire of 1931, when nine paintings by Friedrich (as well as others by Runge, Carus, and other German Romantics) were destroyed,[15] Ernst 'felt the loss to the point of sickness.'[16] Thus, although Ernst's search for a mythic

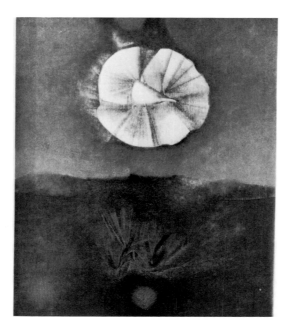

255 MAX ERNST
*When Sirens Awake Reason Goes
to Sleep*
1960

landscape that can take us back to cosmological, biological
and geological ultimates may be shared by other Surrealists
—Miró, Masson, Tanguy, for example—the particular spell
cast by his art is often more strongly allied to that of Friedrich
and Runge than to his Surrealist contemporaries.

Ernst continued to pursue these visionary landscapes
throughout his later career, into the 1960s, at which time he
often reduced their components to a stark economy that
verges upon the structure and mood of works by such
American Abstract Expressionists as Rothko and Gottlieb.
In many of these late paintings, Ernst takes the most primal
255 landscape elements—a single horizontal division between
zones of heaven and earth, one celestial sphere—and distills
them into radiant emblems that evoke, like their American
counterparts, thoughts of the beginning and the end of the
world. They are images that, in their search for nature's
ultimate mysteries, have the transcendental character that
informs a major vein of abstract painting. But they are also
images that look back to Friedrich, and particularly to the
Monk by the Sea. Small wonder that in 1972 Ernst paid explicit
homage to this great Romantic meditation. Not only did he
translate into French Heinrich von Kleist's famous discussion
of the painting that originally appeared in the *Berliner
Abendblätter* (13 October 1810), but he included in the *de luxe*
edition of his translation six original collages inspired by
Friedrich's masterpiece,[17] whose haunting confrontation
with the void was to be resurrected so often in twentieth-
century art.

Part IV Transcendental abstraction

7 Mondrian THE Paris-based ideal of art-for-art's sake so fully dominated the mid-twentieth-century view of modern painting that it has taken almost a half-century to realize that the impulses behind the creation of much abstract art were anything but aesthetic in character. To be sure, many French pioneers of abstract art—Léger, in his *Contrasts of Forms*, Delaunay in his early color abstractions—may have been concerned primarily with the formal manipulation of shapes and hues; but outside France, the evolution of an art that could be totally freed from the depiction of the empirical world was prompted by dreams of mystical and spiritual realms. In their transcendental ambitions, these dreams perpetuated the Romantic search for an art that could penetrate beneath the material surfaces of things and extract a religious essence.

Already we have seen how Kandinsky and Marc approached complete abstraction by envisioning apocalyptic upheavals that, like spiritual earthquakes, would destroy all matter and permit the beholder to enter an objectless world of feeling and spirit. It was the kind of thinking that prompted, too, the emergence of purely abstract fantasies in the work of other artists of non-French origin, such as the Lithuanian Mikalojus Čiurlionis or the Czech Frank Kupka. Čiurlionis had ambitions that involved the creation of private cosmogonies—mystical cycles of nature dematerialized through analogies with the abstraction of music;[1] and Kupka, who had actually been a practicing spiritualist, had similar dreams of constructing abstract cosmogonies that mirrored, through the metaphor of geometric variations upon the circle, the origins of life or the formation of the solar system.[2] Such preoccupations with these universal ultimates were widespread in the artistic milieu of 1900, and may well be considered yet another extension of those Romantic dreams that would seek in art a means of unveiling the mystical truths that, before the Romantics, had been located within the domain of traditional Christian iconography.

But of all the early twentieth-century artists who pursued these mystical directions to the brink of abstraction and beyond, it was the Dutchman, Piet Mondrian, who provided the clearest and most artistically compelling link between a nineteenth-century tradition based on the themes, the spaces, the emotions of Northern Romantic art and the transformation of these historical roots into a twentieth-century art

where all explicit references to the material world are banned. Even in his mature, abstract style, it is possible to consider that one of his characteristic spatial structures—a perpendicular black grid interacting with a white, void-like ground of expansive openness—is a metaphorical reprise of, say, Friedrich's equally austere reduction of the Romantic window view to a skeleton of thin, rectilinear mullions beyond which an immeasurable boundlessness is glimpsed. But if one turns to the work Mondrian executed in the years before the First World War, one finds, as in the case of Kandinsky's work of the same years, even more explicit connections with Romantic imagery in general and with the new religious goals of Theosophy in particular.

As in the case of other Northern artists we have discussed—Hodler, Munch, Van Gogh—whose nineteenth-century national traditions are, by Parisian standards, belatedly Romantic, Mondrian, too, began by painting pictures that seem totally oblivious to French Realism and Impressionism and that pick up, rather, where late Romantic generations had left off. His very early *Ships in the Moonlight* of 1890 might almost be mistaken for one of Friedrich's nocturnal views of ships on the Baltic Sea under a cloudy, moonlit sky, though its ultimate sources are undoubtedly not Friedrich but rather a native tradition of seventeenth-century Dutch marine painting which Friedrich himself had used for the creation of the Romantic image of boats disappearing into the foggy distances of a moonlit sea.[3]

Mondrian was only eighteen when he painted *Ships in the Moonlight*, a picture that primarily demonstrates how long early nineteenth-century traditions could endure outside Paris. But soon Mondrian's retention of Northern Romantic attitudes became not a question of an art student's *retardataire* mimicry but of a profoundly original reinterpretation of many of the questions that had obsessed masters like Friedrich and Runge. Merely to glance at Mondrian's early self-portraits is sufficient to make one realize that he belongs, like Munch, Hodler, and Van Gogh, to the emotional community of artists who sought to penetrate a world of spirit rather than

256 PIET MONDRIAN
Composition 1-A, Diagonal
1930

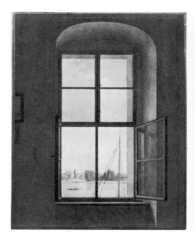

257 CASPAR DAVID FRIEDRICH
Studio Window
1805

258 PIET MONDRIAN
Ships in the Moonlight
1890

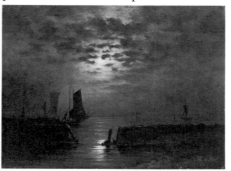

259 PIET MONDRIAN
Self-Portrait
c. 1908

260 PIET MONDRIAN
Self-Portrait, Face
c. 1908

261 PIET MONDRIAN
Self-Portrait, Eyes
c. 1908

of surfaces. In a series of self-portrait drawings of c. 1908,[4] the spell of Romantic self-portraiture is again cast. In the most conventional of these, the eyes, as in Carstens' self-portrait of c. 1784, are the windows of the soul, staring at us frontally in a quasi-hypnotic trance that, in the case of the Mondrian, renders almost impalpable the rest of the head and body. This uncanny focus upon the eyes reaches, in two other self-portrait drawings of the series, an even more extreme intensity, focusing first upon the face alone, and finally upon just the pair of staring eyes, whose gaze is as haunting as that in Friedrich's self-portrait drawing, where the artist also forces attention upon his wide-eyed stare. And both artists make the eyes all the more disconcerting by locating them just below, rather than (as would be the case in traditional portraiture) just above the center of the page.

259

74

260

261

75

This search for a contact with a world that lay beyond or beneath the outer shell of matter took on, in many of Mondrian's early figure compositions, the quality of a private religious meditation. In *Passion Flower*, of c. 1901, Mondrian perpetuated the mood and posture first invented by Friedrich and then revived, in a new mystical context, by Munch and Hodler in their comparable images of figures who seem to be rapt in a state of trance.[5] In this tradition, the figure stands, still and solemn, as if effecting a communion with invisible forces that emanate from a mysterious world within the communicant or from some equally transcendental power that may lie outside in nature. Mondrian's variation on this theme again offers a structure of stark symmetry, which translates a human being into an icon; and the emphatic closing of the eyes as well as the inactive position of the arms at the figure's sides locate us in an interior world of spirit and feeling. Above the shoulders are two emblematic passion flowers (traditional symbols of the agony of Christ) which,

262

together with the figure's expression of uncommon suffering —either physical or spiritual—transform her into the martyred saint of some strange new twentieth-century religion. It has even been suggested that Mondrian was aware that the model might be suffering from a venereal disease, a fact that must have made all the more poignant the metamorphosis of an earthly model into a symbol of spiritual pain and release.[6]

Like so many Romantic artists who had to seek the answers to ultimate questions outside the canons of traditional Christianity, Mondrian was also compelled to look beyond conventional religious belief for a means of penetrating the mysteries of spirit and feeling. For him, as for Kandinsky, this means was the Theosophist Movement, which could provide not only dreams of spiritual worlds that annihilated the realm of terrestrial matter, but also specific iconographical clues to describe symbolically this invisible domain. Thanks to the research of Robert Welsh, we can now understand how deeply Theosophy affected Mondrian's art and thought.[7] For Mondrian not only followed closely the writings of Rudolf Steiner, which had also left their mark on Kandinsky, but actually became a member of the Dutch Theosophic

262 PIET MONDRIAN
Passion Flower
c. 1901 (?)

263 PIET MONDRIAN
Devotion
1908

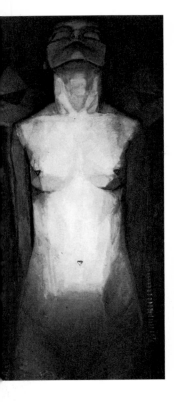

264 PIET MONDRIAN
Evolution
c. 1911

Society in May 1909. A painting of the preceding year, *Devotion*, already reflects Mondrian's absorption of theo- 263 sophic beliefs: we see a profile view of a young girl who meditates upon a single chrysanthemum blossom which, like her, moves from the realm of matter to that of spirit, emanating as it does 'aural shells,' that is, a kind of halo that elevates a living thing to a mystic, bodiless sphere of being.

This immersion of a figure into a state of nearly transcendent communion with the impalpable mysteries of life forces became even more mesmerizing in Mondrian's *Evolution* of 264 c. 1911, where the traditional Christian format of a triptych altarpiece is transformed into an icon for theosophist worship. Like so many Romantics who imposed upon their landscapes and figures a motionless symmetry that is religious in implication, Mondrian, too, created an emblematic mystery in this three-part cycle of figures viewed in postures of stark frontality and arranged in patterns of frozen geometric order. Against a background of deep, celestial blues that, like the blues of so many spiritually oriented artists from Friedrich and Van Gogh to Marc and Feininger, are meant to locate us in an ethereal, otherworldly realm, we see the extreme statement of that posture of meditation and communion projected more corporeally in the earlier *Passion Flower*. Like the figure,

177

who is metamorphosed in three stages—left, right, and center—from a more terrestrial plane to an occult one of spirit, the accompanying flower emblems move from a form, in the left panel, almost identifiable as an amaryllis, to the sacred geometries—at the right a hexagram, in the center a triangle inscribed in a circle—of the theosophist cult. The precise details of this transcendental journey from matter to spirit may need close explanation, but the overall pattern, in which a once corporeal being, of nearly androgynous character, is elevated to a weightless, ethereal sphere, is relatively intelligible.

Although *Evolution* may at first appear only a bizarre and peripheral effort to illustrate the occult principles of the theosophist religion, its central ideas, looked at more broadly, not only permeated all of Mondrian's work but also posed once again many of the dilemmas inherited from comparable Romantic searches for spirit in matter, for the supernatural in the natural. Not only does Mondrian distill to mystical ghostliness the long Romantic tradition of a figure that attempts to immerse itself in the great beyond, but even more explicitly, he absorbs, in the floral geometric diagrams, another long Romantic tradition that would seek some ultimate clue to the structure of the universe by studying that microcosm of nature, a flower. Long before Theosophy was to have its impact on him, Mondrian had begun to single out individual flowers for an almost mystical scrutiny. Although he was capable, in his earliest work, of representing, say, five chrysanthemums in a vase that still belonged to the nineteenth-century world of middle-class interiors with table tops and pots filled with decorative flowers (the world, that is, of Realist and Impressionist flower painting from Courbet to Monet), he was more at home studying a single chrysan-
265 themum, as in a watercolor of 1900, in which the flower is removed from a human environment and magnified to that Romantic scale which lets us peer into the microcosm of
266 nature. Even more mysterious is a watercolor of an amaryllis of 1910, where the burning red petals become almost a heraldic pattern upon an abstract ground of deep, celestial blue. Without any knowledge of Romanticism or Theosophy, it would still be apparent that such flowers are not to be interpreted merely as decoration; for their isolation, their centrality, and their magnification give them a symbolic aura that far transcends only aesthetic contemplation. But in fact, Mondrian's flowers clearly do pertain to mystic traditions of flower painting, both old and new. His intuitive penchant for examining the individual facts of nature as if their mysteries could be so extracted was ultimately indebted to Romantic traditions that could find their origins in Runge's wide-eyed scrutiny of single flowers.

265 PIET MONDRIAN
Chrysanthemum
1900

266 PIET MONDRIAN
Amaryllis
winter 1909–10

267 PIET MONDRIAN
Chrysanthemum
1908

268 PIET MONDRIAN
Dying Chrysanthemum
1908

Often, Mondrian painted flowers in what becomes a two-part sequence of life and death. At times we see a healthy, living chrysanthemum that blossoms with Runge-like vitality 267 against an abstract blue ground; but this is inevitably followed by an image of the same flower as it expires, completing its 268 organic cycle and bending toward a symbolic margin of deathly black. Elsewhere, Mondrian chooses a sunflower to 269 make the same point, showing us, on the one hand, a vigorously upright stalk and blossom that seem to quiver with emergent strength; and on the other, a poignantly withering plant that seems to expire tragically before our eyes, a symbol 270 of the conclusion to all organic cycles and, particularly in the case of the sunflower, of the extinction of the solar light of day. Such flower paintings belong, generally speaking, to early nineteenth-century traditions, to the spiritual speculations on botany offered by Goethe in words and by Runge in both words and images; but their immediate origins may

belong more explicitly to the milieu of Mondrian's great compatriot Van Gogh, whose paintings of flowers, and especially of sunflowers, are impregnated with a sense of the pathos and mystery surrounding the simple life cycle of these humble plants which mirror so closely the energies of God-given sunlight.

We might almost be tempted to say that the nearly human tragedy we sense in Mondrian's dying sunflower was unpre-

115 cedented were it not for the existence of Van Gogh's close-eyed views of sunflowers breathing, as it were, their last breath. And it should be said, too, that the tradition of anthropomorphizing flowers, and particularly sunflowers, was made explicit in the milieu of Dutch Symbolism, as in

271 the cover designed by R. N. Roland-Holst for the Van Gogh memorial exhibition held in Amsterdam in December 1892.[8] Here, in terms that reduce Van Gogh's evocative metaphors of divinity in nature to almost a trivial code, Roland-Holst represents the recently dead artist in terms of an expiring sunflower, whose passing is echoed by the setting sun on the horizon and whose sanctified martyrdom is symbolized by the halo that encircles the drooping blossom.

Mondrian's intense empathy with the life and death of flowers may stem not only from the immediate late nineteenth-century past of Van Gogh and Dutch Symbolism but, more generally, from the sources of such attitudes in Northern Romanticism. But his choice of flowers as one of the vehicles through which ultimate mysteries might be glimpsed also converged with the theosophist theories of Rudolf Steiner, whose spiritual speculations about how plant life mirrored the macrocosm owed much to the ideas of Goethe. Just as Runge's studies of plants and flowers paralleled Goethe's ideas about flowers as reflections of life forces and about the concept of an underlying *Urpflanze*, or primordial plant, beneath all species, so too did Mondrian's flowers reflect the neo-Romantic botany of Steiner, who found in flowers the key to life, death, and resurrection and who felt that particular species were ultimately subsumed under a more fully encompassing structure.[9] In this regard, Runge's imposition of some dominant circular geometric pattern upon the individual

54 variations of, say, a cornflower, is a prophecy of Mondrian's tendency to abstract from the particular a regularized geometric form. Thus, the emblems that accompany the

264 three-part sequence of *Evolution* move from an almost recognizable amaryllis in the left panel to an abstract geometry that would absorb not only the individual flower but ideas of terrestrial and spiritual existence as well. Similarly, in many of the later drawings and paintings that Mondrian was to make between 1911 and 1914 of his favorite subjects—trees,

285 church façades, views of the sea—he would inscribe the

269 PIET MONDRIAN
Upright Sunflower
c. 1908

270 PIET MONDRIAN
Dying Sunflower
1908

271 R. N. ROLAND-HOLST
Cover Design for Van Gogh
Exhibition, Amsterdam
December 1892

286 motif symmetrically within a circle or oval that imposed upon
the whole the same polarity between the particular and the
universal or, in more theosophic terms, between matter and
spirit. Indeed, in the thinking of the high priestess of Theo-
sophy, Mme. Blavatsky, pure geometric form is associated
with the realm of divinity.[10]

272 PIET MONDRIAN
Summer Night
c. 1907

273 PIET MONDRIAN
Trees on the Gein by Moonlight
c. 1908

The above-named subjects—trees, churches, the sea—
again provided, as did flowers, the means through which
Mondrian sought the spiritual ends that obsessed his life and
his art. It is telling that they are also among the major themes
of Friedrich, who found, too, that the mysterious life of trees,
the spiritual associations of religious architecture, and the
haunting immensity of the sea were observable motifs that
might open vistas to unseen worlds. In almost every way,
Mondrian's interpretations of these themes both perpetuate
and revitalize their first quasi-religious inflection in the art
of Friedrich and other Northern Romantic masters.

Thus, in Mondrian's early landscapes, one finds a pervasive
mystery in moon and sun, heavenly orbs that seem to animate
272 magically the terrestrial landscape below. In *Summer Night*
of *c.* 1907, a strange silvery moon, surrounded by a hazy halo,
presides over an almost barren landscape in a way that recalls
not only the mystical moonlit landscapes of Munch, but
ultimately those of Friedrich, where dimly glowing moons
also cast an incantatory spell on sky and earth, and transfix
spectators into enrapt stillness. Elsewhere, Mondrian's moons
almost transform the vertical thrust of trees against the
horizon into living, throbbing beings. In a view of five trees
273 on the Gein River by moonlight, the trees, rendered nearly
impalpable by the silhouetted frailty of their thin trunks and
by the continuation of these lean vertical axes in the watery
reflection below the horizon, virtually quiver in response to
the remote glow of lunar light. It is a theme rendered even
274 more passionate in the large *Woods near Oele* of 1908, where
the spectator is immersed in a forest that seems virtually to
pulsate with the energies discharged by a glowing, golden

orb. That this painting has been identified as both a morning and an evening scene,[11] which in turn might even transform the sun into the moon, restates a recurrent ambiguity in much Northern landscape painting of a mystical cast. Just as in many of Munch's scenes of summer nights it is almost impossible to distinguish sun from moon (or is the orb a symbolic fusion of the two?), and as in many of Friedrich's hazy skies we are confronted with what might be either a moonrise or a sunset, so too in Mondrian do we often transcend the specific phenomenon of sun or moon and perceive rather a more generalized light source that elevates empirical observation to a more symbolic plane. It was a search for underlying, universal truths that is further borne out in the colors of *Woods near Oele*, which now tend toward a primary triad of yellow, red, and blue, and in its very structure, which extracts from the density of a forest a lean skeleton of strong vertical axes countered by the reposeful reiteration of continuous horizontal rhythms both above and below what may be the edge of a body of water. Like Friedrich, Mondrian intuitively

274 PIET MONDRIAN
Woods near Oele
1908

distills from the abundance and variegated surfaces of nature a pattern of stark simplicity that transforms what might be fugitive and casual into a symbol that would evoke elemental forces and mysteries.

In *Woods near Oele*, Mondrian's trees seem less like palpable objects than like paths of energy and feeling which virtually emanate halos of luminous color that muffle the distinction between solid and void. This translation of inert matter into vital spirit can be seen in many other tree studies by Mondrian which offer, among other things, an impassioned twentieth-century statement of the pathetic fallacy. In the *Red Tree*, of 1908, we are confronted with a single tree so forceful in its thrusting extensions of nervous, intertwining branches that it becomes, like the trees of Van Gogh or Friedrich, the protagonist of some drama more human than botanical, and the conveyor of sensations more emotional than physical. The red hue that seems to rise from the earth and to penetrate the trunk and the branches may originally have been suggested by the reflections of a blazing sun (as in the red of *Woods near Oele*), but in this context the effect is of a searing, almost bleeding passion that pervades, like a circulatory system, the very blues of the membranous sky and earth. Again, as in *Woods near Oele*, a heavenly orb—probably to be identified as a moon, though the red reflections might also suggest the sun[12]—seems to provide the source of mysterious energy.

Such passionate empathy into the life and feeling of a single tree continued as a prominent motif in Mondrian's work, a motif that became more and more dematerialized, as in the *Blue Tree* of 1909—10, where the tree's agitated silhouette is as impalpable as a diagram of the nervous system, a strange network of botanical ganglia that again discharge their vital forces into an equally responsive blue sky and earth. As in the case of Mondrian's studies of single flowers, these paintings of isolated trees become microcosmic mirrors of a radiant, organic vitality so potent that it can transform roots, trunk, and branches into a vibrant web, hovering in some transitional domain between matter and spirit, solid and void.

Like Friedrich, Mondrian constantly sought in the real world some motif that could be translated into a metaphor of the spiritual and, like Friedrich, he was also drawn to Gothic architecture as a symbol of transcendental experience that could guide us from terrestrial to heavenly realms. By 1909 he had abandoned the more casual oblique views of Dutch churches and medieval castle ruins inherited from a nineteenth-century picturesque tradition in favor of starkly frontal views of medieval church façades that transformed a record of topographical fact into an imposing symbol of

275 PIET MONDRIAN
The Red Tree
1908 (reworked 1909–10)

276 PIET MONDRIAN
The Blue Tree
1909–10

looming power and mystery. In these new, hieratic pictures of Gothic façades from Zeeland, whether the church at Zoutelande or that at Domburg, Mondrian experimented with a variety of pictorial vocabularies—from pointillist dabs of color to more geometricized, angular *Art Nouveau* lozenge patterns—but these varied languages participate in a common search for a style that would permit a maximum fusion between the solid of the church and the void of the ambient space.

Eventually, the masonry of these Dutch churches is transformed into a pulsating substance as immaterial as that of Mondrian's trees. In the *Church at Zoutelande* of 1909—10, the 277

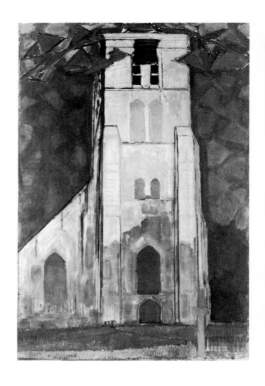

sunlit façade shimmers as impalpably as the resonant blue sky around it, and the common denominator of pointillist tesserae of color unites the parts in an indissoluble whole. In 278 the later and more mysterious *Church at Domburg*, of 1910—11, the irregular weave of luminous blue lozenge patterns dominates the whole, confounding suggestions of surrounding leaves and branches with the blue of a night sky and the dark blue of the foreground shadows that, in covering the lower third of the façade, help to render the architecture more heaven-borne than earthbound.

Like Feininger in his views of North German Gothic architecture, Mondrian also perpetuates in these works a Northern Romantic tradition of the painting of Gothic buildings that is to be sharply distinguished from its French counterpart. Again, by comparison to such Cubist-Gothic 232 views as Gleizes' or Delaunay's of the cathedrals of Chartres or Laon, Mondrian's dematerialization of Gothic masonry alludes more to the world of spirit than to a *tour de force* of rational structure. Approached not by foot in a picturesque landscape but by spirit in an intense frontal view, Mondrian's church façades become almost two-dimensional emblems that rise majestically above us like paths to a mysterious, translucent beyond. The *Church at Domburg*, in particular, is 32 virtually a reprise of Friedrich's visions of Gothic façades that can rise heavenward, totally freed from the laws of gravity

277 PIET MONDRIAN
Church at Zoutelande
summer 1909–early 1910

278 PIET MONDRIAN
Church at Domburg
1910–early 1911

279 PIET MONDRIAN
The Red Mill
c. 1911

280 PIET MONDRIAN
Mill by Moonlight
c. 1907–early 1908

281 PIET MONDRIAN
Sea at Sunset
1909

and the materiality of stone. Its scale, too, dissociated as it is from an earthly, man-made environment, is awesome, offering us, like Friedrich's churches, a glimpse of otherworldly mysteries and glories.

So saturated was Mondrian's view of the empirical world with a sense of spirit and symbol that he could even translate a secular building into an emblem of almost religious connotation. Thus, in the *Red Mill*, which is close in date to the 279 *Church at Domburg*, he transforms his earlier, more picturesque 280 views of windmills observed in the Dutch landscape—a tradition he inherited from his nineteenth-century Dutch pictorial ancestors and ultimately, from Ruisdael and Rembrandt—into an uncanny symbol of strength and faith in a virtually abstract landscape of deep, celestial blues that move imperceptibly from earth to sky. Just as Friedrich could impose upon the naturalist tradition of Baroque landscape painting a new structure of stark geometric simplicity that turned perception into symbol, so too could Mondrian alter the naturalist tradition of nineteenth-century landscape painting in the direction of a strange, heraldic symmetry. Thus, the *Red Mill* could never be confused with Mondrian's earlier views of Dutch windmills in Zeeland, but becomes, rather, a haunting tower of the spirit. In structure alone, the tower itself is located on an axis of strict vertical symmetry, which, like the fixed cruciform pattern defined by the intersecting blades, immobilizes the whole in a building of monumental grandeur that belies its prosaic function. Moreover, the window in the tower and the diamond-shaped hub of the wheel above seem to gaze progressively upward, almost a humanoid counterpart to the meditative postures of *Evolution*. Like the greatest Northern Romantics, Mondrian can transform the humblest object into a symbol of some spiritual quest, creating here what almost seems the central icon of a private religion.[13]

In his scrutiny of those experiences of the empirical world that could provide vehicles for a world of spirit, it was inevitable that Mondrian turn to that motif which had also provided Friedrich, and other great Romantics, with an image in nature that could evoke ultimate mysteries, the edge of the sea. About 1909, he began to change his relatively more naturalistic views of Dutch sea and sky into images of minimal simplicity, the counterpart in seascapes to the severely frontal views of symmetrically fixed trees and church façades. In *Sea at Sunset* of 1909, we stand at the bleakest fringe of the 281 Dutch dunes, where the edge of the earth merges with the vast expanse of sea and sky, and the whole palpitates with the last yellow rays of solar energy. As in Munch's vision of the 169 sun in the University of Oslo murals, Mondrian's sunset on the coast locates us in elemental nature, totally uninhabited

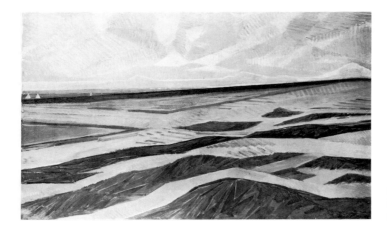

282 PIET MONDRIAN
Dune Landscape
c. 1911

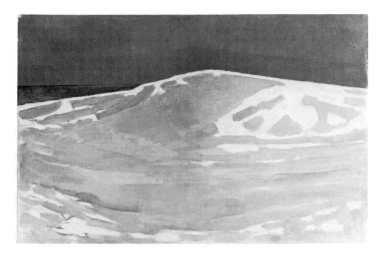

283 PIET MONDRIAN
Dune V
summer 1909–early 1910

by man, and so far-reaching in its expanses that the earth below and the sky above curve slowly away from the distant, almost imperceptible horizon line. It is a vision of a stark, all-encompassing universe that evokes, too, the ultimate land-scapes of Van Gogh, with their curving vistas of boundless earth, or their spiritual precedents in such drawings of Friedrich as his barren vista of sea and sky framed symmetric-ally by the rising curves of the edge of a dune that stretches outward to the left and the right.

Like Friedrich's Capuchin monk meditating upon the mysteries that lie beyond land's end, Mondrian found in these low coastal regions on the North Sea a metaphor of the perhaps supernatural infinities of nature. In Mondrian's dune paintings there are no objects, not even a plant, so that the beholder feels that he is on the precipice of a world that has annihilated matter in favor of a vast, all-engulfing void. At

188

times, as in a dune landscape that employs the irregular 282
lozenge patterns of the *Church at Domburg*, the boundless
vista of blue sand and sky is breathtaking in its infinite
horizontal extension; in other dune paintings, these horizon-
tal infinities are countered by swelling forms that almost 283
suggest an underlying ovoid shape, perhaps a reflection of the
theosophic belief in a 'world egg,'[14] an image of cosmic
origins that would become even more clearly defined in the
later *Pier and Ocean* series of 1914–15. But in all cases, Mon- 285
drian pursued that Romantic quest for a part of nature so
primal, so remote from man and his work, so drastically
reductive in its few elements—sea, sky, and sand—that the
beholder becomes a witness to what is virtually the beginning
moments of a new cosmogony.

Mondrian, however, was soon able to go beyond even the
startling economy of these dune landscapes, which ultimately
remained within the naturalistic confines that had already
been stretched to a point of equally elemental economy in
Friedrich's *Monk by the Sea*. Beginning in 1912, Mondrian's 1
search for a world without objects, for that world of *Gegen-
standslosigkeit* (to use the German word most often applied to
the goals of abstract art) which had already begun to haunt
the imaginations of many German Romantic artists and
aestheticians,[15] would be furthered by his absorption of the
Parisian language of Cubism, whose vocabulary of inter-
secting planar and linear fragments threatened the total
dissolution of matter and objects. For Mondrian, such a
potential, soon to be rejected by Picasso and Braque, was
desirable, since it permitted a still more profound disclosure
of the spirit that lay beyond the material surfaces of nature;
and his mystical program, which was verbalized in many
quasi-religious aphorisms inscribed in the sketchbooks he
compiled in Paris in 1912—14,[16] became yet more visible in
the drawings and paintings of these years.

In the *Sea* of 1912, Mondrian, then working in Paris, 284
translated the earlier motif of the Dutch coastal view into an
even more reductive language, where there is no longer any
distinction at all among the elements of land, sea, and sky.
Instead, we see only a weave of arced and horizontal planes
that diminish in size as they move upward and inward,
suggesting, within the shallow spaces of Cubist planar inter-
sections, a deep vista that extends from the foreground
threshold (a point on land?) to the uppermost arcing line that,
unlike those below, extends uninterruptedly across the canvas
and thereby suggests the sweeping continuity of the horizon
at the extremity of the vista. Nevertheless, it has become
almost impossible here to distinguish even the most primary
of natural elements—earth, water, air—for all is fused in an
impalpable gray expanse that seems to permit no further

reduction. Yet the mysterious energies of nature are also active here, for the equally impalpable linear network of the painting suggests, like the sea itself, the oppositions of movement and rest. Whereas some of these linear fragments swell like waves in expanding arcs, others subside in serene horizontal axes. And if we feel a pervasive unity in this immersion into the forces of the sea, we also perceive a surface variety in the changing patterns that animate the whole. It is an image that evokes simultaneously the irreducible oneness and the infinite complexity that the Romantics themselves experienced in nature.

Mondrian's passionate search for a vocabulary that could express such elemental dualities reached even more rockbottom distillations. After returning to Holland in 1914, Mondrian again explored the inexhaustible mysteries of the sea, this time choosing as a motif a point on the dunes at Domburg, where a wooden pier jutted out into the water. In this so-called 285 *Pier and Ocean* series, the restless swelling and subsiding arcs

284 PIET MONDRIAN
The Sea
1912

285 PIET MONDRIAN
Composition No. 10, Pier and Ocean
1915

of the 1912 painting are further regularized into crisscrossing grids that approach the pure opposition of a static, serene horizontality with restless, vertical thrusts. Mondrian's annihilation of matter and objects is here complete: the vestige of the pier, projecting upward from the bottom, is totally absorbed in twinkling patterns that seem both infinitely complex in their varied overall patterns and infinitely simple in their ultimate reduction to only parallel and perpendicular relationships and to the primary luminary opposition of light and dark, white and black. These experiences of an elemental nature—spiritual, bodiless, at once awesomely simple and awesomely complex—perpetuate that Romantic sense of a quasi-religious mystery behind the material surfaces of the seen world. Like Friedrich, Mondrian extracts from his motifs in nature an underlying structural skeleton of almost symbolic clarity. In the case of the *Pier and Ocean* series, the compositions seem on the verge of disclosing a stark, cruciform symmetry beneath the impalpable agitation

of the surface rhythms; and similarly, the vista of the sea, which might be infinitely extendible, is ultimately inscribed in an oval format that, for Mondrian, might well have evoked the microcosmic image of the 'world egg', borrowed from Hindu mythology by Mme. Blavatsky.[17] And it is worth noting that like other Romantic pictures of nature's most elemental mysteries—Friedrich's *Monk by the Sea*, Turner's *Sun Setting Over the Sea*—Mondrian's *Pier and Ocean* series can be experienced as both shallow and deep. Without material objects to define successive positions in space, these pictures become resonant, luminous expanses that can alternately remain within the narrow confines of the picture's flat surface or expand into illusions of infinite recession toward remote or unseen horizons. It is a spatial mystery that, in fact, will be recreated in many works by Pollock, Rothko, and Newman.

In the case of Mondrian's *Pier and Ocean* series, the intervals of intersecting and parallel lines gradually diminish in size as we move from bottom to top, so that an illusion of almost perspectival diminution is conveyed within what seems to be so overtly flat a design. Similarly, the use of an oval format not only flattens the surface but also extends it in depth by implying an illusory projection of a circular area that, as in traditional perspective, has been distorted into an elliptical shape. Just as the ascending rhythms can be seen as moving alternately upward or inward, so too can the oval (whose definition in these works is always imprecise) move toward either a flat surface pattern or the illusion of a circular periphery that recedes from the foreground to the extremities of the horizon.

For Mondrian, the sea provided, as it had for the Romantics, a metaphor in nature of boundless mysteries. It was not, however, the only motif that he used as a vehicle for extracting what for him were almost religious ultimates. Two other major themes, again inherited from the Romantics, also preoccupied him in this combination of formal and spiritual research: the church façade and the tree. For Mondrian, as for Friedrich, these themes were as fraught with as many symbolic allusions as the sea, and were also subjected to the same kind of reductive metamorphosis. In Paris, in 1913—14, he continued to explore the motif of a church façade, which had already fascinated him in his earlier studies of Dutch churches. This time, he focused upon the mid-nineteenth-century church of Notre-Dame des Champs, distilling from it, with 286 his new Cubist vocabulary, an immaterial skeleton that transformed matter into spirit, that rendered Cubism's translucent and intersecting planes still more ghostly and impalpable, and that rejected entirely the Parisian Cubists' preference for discrete, palpable objects. So bodiless and so

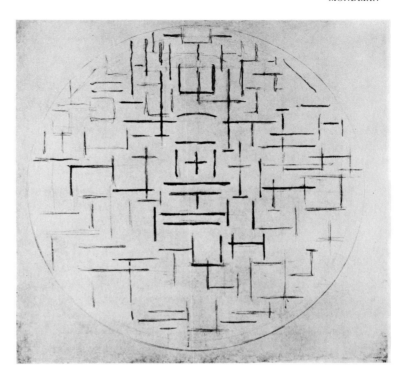

286 PIET MONDRIAN
*Circular Composition, Church
Façade*
1914

unearthly are these studies of Notre-Dame des Champs that
they eradicate the sense of any material core. Fading gradually
toward the periphery, their energies, like those of the sea,
radiate outward in all directions.

Little by little, in these reductive abstractions, it becomes
difficult not only to distinguish between those based on the
Parisian church and those executed a bit later, which are
based again on the church at Domburg, but also to discern
whether the motif that inspired the drawing is a church at all,
as it may also be the sea, or even a tree.[18] For the tree theme,
too, continued to provide Mondrian with a motif that could
suggest in the natural structure of the trunk's vertical thrust
against the horizontal expanse of the branches and of the
earth a cruciform pattern that can be sensed not only in the
underlying skeleton of the whole but also in the crisscrossing
patterns of the parallel and perpendicular parts. And it was
also a structure that Mondrian had extracted from many of
his early flower studies, which impose almost a crucifix
heraldry upon an organic form. In this light it is worth
noting that the actual cross observed on the church façades of
Notre-Dame des Champs and Domburg becomes, in some
of these studies, a kind of central focus that is both composi-
tional and spiritual; for Mondrian could hardly have avoided
the association of religious meaning with this elementary

geometric pattern, a pattern that was in fact to become the structural basis of the remaining thirty years of his objectless, abstract art.

Like Friedrich, Mondrian seemed to be searching for the mysterious skeleton of nature, rejecting matter in favor of immeasurable voids, and disclosing beneath the surfaces of the seen world a unifying structure of elemental, almost geometric clarity. Working still within the premises of a fundamentally naturalist style, Friedrich could only reveal these spiritual bones by implication, emptying his landscapes of objects, dividing sea from sky by an uninterrupted horizon line, imposing a fixed symmetry upon the transient data of nature, or transforming a clump of leafless bushes in the snow into a fragile network of radiant lines almost as impalpable as Mondrian's Cubist trees and almost as suggestive of the metamorphosis of organic forces into spirit. But Mondrian, working from the premises of Cubism, could pursue these impulses much further, so that by 1914 all the Romantic motifs that had dominated his pre-abstract work—sea, flower, tree, church—were absorbed in these ultimate distillations of the manifestations of the seen world into the language of the spirit. In later abstractions, like *Composition 1-A* of 1930, whose very format, a lozenge, may evoke the religious symbolism of the heraldic, diamond-shaped funerary plaques so ubiquitous in Dutch Protestant churches,[19] we are confronted with a world whose insistent dualities of microcosm and macrocosm and whose destruction of matter and objects echo a major vein of Romantic mysticism. As small as it is intense, such an image radiates outward in all directions; and its rockbottom vocabulary of basic dualities— black and white, horizontal and vertical—is both irreducibly elemental and, in its unexpected surface variations of irregular widths and intervals, infinitely complex. But as ultimate as Mondrian's pictorial statement may seem, many of its formal and spiritual goals were to be resurrected in the art of the American Abstract Expressionists, several of whom—Mark Rothko and Barnett Newman, in particular—could also envision paintings whose total destruction of matter and whose sense of boundless space locate us on the brink of mysteries as religious in implication as those evoked by Mondrian.

287 CASPAR DAVID FRIEDRICH
Trees and Bushes in the Snow
c. 1828

FROM Friedrich and Turner through Kandinsky and Mondrian, the Northern artists we have considered were all confronted with the same dilemma: how to find, in a secular world, a convincing means of expressing those religious experiences that, before the Romantics, had been channeled into the traditional themes of Christian art. For the Romantics themselves, the solutions could range from the creation of a whole new language of private religious symbols, as in Blake's and Runge's complex iconographic systems, to the evocation, through such observable Christian phenomena as Gothic architecture, crucifixes, monks, or pious peasants, of a nostalgia for a long-lost world concerned with transcendental values. Or, even more often, this pursuit of the supernatural could be redirected to the observation of nature itself, whose every manifestation, from the most common wildflower to the most uncommon mountain summit, could provide a glimpse of divinity. It is a telling fact that many Northern Romantic landscape painters, whether major or minor, blurred the distinction between a natural and a supernatural subject, so that Turner, for example, could permit an angel or the biblical Deluge itself to congeal from his images of molten, glowing light, and the American Thomas Cole could paint mountains, cataracts, or blasted trees scrupulously observed in the Catskill mountains and then, on occasions, populate these sublime vistas with such biblical motifs as the *Expulsion of Adam and Eve* or *St. John in the Wilderness*.

But this search for a new means of conveying religious impulses in which nature alone, even without overt religious motifs, could reveal a transcendental mystery, hardly expired with the Romantics. For many late nineteenth-century artists, too, especially those of Protestant origins in Northern Europe or America, the rechanneling of religious experience outside the traditions of Christian art was a constant goal. Van Gogh, Hodler, and Munch all explored, in different ways, the sense of divinity in landscape, whether through the miraculous energies of sun, stars, and moon or through boundless voids seen from mountain heights, virgin meadows, and desolate shores. And they all, too, attempted to create a more specifically religious art, whether by resurrecting, as in Van Gogh's case, old-master Christian paintings experienced with a new intensity gleaned from landscape, or by inventing, as in Munch's and Hodler's case, new symbolic themes that

288 ALBERT PINKHAM RYDER
Jonah
c. 1885

related man to the cyclical destinies of nature's forces. Similarly, an American master of this late nineteenth-century generation, Albert Pinkham Ryder, could also paint the phenomena of sea, sky, and moonlight with such awareness of their supernatural potential that it was easy for him to
288 convince us, as in his *Jonah*, that a biblical miracle could take place within the magical environment he usually created in terms of landscape alone.

This capacity to blur the distinctions between landscape and religious painting, between the natural and the super-natural, continued even beyond these late nineteenth-century survivals and revivals of Romantic traditions, and in fact, flourished well into the twentieth century. Masters like Marc and Nolde studied the natural world—flowers, landscapes, animals—but could also translate these motifs into pictures of
210 overtly religious symbolism, as in Marc's *Tyrol*, with its mountain-top vision of the Madonna and Child, or Nolde's
203 *The Great Gardener*, with its folklike image of God nurturing terrestrial flowers. And in the case of Kandinsky and Mondrian, not to mention such minor pioneers of abstract painting as Čiurlionis and Kupka, a whole new world of esoteric religious iconography culled from such occult sources as Theosophy and spiritualism provided, together with land-scape imagery, the matrix for a totally abstract pictorial language that was meant to create what were virtually spiritual icons for new, mystical religions.

These impulses emerged yet again in the United States in the years directly following another historical event of apocalyptic dimensions and implications, the Second World War. In the work of many, if not necessarily all of that

diverse group of American artists who, for want of a better name, are loosely classified together as 'Abstract Expressionists,' the Romantic search for an art that could convey sensations of overpowering mystery was vigorously resurrected, at times, as in the case of Mark Rothko and Barnett Newman, with explicit religious associations.

Although the new power and communal energy of artists like Still, Pollock, Rothko, and Newman persuaded many spectators that their forms and emotions were unprecedented in the history of Western painting, in retrospect their art often reveals not only deep roots in Romantic traditions in general, but in American traditions in particular. A revealing case in point is the work of Augustus Vincent Tack, an artist who was admired, collected, and exhibited by Duncan Phillips in the period between the two wars. Although Tack's work could always be seen in the Phillips Gallery in Washington, it somehow elicited not even passing comment in histories of twentieth-century American art. But thanks to a circulating exhibition in 1972, Tack's work has suddenly commanded fresh attention as a connecting link between the generation of Abstract Expressionists which emerged after 1945 and some earlier traditions of American painting.[1] In fact, Tack's work also seems to perpetuate on American soil any number of forms and intentions we have been tracing in Northern Romantic traditions. Already by the 1920s Tack was painting sublime landscapes that, like those of Kandinsky and Mondrian, were not only mystical in implication but could even translate the natural world into a vehicle for approaching the supernatural. Tack himself, visiting the Rocky Mountains, spoke of 'a valley . . . walled in by an amphitheater of mountains as colossal as to seem an adequate setting for the Last Judgment,'[2] and found, in paintings like *Voice of Many Waters* of 1924, a means of reducing these ragged, geological configurations into patterns that hovered between total abstraction and compelling icon that might invoke the religious experiences he himself had inherited as a Roman Catholic but had then expanded to universal dimensions in his exploration of Oriental religions and perhaps even Theosophy.

It was easy for Tack to translate these transcendental experiences of nature into images that could support supernatural content, such as *Christmas Night* of 1932, in which, as in Marc's *Tyrol*, heaven and earth join forces to evoke a Christian mystery. Within a golden oval border that suggests the mandorla of a Byzantine mosaic of the Virgin, Tack describes the fusion of a celestial blue sky with the brown earth below, as if the coming of Christ could be conveyed through landscape imagery alone. Tack's most enthusiastic supporter, Duncan Phillips, described exactly this quality of

289

290

divinity in nature when, in 1928, he commented on Tack's painting, *Storm*: 'We behold the majesty of omnipotent purpose emerging in awe-inspiring symmetry out of thundering chaos. . . . It is a symbol of a new world in the making, of turbulence stilled after tempest by a universal God.'[3] Phillips's statement is one that touches on many of the

291

289 AUGUSTUS VINCENT TACK
Voice of Many Waters
1924

290 AUGUSTUS VINCENT TACK
Christmas Night
1932

291 AUGUSTUS VINCENT TACK
Storm
before 1928

major questions and solutions inherited from Northern Romantic art, expressing as it does the search for some deity in the most overwhelming phenomena of nature, and pin-pointing two of the visual extremes so common to the Romantic tradition, 'thundering chaos' and 'awe-inspiring symmetry'—extremes that could often define the structural and emotional polarities of the landscape painting of Turner and Friedrich, of Van Gogh and Hodler, of Kandinsky and Mondrian. Tack himself could move, in his art, from the sublime chaos of *Storm* to the equally sublime symmetry of an explicitly religious painting, an *All Souls* triptych, whose 292 shadowy and diminutive Christian personages almost dissolve within a celestial blue void. The structure of this work is daringly elementary—a small, centralized Christ hovers in a sea of blue that is shaped only by the tripartite, golden frame, so redolent of traditional religious triptychs.

The structural duality between such a work, with its objectless hazy void of silent, stunning symmetry, and Tack's other quasi-abstract visions of storms and landscapes, with their craggy, unpredictable shapes that meander into infinite expanses, is exactly that which one finds at the extremes of the vocabulary of those Abstract Expressionists whose art seems predicated upon the imagery of landscape. On the one hand, there is the 'awe-inspiring symmetry' of Rothko's luminous voids; on the other, the no less immaterial images of a kind of 'thundering chaos'—swirling vortices of pure

292 AUGUSTUS VINCENT TACK
All Souls
c. 1939

energy or equally organic images of changing shapes that
evolve erratically, like clouds or stalactites, in an elemental
universe. The latter kind of configuration suggests not only
those quasi-abstract landscapes and skyscapes of Tack that
were inspired by the sublime storms and mountains of the
American West, but also the art of Clyfford Still. Indeed, a
293 characteristic Still of the 1950s has its closest visual and
294 emotional precedent in Tack's *Spirit of Creation* (or *Time and
Timelessness*), a painting which, especially when aggrandized
to the size of a fire curtain in the Lisner Auditorium, at George
Washington University, for which it was designed, could
expand its abstractly conceived and painted message of the
first moments of a universal genesis into the heroic dimen-

293 CLYFFORD STILL
Untitled
1957

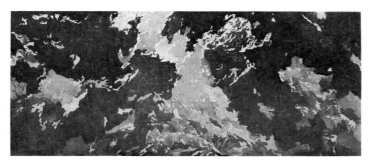

294 AUGUSTUS VINCENT TACK
*Spirit of Creation (Time and
Timelessness)*
1944

sions of Still's own art. These irregular patterns, abstracted from the shapes of such incommensurable elements of nature as clouds and mountains, provide in Still's work, as they do more literally in Tack's *Spirit of Creation*, a metaphor of some primeval chaos in which no human presence or will has yet intruded. It is an image which, in its form and its cosmological evocations, is a deeply ingrained one in the Romantic tradition, especially in American painting. And it not only recalls Tack's earlier and more geographically specific views of such desolate, uninhabited sites as the Amargosa Desert, but the works of other American artists who, like Tack, came to maturity between the two world wars.

Georgia O'Keeffe, for one, often painted the same sublime sites in the American West, describing those breathtaking infinities of unspoiled nature where the absence of human beings prevents us from determining whether we are looking at mountains or mole hills. At times, as in *Red Hills and Bones* 295 of 1941, she includes in this uninhabited desert landscape, remote from man, his history, and his works, the bleached and dried remnants of an animal skeleton, a fossil fragment that affirms the metaphor of a prehistoric landscape and that perpetuates, in its ambiguous size (is it much larger or much smaller than a man?), that characteristic Romantic sense of scale which leaps from the microcosm to the macrocosm, from the infinitely large to the infinitely small.

Although O'Keeffe's vistas of a primeval nature were inspired, like many of Tack's, by specific sites in the American West, their vast, uncharted spaces are reflected in Still's huge expanses of paint that translate the experience of a sublime, desolate landscape into the language of pure abstraction. His tar-like surfaces, whose ragged edges seem to spread unpredictably, evoke associations of organic change in trees, rocks,

295 GEORGIA O'KEEFFE
Red Hills and Bones
1941

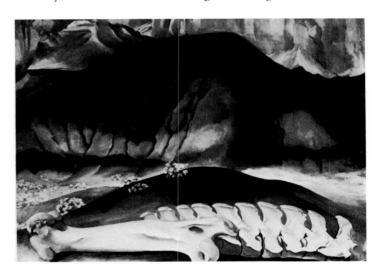

or sky; and it is worth noting that Still himself claimed that the fluid and flame-like vertical shapes in his abstract paintings were influenced by the shapes of the Dakota plains where he was born,[4] and that he had actually painted landscapes of the American West in the 1930s.[5] As such, even his abstract paintings are understandably marked by the particular feeling of almost primeval immensity and openness common to much of the landscape in the American West. It was a landscape that not only provided a direct stimulus to Tack, O'Keeffe, and others of their generation, but also to a rich late nineteenth-century tradition in American painting that perpetuated uninterruptedly earlier nineteenth-century landscapes of the sublime. Of the many examples of this native tradition, which includes masters like Albert Bierstadt, Thomas Moran, and 296 Frederic Edwin Church, one—Bierstadt's view of *Lake Tahoe* (1868)—may characterize the genre: a forest primeval, where infinite, immeasurable distances of pure lakes and craggily silhouetted mountains reduce the spectator to insignificant size and place him before the unfathomable majesty of untamed nature.

The American landscape, with its abundance of sublimities, was particularly conducive to the later flourishing of this Romantic tradition that would continue from Bierstadt and his late nineteenth-century contemporaries down to artists like O'Keeffe and Tack, and ultimately, to Still; but the tradition, of course, was born of European Romanticism. Thus, in terms of its sheer enormity of size, numbing scale, wildly irregular silhouettes, and abrupt luminary contrasts, it is James Ward's depiction of the Yorkshire sublimity, 14 *Gordale Scar*, that comes closest to Still's vast abstractions of

296 ALBERT BIERSTADT
Lake Tahoe
1868

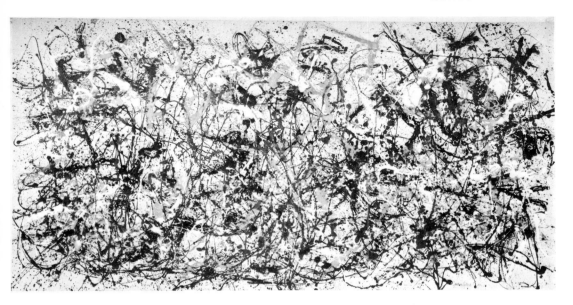

297 JACKSON POLLOCK
Autumn Rhythm
1950

the 1950s, whose very dimensions frequently approximate those of Ward's gargantuan canvas, i.e., about eleven by fourteen feet.

The genealogical table that can be constructed for the erratic configurations and gigantic scale of Still's paintings would seem to lead back through the history of Romantic landscape painting. The situation is also the same for much of the work by Jackson Pollock, whose images, like Still's, may be abstract but nevertheless elicit metaphors within a range of natural, organic phenomena rather than evoking the rational constructions of the intellect. Indeed, the classic Pollock of the late 1940s and early 1950s almost becomes a 297 spectacle of nature, a whirlwind vortex of sheer energy that may take us to the cosmological extremes of microscopic and telescopic vision—glimpses of some galactic or atomic explosion, or in more terrestrial terms, the overpowering forces of nature's most impalpable elements, air, fire, and water. These metaphors are borne out not only by Pollock's occasional titles with their suggestions of natural phenomena —*Full Fathom Five, Ocean Greyness, The Deep, Autumn Rhythm*—but, as in the case of Still, by the fact that his earlier, pre-abstract work often attempted to grasp in paint on canvas the ungraspable forces of nature. Thus, even before 1947, when, with his famous technique of pouring rather than brushing paint on canvas, he succeeded in dematerializing even further the skeins of agitated energy and shimmering color that obsessed his imagination, he often chose subjects in nature that offered a maximum of elemental force and impalpability. Such was the case in *The Flame*, (c. 1937), a small 298 oil painting that attempts, clumsily but powerfully, to create

298 JACKSON POLLOCK
The Flame
1937

a metaphor of fiery, molten energy, as close to primal chaos
as the earthquake landscapes of the early Kandinsky. Still
299 earlier, one finds small, intense oils like *Seascape*, of 1934,
which, in its sense of a storm-tossed drama, where moonlight
and streaked skies are confounded with a tiny sailboat and a
tempestuous, white-capped sea, reminds one of the fact that,
at the time, Pollock admired most, of his American pictorial
ancestors, Albert Pinkham Ryder.[6]

Indeed, Ryder's art, even within its literally small format,
often seizes the immensities of elemental forces in a manner
prophetic of Pollock's search for a structure and a technical
means that would convey the overwhelming energies and
300 velocities of nature. In the *Flying Dutchman*, inspired by
Wagner's opera, Ryder strains oil paint to a point of veil-like
impalpability that confounds the distinction between waves,
wind, masts, and sails in a ghostly fusion appropriate to the
phantom subject. And the churning, vortical tempests of
wind and water also prefigure Pollock's structures of end-
lessly gyrating rhythms that become the metaphors of some
primal power. Once again, the ultimate source for this con-
figuration in the traditions of modern painting lies within the
domain of Northern Romantic landscape painting, especially
in the work of those British Romantics like John Martin,
Francis Danby, and Turner, who were haunted by apocalyp-
tic visions that turned matter and the works of man into
swirling, cosmic upheavals. Turner, in particular, offers close
analogies to Pollock in the way he strove throughout his life
to achieve a pictorial means that would transcend the rela-
tively literal description of unleashed, destructive nature in
his early scenes of avalanches or snowstorms and to create
finally, as in his late works of the 1840s, a vision of vortical
energy so torrential and so immaterial that it becomes

possible to bridge the imaginative gulf between the depiction of a specific storm at sea and the biblical Deluge. No other artist before Pollock had been so successful in transforming palpable paint into shimmering whirlwinds of impalpable energy. Turner, like Pollock, metamorphosed matter into some ultimate, insubstantial element of nature, an overwhelming power that evokes cosmological archetypes. As William Hazlitt described Turner's work: They are pictures of the elements of air, earth, and water. The artist delights to go back to the first chaos of the world, or to that state of things when the waters were separated from the dry land, and light from darkness, but as yet no living thing nor tree bearing fruit was seen upon the face of the earth. All is without form and void. Some one said of his landscapes that they were *pictures of nothing and very like.*[7] It is a description that could well apply to the ostensibly formless imagery of a Pollock, a Newman, or a Rothko.

Such a search for primal myth and nature characterized many of the Abstract Expressionists, as it had, before, many of the Northern Romantics. Like the typical, signature painting of Pollock or Still, that of Adolph Gottlieb seems to distill some elemental phenomenon of nature, in his case what appears to be a celestial body—sun, moon, distant planet— that has just taken form from the kind of explosive energies that characterize the more shapeless burst below. In the 1940s, Gottlieb, like Pollock and Still among others, had searched for more literally mythic images, whether in American Indian pictographs, Jungian archetypes, elemental Greek myths, or more private cosmogonies, but soon this search for pure, unspoiled origins, so like that of the Romantic exploration of esoteric, exotic, primitive, or personal mythologies, was even further reduced to the more overtly abstract images that evoke far less specifically a moment in the Book of Genesis. Gottlieb's fascination with heavenly orbs, which glow with mysterious color and which, in their atmospheric halos and imprecise contours, are still in the process of being formed from some molten substance, is in some ways the abstract translation of that pagan sun and moon worship so ubiquitous among Northern Romantic landscape painters as well as among their heirs in late nineteenth- and twentieth-century art. Typically, Gottlieb's unidentifiable planets from a mythic universe take their places in the top center of a vertical format, a structure that imposes an heraldic centrality as appropriate here to the mythic content as it is in many Romantic cosmogonies.

The specific sense in Gottlieb's work of an almost religious translation of the natural phenomenon of a celestial body into a starkly simplified icon is one that has many parallels in earlier European art, but it is worth noting, too, that as in the case of

299 JACKSON POLLOCK
Seascape
1934

300 ALBERT PINKHAM RYDER
Flying Dutchman
1887

301

301 ADOLPH GOTTLIEB
Thrust
1959

Still's analogies with American painters of an earlier twen-
tieth-century generation, Gottlieb may also be related to
more native American traditions. In particular, many of the
lunar fantasies of Arthur Dove, for all their relatively 302
diminutive size by comparison with the typically imposing
dimensions of American abstract painting of the 1950s, pro-
vide prototypes for Gottlieb's luminous orbs. In Dove's many
pictorial hymns to the pagan mysteries of the moon, this
silvery disc is seen as a glowing light in the heavens, hovering
above a landscape of primal, mythical simplicity; and often,
a tree reaches up to embrace, like a worshipper, its impalpable
luminosity within its own branches.[8] Dove's reductions of an
already elemental nature result in shapes so abstracted from
literal landscape description that they verge, like Gottlieb's,
on the symbolic, as if nature's primary forces—earth, sky,
moon—had been transformed into the icon of a new nature
religion.

The same may be said of some of Georgia O'Keeffe's
transformations of primary phenomena in nature into

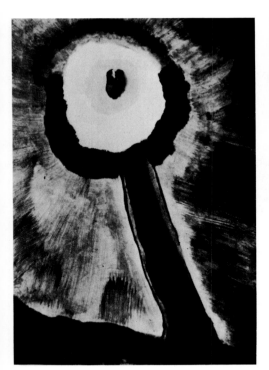

302 ARTHUR DOVE
Moon
1935

303 GEORGIA O'KEEFFE
Evening Star III
1917

303 almost heraldic patterns. In such a watercolor as *Evening Star, III* of 1917, she, too, distills the polarity of the earth below and a luminous heavenly body above into a simplified emblem that recalls nature in some primeval state, where liquid light and color have not yet congealed into matter and discrete objects. But Gottlieb's iconic orbs, presiding over an unspoiled, primitive landscape, find their echoes not only in an American tradition that goes back through Dove and O'Keeffe to Ryder's moonlit visions but also in a thoroughly international tradition. One thinks in the twentieth century not only of the frozen discs that dominate Ernst's extraterrestrial forests, but of the molten ones that animate the alternately serene or turbulent landscapes of the early Mondrian and the early Kandinsky. And in this ancestral table, one would also find the enrapt visions of sun and moon that control the life on Van Gogh's earth and Munch's sea coasts. Finally, the archetypes of this pagan deity are seen in the enchanted landscapes of the Romantics, in the moons and suns that, in Palmer, take on the role of fertility goddesses in a pastoral of mythic bounty or that, in Friedrich, illuminate dimly the distant realms of spirit that lie beyond this terrestrial world.

Gottlieb's pursuit and capture of an elemental image was typical of the quest of his American contemporaries in the 1940s who were constantly searching for a universal symbol that could encompass an irreducible truth. Like so many Romantics, they wished to start from scratch. Indeed, Still's sense of an oppressive, moribund tradition of Western art ('We all bear the burden of this tradition on our backs but I cannot hold it a privilege to be a pallbearer of my spirit in its name'[9]) virtually duplicates that of Runge in his wish to reject the heavy baggage of history. What was sought by these 'Myth Makers' (as Rothko was to refer to Still and this group in 1946)[10] was virtually a new pictorial cosmogony and a new, elemental style that could come to terms with the need for, in Rothko's words, 'tragic-religious drama.'[11] And in the years just before and after the apocalyptic conclusion of the Second World War, this need for purification and regression must have been as acute as it was for artists like Marc and Kandinsky on the eve of the First World War.

So total a regeneration of form and content was nowhere demonstrated more fervently than in the work of Barnett Newman. Beginning about 1946, that is, in the aftermath of Hiroshima, Newman explored a world of new cosmogonies that recall, in many ways, William Blake's passionate efforts, at a time of revolutionary hope and despair, to reconstruct a new quasi-religious imagery of primal creative force. In 1946 Newman drew and painted a series of variations on circular

304 forms that, even without such titles as *Genesis— The Break* (1946), *The Beginning* (1946), or *Genetic Moment* (1947),

304 BARNETT NEWMAN
Genesis— The Break
1946

305 BARNETT NEWMAN
The Command
1946

convey an image of mythic origins, the beginnings of life or the emergence of the universe from chaos. These circular forms seem to be seized in the process of becoming, primal shapes that are slowly congealing from boundless, inchoate energies, as if we were witnessing the first day of Creation, before the distinction between solid and void, the formed and the unformed, had been made. The intrusion of a divine, shaping force in this environment of formless infinities began to be made more explicit in works like *The Command* of 1946, 305 where a shaft of piercing white light rends asunder two differentiated areas of what seem like mythic elements—a symbolic translation of water or earth, air or fire. The searing beam that cuts through these fields of primordial stuff may well be inspired, as Thomas Hess has suggested, by a metaphor in the Kabbalah—'with a gleam of His ray he encompasses the sky and His splendor radiates from the heights'[12]—but again, even without such a specific verbal reference, one senses here an image of primal creative force. In both its effort to provide a visual metaphor for divine creation and in its passionate insistence on projecting spaces of boundless sublimity, Newman's *Command* bears comparison with Blake's *Ancient of Days*, who emerges from fearful chaos and, 45 with his piercing compasses—more shafts of light than palpable matter—imposes a shaping will upon the universe's shapeless beginnings.

Tellingly, both Blake and Newman, for all the seeming structural lucidity of their work, rebelled against the idea of geometry, for it represented to them a rational system that narrowed form and experience into the finite and the commensurable. Blake's *Ancient of Days*, like his *Newton* of 1795,

is, in effect, an evil force, imposing trivial clarity in a sublime universe. For Newman, too, geometric form was anathema. He not only disliked Mondrian, undoubtedly confusing the master's influence on American disciples, who propagated geometric abstraction, with the profoundly antigeometric character of Mondrian's abstract art, but he painted what were virtually symbolic manifestos against the principles of geometry in art, the *Euclidean Abyss* (1946—47) and the *Death of Euclid* (1947). Tidy pictorial structures of rectangles, aligned in parallel and perpendicular relations, appeared to Newman as a petty abstract art that stood in opposition to the unlimited spaces, the vertical forces without beginning or end, that he began to use to elicit sensations of sublimity.

In 1948 Newman published an essay, 'The Sublime Is Now,' in *The Tiger's Eye*,[13] which had organized a symposium on the topic of the Sublime. Newman's exploration of this aesthetic category that went back to Edmund Burke and Longinus bore out the experience he had earlier evoked that
306 year in his *Onement, I*, a painting that dared the kind of 'fearful symmetry' which Blake himself had named and illustrated and which provided a compositional system for many other artists in the Northern Romantic tradition— Blake, Runge, and Friedrich; Hodler and Munch; the early Mondrian—who were similarly concerned with the expression of some ultimate, indivisible mystery in nature. Newman's *Onement, I* of 1948, the first of a series by this title, already transmits, in surprisingly small dimensions, the effect of sublimity that Newman would explore and aggrandize until the end of his life. The stark bisection of a colored field with a vibrant vertical shaft of glowing, fiery light suggests again the domain of primal creation, and it has even been proposed that the imagery alluded to in the title is related to Kabbalistic texts describing the first creation of man.[14] At the very least, Newman's painting is as drastic an image and
21 structure as Friedrich's vision of the beginning of the universe, a drawing in which the field is bisected horizontally and the glow of the rising sun conveys the coming of order into chaos. Such cosmic visions of a void suddenly energized by a primordial force or will were expressed most potently by the radical simplicity of Friedrich's symmetrical structure, just as in Newman, the centralized vertical 'zip,' as he called it, created an image of indivisible strength, a single line of energy that cuts across a void, like an abstract re-creation of genesis.

It must be stressed that the symmetry of the *Onement* series is distinct from the Euclidean geometry Newman—and, for that matter, Blake—detested; for its clarity is of a sublime character. None of the forms or spaces is bounded. By implication, the vertical zip extends infinitely above and

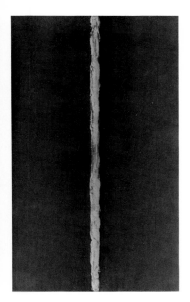

306 BARNETT NEWMAN
Onement, I
1948

below the canvas, just as the monochromatic field expands in all directions beyond the canvas edges. The linear axis and the shapeless void are endless, unlimited by the predictable systems of geometry. Matter and objects are as thoroughly excluded from this visionary sphere as they are from the work of Mondrian, who shares with Newman not only the sense of infinite radiance but also the triumphant annihilation of matter whereby both the open ground planes and the lines that cross them seem thoroughly impalpable, fields of spirit and paths of energy rather than earthly substances.

The symmetry of Newman's *Onement* series is overt, but, as Thomas Hess has proposed, even his overtly asymmetrical paintings may be dominated by a 'secret symmetry,'[15] that is, a covert structural system that may be perceived as a magnetic force of ultimate, centralized order beneath the asymmetry of the surface. Inevitably, the starkness of Newman's pictorial vocabulary produces, as in the case of Mondrian's, so elementary and so potent an effect that we feel that each variation of this primal theme is only one degree removed from a rockbottom statement of absolute indivisibility. As in Mondrian's *Pier and Ocean* series, where the surface variations seem to adumbrate a covert cruciform structure, Newman's variations of vertical linear energy against an open field imply the first statement of the theme, which he himself reiterated in the overt symmetry of the *Onement* series.

Like Blake and many other Romantics, Newman sought mystical inspiration in a variety of religious sources that transcended the confines of a particular sect, for the doctrine of any individual religion was too limiting for his universal ambitions. In his quest for new cosmogonies, he explored not only the question of myth-making among primitive peoples and among the Greeks, but a wide range of literature from the Judaeo-Christian tradition, from the Kabbalah and the Old Testament to the story of the Passion as represented in the traditional narrative sequence of the Stations of the Cross. Within this domain of comparative religion, however, Newman always pursued the sublime and the visionary, dealing with the ultimate mysteries of creation, of divinity, of death and resurrection, just as the landscape references in his titles—*Horizon Light, Tundra*—pertain to those experiences of unbounded nature that, for the Romantics, too, became metaphors of supernatural mysteries.

Working within an abstract vocabulary that was to chart these spiritual territories, Newman could of course only suggest, by association, the particular texts that inspired him; but knowledge of his titles and their sources can often enrich the abstract metaphor. In *Cathedra*, for example, the title 307 refers to a passage in Isaiah (VI, 1)—'I saw also the Lord

307 BARNETT NEWMAN
Cathedra
1951

sitting upon a throne, high and lifted up, and the train of His mantle filled the Temple'[16]—and if only by its sheer dimensions (about eight by eighteen feet), the painting virtually immerses the spectator in a sea of celestial blue that, like the pervasive blues in the Romantic tradition, from Friedrich and Carus down to the masters of the Blue Rider, evokes a boundless spiritual domain where an invisible divinity might reside. In the *Stations of the Cross* series,[17] Christian narrative replaces Jewish symbolism. Here the ultimates pertain to death and resurrection, evoked by the primal duality of black and white, and of taut linear forces that, like paths of feeling, quiver and strain against a field of raw canvas, translating the sequence of Christ's martyrdom into irreducible, abstract metaphors, and totally transforming the corporeal Passion into a spiritual one.

That Newman himself was Jewish may in part account for his desire and capacity to present such religious themes in abstract terms;[18] for the Jewish tradition of proscribing graven images would have supported, unlike Catholic traditions of religious art, the possibility of Newman's creating totally incorporeal images of the Lord, of Adam or Eve, of Abraham or Christ. The sense of divinity in boundless voids, where figures, objects, and finally matter itself are excluded, belongs to a Romantic tradition primarily sustained by non-Catholic artists—Protestants, Jews, or by members of such modern spiritualist sects as Theosophy—for the iconoclastic attitudes of these religions were conducive to the presentation of transcendental experience through immaterial images, whether the impalpable infinities of horizon, sea, or sky or their abstract equivalents in the immeasurable voids of Mondrian or Newman.

Mark Rothko, who, like Newman, was Jewish, also

308 BARNETT NEWMAN
The Stations of the Cross, the First Station
1958

belongs fully to this tradition, carrying as he does the annihilation of matter and the evocation of an imprecise yet mystical content to an extreme that parallels Newman's. Like Newman and, in fact, like Pollock, Gottlieb, and Still, Rothko evolved the archetypal statement of his abstract painting—those hovering tiers of dense, atmospheric color or darkness—from a landscape imagery of mythic, cosmological character; but he was also attracted to what he was later to describe as '. . . pictures of a single human figure—alone in a moment of utter immobility,'[19] a description that, tellingly, could apply to many paintings by Friedrich himself. By 1950, Rothko had reached that stark format he was to explore, 309 with variations, for the remaining two decades of his life, an image that, like Newman's, locates the beholder at the brink of a resonant void from which any palpable form is banned.

309 MARK ROTHKO
Number 10
1950

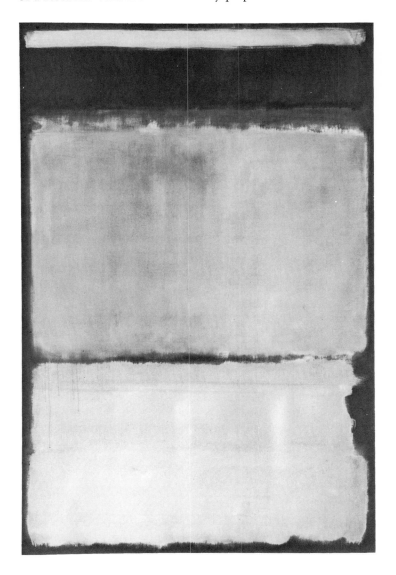

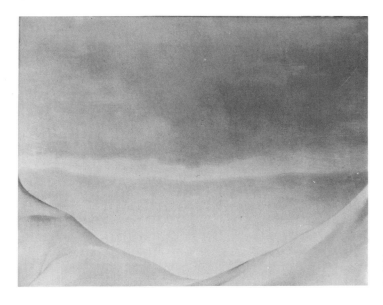

310 GEORGIA O'KEEFFE
Red Hills and Sky
1945

Instead, there are metaphorical suggestions of an elemental
nature: horizontal divisions evoking the primordial separa-
tion of earth or sea from cloud and sky, and luminous fields
of dense, quietly lambent color that seem to generate the
primal energies of natural light. Rothko's pursuit of the most
irreducible image pertains not only to his rejection of matter
in favor of an impalpable void that wavers, imaginatively,
between the extremes of an awesome, mysterious presence or
its complete negation, but also to his equally elementary
structure, which, as is often the case in Newman, is of a
numbing symmetry that fixes these luminous expanses in an
emblem of iconic permanence. As drastic as these reductions
may seem, they again find many precedents in artists working
within those Romantic traditions that would extract super-
natural mysteries from the phenomena of landscape. Even
within earlier twentieth-century American art, Rothko's
symmetry and luminous emptiness find precedents in Georgia
310 O'Keeffe, who, both in large late paintings like *Red Hills and*
311 *Sky* of 1945 or in early small watercolors like *Light Coming on*
the Plains, II of 1917, distilled the components of a primitive
landscape experience to an almost abstract image. And in
more international terms, one thinks back not only to such
other twentieth-century views of primal nature that place us
on the brink of a symmetrical abyss—many of Mondrian's
dunescapes, for example—but also to Hodler's and Munch's
symmetrical views of sun, sea, or sky, beheld from the edge
of a coast or a mountain top. And ultimately, the basic con-
figuration of Rothko's abstract paintings finds its source in
the great Romantics: in Turner, who similarly achieved the

311 GEORGIA O'KEEFFE
Light Coming on the Plains, II
1917

dissolution of all matter into a silent, mystical luminosity; in Friedrich, who also placed the spectator before an abyss that provoked ultimate questions whose answers, without traditional religious faith and imagery, remained as uncertain as the questions themselves.[20]

The visual richness of Rothko's paintings has often fostered the idea that they are exclusively objects of aesthetic delectation, where an epicurean sensibility to color and formal paradoxes of the fixed versus the amorphous may be savored. Yet their somber, mysterious presence should be sufficient to convince the spectator that they belong to a sphere of experience profoundly different from the French art-for-art's sake ambience of a Matisse, whose expansive fields of color may nevertheless have provided the necessary pictorial support for Rothko's own achievement (much as Parisian Cubism provided the means for Mondrian's anti-Cubist, mystical ends). But even without the emotional testimony of the pictures themselves, there is Rothko's statement of a passionately antiformalist and antihedonist position:

I am not interested in relationships of color or form or anything else. . . . I am interested only in expressing the basic human emotions—tragedy, ecstasy, doom, and so on—and the fact that lots of people break down and cry when confronted with my pictures shows that I *communicate* with those basic human emotions. The people who weep before my pictures are having the same religious experience I had when I painted them. And if you, as you say, are moved only by their color relationships, then you miss the point![21]

Fortunately, the implicit religious experience' of Rothko's art—to use his own phrase—was, on one occasion at the end of his life, made magnificently explicit in the project envisioned and then realized by private patrons, Mr. and Mrs. John de Ménil.[22] Already recognizing in Rothko's art the expression of experiences that lay beyond the aesthetic and then seeing, in 1964, the dark and somber paintings that the artist justifiably found to be inappropriate solutions to his commission for decorative work at an elegant New York restaurant, the Four Seasons, the de Ménils conceived the idea of a separate chapel, to be built in Houston, Texas, where a group of Rothko's paintings might function in a quasi-religious way. There Rothko's art could inspire the kind of meditation which was elicited less and less in the twentieth century by conventional religious imagery and rites. That Rothko's paintings—or for that matter, Newman's—could not properly function within the ritualistic traditions and iconographic needs of a church or synagogue is both a tribute to their originality in the expression of spiritual experiences and a reflection of the dilemma that riddled the work of so many artists since the Romantics who tried to convey a sense

of the supernatural without recourse to inherited religious imagery.

312 Rothko Chapel, Houston, Texas

It was appropriate, then, to the unspecified religious character of Rothko's work that the paintings commissioned by the de Ménils would finally have to be contained within a secular rather than a conventionally sacred shrine, just as the quasi-religious landscapes of a Friedrich, a Van Gogh, or a Mondrian could never have been accepted by the Church, even though their evocation of ultimate mysteries might be far more persuasive than those in orthodox modern Christian art. And it was appropriate, too, that at the opening of what is now called the 'Rothko Chapel' (which was originally part of a philanthropic organization, the Institute of Religion and Human Development), there was a wide, ecumenical range of religious leaders from both Western and Eastern faiths. At the dedication ceremony on 27 February 1971, there were present the chairman of the Central Conference of Rabbis, an imam who represented Islam, Protestant bishops, a bishop from the Greek Orthodox Church, and, as personal ambassador of the Pope, a Roman Catholic cardinal. And, in less official terms, subsequent visitors of a Zen Buddhist persuasion could find the uncanny silence and mystery of the chapel conducive to the practice of Yoga meditation.

The idea of a chapel in the modern world that was to convey some kind of universal religious experience without subscribing to a specific faith was, in fact, a dream that originated with the Romantics. Runge himself, after all, had 48 planned his *Tageszeiten* series as a sequence of new religious icons that were to be housed in a specially designed chapel 24 with specially composed music; and Friedrich's *Tetschen Altar*, while alluding to more traditional Christian iconography, would still have been too heretic in its personal interpretation of the Crucifixion to be acceptable anywhere but in a private chapel. More generally speaking, the most passionate religious art of the Northern Romantics—Blake or Palmer, Friedrich or Runge—was usually so unconventional in its efforts to embody a universal religion outside the confines of Catholic or Protestant orthodoxy that it could only be housed in chapels of the artists' dreams or in a site provided by a private patron. And this problem generated by the Romantics is no less acute in the late twentieth century. What Catholic church would hang Newman's *Stations of the Cross*, but what art museum seems sufficiently sanctified to house them?

312 The Rothko Chapel perpetuates these Romantic difficul-
313 ties of providing an authentic religious experience in a
314 modern world of doubt. In both architectural and pictorial terms it does so by allusion to essentially moribund religious traditions. The octagonal plan of the building—first pro-

313 Rothko Chapel, Houston, Texas

314 Rothko Chapel, Houston, Texas

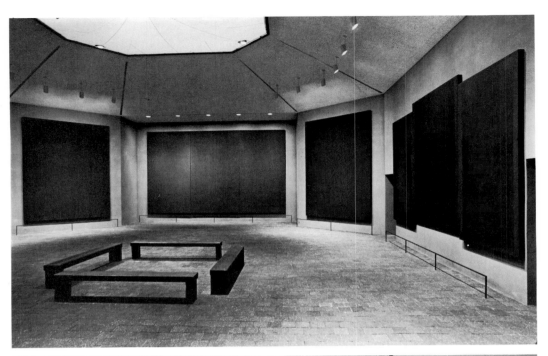

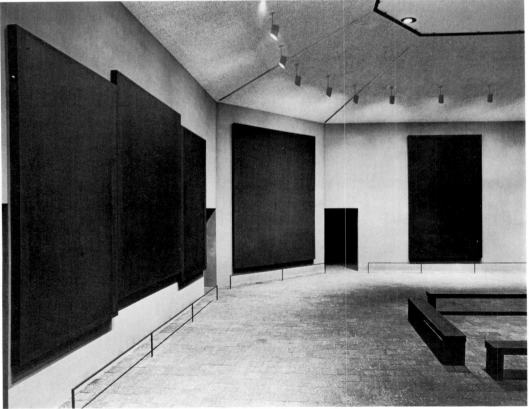

jected by Philip Johnson but then altered by Howard Barn-
stone and Eugene Aubry—evokes the form of a Catholic
baptistery, such as the eleventh-century baptistery at Torcello
which actually inspired it. And the paintings, too, evoke a
traditional religious format, the triptych, a format that Tack
had almost emptied of its Christian subject in his *All Souls*
triptych, whose deep blue voids prefigure Rothko's dark and
resonant spaces.[23] On three of the chapel's eight walls—the
central, apse-like wall, and the facing side walls—Rothko
provided variations on the triptych shape, with the central
panel alternately raised or level with the side panels. Yet these
triptychs, in turn, are set into opposition with single panels,
which are first seen as occupying a lesser role in the four angle
walls but which then rise to the major role of finality and
resolution in the fifth single panel which, different in color,
tone, and proportions, occupies the entrance wall, facing, as
if in response, the triptych in the apse. It is as if the entire
content of Western religious art were finally devoid of its
narrative complexities and corporeal imagery, leaving us
with these dark, compelling presences that pose an ultimate
choice between everything and nothing. But the very fact
that they create their own hierarchy of mood, shape, and
sequence, of uniqueness and duplication, of increasingly dark
and somber variations of plum, maroon, and black, suggests
the presence here of some new religious ritual of indefinable,
yet universal dimensions. And in our secularized world,
inherited from the Romantics, a world where orthodox
religious ritual was so unsatisfying to so many, the very lack
of overt religious content here may make Rothko's surrogate
icons and altarpieces, experienced in a nondenominational
chapel, all the more potent in their evocation of the transcen-
dental.

With this in mind, one may again raise the question with
which this book began: are the analogies of form and feeling
between Friedrich's *Monk by the Sea* and a painting by Rothko
merely accidental, or do they imply a historical continuity
that joins them? To which, perhaps, another question might
be posed: could it not be said that the work of Rothko and
its fulfillment in the Houston Chapel are only the most recent
responses to the dilemma faced by Friedrich and the Northern
Romantics almost two centuries ago? Like the troubled and
troubling works of artists we have traced through the nine-
teenth and twentieth centuries, Rothko's paintings seek the
sacred in a modern world of the secular.

Notes on the text

Foreword

[1] The interested reader can find my earlier thoughts on this complex topic in the following texts (listed in chronological order): *Cubism and Twentieth-Century Art*, New York and London, 1960, Chapters VIII (Cubism and the German Romantic Tradition) and X (Cubism and Abstract Art: Malevich and Mondrian); 'The Abstract Sublime,' *Art News*, LIX, February 1961, pp. 38ff. (reprinted in Henry Geldzahler, *New York Painting and Sculpture: 1940–1970*, New York, 1969, pp. 350–59); 'Notes on Mondrian and Romanticism', in *Piet Mondrian, 1872–1944* (catalogue by Robert P. Welsh), The Art Gallery of Toronto, 1966, pp. 17–21 (reprinted in *Art News*, LXIV, February 1966, pp. 33–7+); 'Caspar David Friedrich and Modern Painting', *Art and Literature*, X, Autumn 1966, pp. 134–46; 'The Dawn of British Romantic Painting, 1760–1780', in Peter Hughes and David Williams, eds., *The Varied Pattern: Studies in the 18th Century*, Toronto, 1971, pp. 189–210; 'German Painting in International Perspective', in *Correlations between German and Non-German Art in the Nineteenth Century*, special issue of the *Yale University Museum Bulletin*, XXXIII, no. 3, 1972, pp. 23–36; 'Caspar David Friedrich: a Reappraisal', *Studio International*, CLXXXIV, September 1972, pp. 73–5.

1 Friedrich and the divinity of landscape

[1] This phenomenon is discussed by Erwin Panofsky in his *Tomb Sculpture*, New York and London, 1964, pp. 25–26.

[2] Frau von Kügelgen's comments are found in Marie Helene von Kügelgen, *Ein Lebensbild in Briefen* (A. and E. von Kügelgen, eds.), Leipzig, 1901, p. 161. They are translated in Helmut Börsch-Supan, 'Caspar David Friedrich's Landscapes with Self-Portraits', *Burlington Magazine*, CXIV, September 1972, p. 627, note 13.

[3] The X-rays, revealing the painting's original state, are illustrated, and their meaning discussed, in Helmut Börsch-Supan, 'Bemerkungen zu Caspar David Friedrichs "Mönch am Meer"', *Zeitschrift des deutschen Vereins für Kunstwissenschaft*, XIX, 1965, pp. 63–76. The position of the *Monk by the Sea* as prophetic of the existential anxieties of abstract art and as parallel to the equally prophetic innovations of Kleist is provocatively suggested by Philip B. Miller, 'Anxiety and Abstraction: Kleist and Brentano on C. D. Friedrich', *Quarterly Review of Literature*, XVIII, nos. 3–4, 1973, pp. 345–54, a translation, with commentary, of Kleist's revision of Brentano's critique of Friedrich's painting for the *Berliner Abendblätter*, 13 October 1810.

[4] Wilson's painting is discussed in the exhibition catalogue, *La peinture romantique anglaise et les préraphaélites*, Paris, Petit Palais, 1972, no. 336.

[5] The quasi-religious motif of hermits and monks in modern art is considered in Hans Ost, 'Einsiedler und Mönche in der deutschen Malerei des 19. Jahrhunderts', in Ludwig Grote, ed., *Beiträge zur Motivkunde des 19. Jahrhunderts*, Munich, 1970, pp. 199–210.

[6] Indeed, the painting has been interpreted as a self-portrait in Helmut Börsch-Supan, 'Caspar David Friedrich's Landscapes . . .', p. 624.

[7] For particularly perceptive comments on Schleiermacher in the context of the Romantic religious revival, see H. G. Schenk, *The Mind of the European Romantics*, New York, 1969, pp. 111ff. In the literature of art history, the analogy between Schleiermacher and Friedrich has been briefly suggested in Klaus Lankheit, *Revolution und Restauration*, Baden-Baden, 1965, p. 166.

[8] See Karl Barth, *Protestant Theology in the Nineteenth Century, Its Background and History*, London, 1972, pp. 425ff.

[9] This comment, quoted in

Schenk, *op. cit.*, p. 125, is taken from a marginal note about disbelief in God and Christianity in Chateaubriand's 'Essai historique, politique et moral sur les révolutions anciennes et modernes', in *Oeuvres complètes*, I, Paris, 1961, p. 587, note.

[10] The seminal discussion of this secularization of Christian motifs is Edgar Wind's 'The Revolution of History Painting', *Journal of the Warburg Institute*, II, 1938–39, pp. 116–27.

[11] For more on Barret's position at the beginning of Romantic landscape painting, see Robert Rosenblum, 'The Dawn of British Romantic Painting, 1760–1780', in Peter Hughes and David Williams, eds., *The Varied Pattern : Studies in the 18th Century*, Toronto, 1971, p. 192.

[12] Journal entry of 13 October 1769, in P. Toynbee and L. Whibley, eds., *Correspondence of Thomas Gray*, III, Oxford, 1935, pp. 1106–7.

[13] For a useful survey of these artistic transcriptions of sublime nature, see the exhibition catalogue, *Three Centuries of Niagara Falls*, Buffalo Fine Arts Academy, 1964.

[14] See Wilfred S. Dowden, *The Letters of Thomas Moore*, I, Oxford, 1964, pp. 76–7.

[15] Emerson's famous passage is found in *Nature*, Boston, 1836, Chapter I, pp. 12–13.

[16] In his *Neun Briefe über Landschaftsmalerei, geschrieben in den Jahren 1815 bis 1824*, Dresden, 1955; English translation in Lorenz Eitner, ed., *Neoclassicism and Romanticism, 1750–1850 ; Sources and Documents*, II,

Englewood Cliffs, N.J., 1970, p. 48.

[17] For an excellent account of this series, see Erika Platte, *Caspar David Friedrich ; Die Jahreszeiten* (Werkmonographien zur bildenden Kunst in Reclams Universal-Bibliothek, Nr. 65), Stuttgart, 1961.

[18] See *ibid.*, p. 8.

[19] This often quoted criticism is found in F. W. B. von Ramdohr, 'Über ein zum Altarblatte bestimmtes Landschaftsgemälde von Herrn Friedrich in Dresden, und Über Landschaftsmalerei, Allegorie und Mysticismus überhaupt', *Zeitung für die elegante Welt*, 17–21 January 1809, pp. 89ff.

[20] A convenient English translation of this text is found in the exhibition catalogue, *Caspar David Friedrich, 1774–1840 ; Romantic Landscape Painting in Dresden*, London, Tate Gallery, 1972, p. 104.

[21] The analogy with Wordsworth is a traditional one. See Frederick Cummings and Allen Staley, *Romantic Art in Britain ; Paintings and Drawings 1760–1860*, Philadelphia Museum of Art, 1968, no. 114.

[22] For a discussion of these Romantic theories of Gothic architecture, see Paul Frankl, *The Gothic ; Literary Sources and Interpretations through Eight Centuries*, Princeton, 1960, Section III.

[23] In the title, 'Friedrichs Totenlandschaft', a short poem inspired by Friedrich's painting and included in Theodor Körner, *Gedichte und Erzählungen* (2nd ed.), Leipzig, 1815, pp. 52–3.

[24] For a recent attempt to

interpret the *Stages of Life*, see Helmut Börsch-Supan, 'Caspar David Friedrich's Landscapes . . .', pp. 629–30.

[25] The correct identification of this painting was made in an important article by Wolfgang Stechow, 'Caspar David Friedrich und der "Griper"', in *Festschrift für Herbert von Einem*, Berlin, 1965, pp. 241–6.

[26] The classic study of the Romantic ship motif is by Lorenz Eitner, 'The Open Window and the Storm-Tossed Boat; an Essay in the Iconography of Romanticism', *Art Bulletin*, XXXVII, December 1955, pp. 281–90. For a further exploration of the shipwreck and the window motifs, see Jan Białostocki, *Stil ed. cit.*, Edward Hüttinger, 'Der Schiffbruch; Deutungen eines Bildmotivs im 19. Jahrhundert', pp. 211–44; and J. A. Schmoll gen. Eisenwerth, 'Fensterbilder; Motivketten in der Europäische Malerei', pp. 13–166. For the most stimulating general account of the meaning of Romantic motifs, see Jan Białostocki, *Stil und Ikonographie*, Dresden, 1965, pp. 156–81.

[27] For an excellent recent study of this painting, see Louis Hawes, 'Turner's "Fighting Temeraire"', *Art Quarterly*, XXXV, Spring 1972, pp. 22–48.

[28] See *Modern Painters*, III, Chapter XII, in E. T. Cook and Alexander Wedderburn, eds., *The Works of John Ruskin*, V, London, 1904, pp. 201–20.

[29] 'I have seen him [Constable] admire a fine tree with an ecstasy of delight like that with which he would catch up a beautiful child in

his arms.' See C. R. Leslie, *Memoirs of the Life of John Constable* (ed. Jonathan Mayne), London, 1951, p. 282.
30 Another version of this painting—a gouache signed and dated 1850—is discussed in the context of international Romanticism in George Mras, 'Romantic Birch Tree by Johan Christian Claussen Dahl', *Princeton University Art Museum Record*, XXIV, 1965, pp. 12–19.
31 For Cole's comments, see Louis L. Noble, *The Life and Works of Thomas Cole*, New York, 1853, pp. 65–6.
32 See Werner Sumowski, 'Caspar David Friedrich und Carl Julius von Leypold', *Pantheon*, XXIX, November 1971, pp. 497–504.
33 Van Gogh, letter no. 195, 1 May 1882.

II Cosmogonies and mysticism: Blake, Runge, Palmer

1 'Romanticism, then, and this is the best definition I can give of it, is spilt religion.' T. E. Hulme, 'Romanticism and Classicism', in *Speculations* (ed. Herbert Read), London, 1936, p. 118.
2 Quoted in Alec R. Vidler, *The Church in an Age of Revolution*, Harmondsworth, 1961, p. 31.
3 I have already expanded these analogies between Blake and Carstens in 'German Painting in International Perspective', in *Correlations between German and non-German Art in the Nineteenth Century*, special issue of the *Yale University Art Museum Bulletin*, vol. 33, no. 3, 1972, pp. 23ff.
4 On the meaning and art-

historical sources of this frontispiece, see Anthony Blunt, 'Blake's *Ancient of Days*: The Symbolism of the Compasses', *Journal of the Warburg Institute*, II, 1938, pp. 53ff.
5 For an explanation of this obscure iconography, see Alfred Kamphausen, *Asmus Jakob Carstens* (Studien zur Schleswig-Holsteinischen Kunstgeschichte, Band 5), Neumünster in Holstein, 1941, p. 176.
6 *ibid.*, p. 78.
7 In Runge's obituary notice of 19 December 1810. See P. O. Runge, *Hinterlassene Schriften*, II, Hamburg, 1840, p. 552.
8 *ibid.*, I, pp. 23ff.
9 The classic study of the genesis of this painting is that by Otto von Simson, 'Philipp Otto Runge and the Mythology of Landscape', *Art Bulletin*, XXIV, December 1942, pp. 335–50.
10 I am indebted to my student, Ms. Manuela Hoelterhoff, for the precise identification of the Christian symbolism Runge associated with the various flowers in the *Rest on the Flight into Egypt*, an identification she plans soon to publish.
11 In a letter of February 1802. See Runge, *op. cit.*, I, pp. 4ff.
12 Runge's particular parallels with Novalis in the treatment of themes of flowers, children, and light are fully treated in Curt Grützmacher, *Novalis und Philipp Otto Runge, Die Zentralmotive und ihre Bedeutungspphäre, Die Blume—Das Kind—Das Licht*, Munich, 1964.
13 For a stimulating account of this portrait, see [Herbert von Einem] *Das Bildnis der*

Eltern von Philipp Otto Runge (Der Kunstbrief), Berlin, 1948.
14 For a full presentation of the Ivimy Sketchbook, see Martin Butlin (introduction), *Samuel Palmer's Sketchbook, 1824*, London, 1962.
15 On Aders's collection of primitive paintings, so important to Palmer, see Geoffrey Grigson, *Samuel Palmer, the Visionary Years*, London, 1947, pp. 14–15; and *idem*, *Samuel Palmer's Valley of Vision*, London, 1960, p. 4.
16 Quoted in David Cecil, *Visionary and Dreamer, Two Poetic Painters: Samuel Palmer and Edward Burne-Jones*, Princeton, 1969, p. 29.
17 Quoted in Frederick Cummings and Allen Staley, *op. cit.*, no. 181.
18 The painting is fully discussed *ibid.*, no. 184.
19 The source usually cited for Palmer's painting is Dürer's *Self-Portrait* of 1500 (Munich, Alte Pinakothek), but the Van Eyck source, discovered by my student, Ms. Deborah Langer, is far more convincing.

III Van Gogh

1 As in the elaborate, and probably too precise interpretation by Helmut Börsch-Supan in the exhibition catalogue, *Caspar David Friedrich, 1774–1840; Romantic Landscape Painting in Dresden*, London, Tate Gallery, 1972, no. 77.
2 On these funereal allegories, see David C. Huntington, *The Landscapes of Frederic Edwin Church; Vision of an American Era*, New York, 1966, p. 54.
3 *ibid.*, pp. 56–7.
4 Professor Linda Nochlin

kindly informs me that this often-quoted statement, presumably found in a letter to Jules Vallès, may in fact be legendary. In any case, it is cited in, among other places, Pierre Borel, *Le Roman de Gustave Courbet*, Paris, 1922, p. 47; *Les Chefs d'œuvre du Musée de Montpellier*, Paris, Musée de l'Orangerie, 1939, p. 35, no. 29.

5 Courbet's painting is also associated briefly with Friedrich's and Whistler's in Marie-Thérèse de Forges, ed., *Autoportraits de Courbet* (Les Dossiers du département des peintures, 6), Paris, Musée du Louvre, 1973, p. 39.

6 Carlyle's phrase is, in fact, the title of Chapter VIII in *Sartor Resartus*.

7 M. H. Abrams, *Natural Supernaturalism; Tradition and Revolution in Romantic Literature*, New York, 1971.

8 *ibid.*, p. 68.

9 The close connection between Protestantism and the religious attitudes of the Northern Romantics is stressed in the classic study by Hoxie Neale Fairchild, *Religious Trends in English Poetry*, III (1780–1830; Romantic Faith), New York, 1949, especially Chapter III.

10 Van Gogh, letter no. 411, [June?] 1885.

11 See Carl Nordenfalk, 'Van Gogh and Literature', *Journal of the Warburg and Courtauld Institutes*, X, 1947, pp. 141–2.

12 Van Gogh, letter no. 242, [November?] 1882.

13 This botanical symbolism is pointed out in the exhibition catalogue, *La Peinture romantique anglaise et les préraphaélites*, Paris, Petit Palais, 1972, no. 97.

14 For a close reading of the symbolism of this print, see the exhibition catalogue, *Caspar David Friedrich . . .*, 1972, no. 21.

15 Although there are, to be sure, some French Romantic paintings that suggest this kind of empathy, as in the conspicuous example of mournful figure and weeping willow tree by Mme Charpentier, *La Mélancolie* (Salon of 1801; Amiens, Musée de Picardie).

16 Van Gogh, letters nos. 425, 428, October 1885.

17 A watercolor study illustrated in Carlos Peacock, *Samuel Palmer; Shoreham and After*, London, 1968, pl. 8.

18 Particularly good descriptive notes on this and other plates are found in Geoffrey Grigson, ed., *Thornton's Temple of Flora*, London, 1951.

19 Van Gogh, letter no. W22, between 3 and 8 June 1890.

20 Van Gogh, letters nos. W20, 15 February 1890, and W22, between 3 and 8 June 1890.

21 As in letters nos. 526, 527, 528, August 1888.

22 On this triptych, and related sunflower imagery, see Konrad Hoffmann, 'Zu Van Goghs Sonnenblumenbildern', *Zeitschrift für Kunstgeschichte*, XXXI, 1968, pp. 27–58.

23 Van Gogh, letter no. 604, September 1889.

24 Van Gogh, letter no. 632, May 1890.

25 Van Gogh, letter no. B21 (to Bernard), December 1889, and letters nos. 614, 615, November 1889.

26 Van Gogh, letter no. 543, September 1888.

27 Aaron Sheon, 'French Art and Science in the Mid-Nineteenth Century: Some Points of Contact', *Art Quarterly*, XXXIV, Winter 1971, p. 451.

28 In Chapter VIII, *Natural Supernaturalism*, London: Everyman's Library Edition, 1908, p. 198.

29 My own interpretation of Van Gogh's symbolism closely parallels the succinct but stimulating essay by Jan Bialostocki, 'Van Gogh's Symbolik', in *Stil und Ikonographie*, Dresden, 1965, pp. 182–6.

30 Suggested in Helmut Börsch-Supan, 'Caspar David Friedrich's Landscapes with Self-Portraits', *Burlington Magazine*, CXIV, September 1972, p. 623.

31 See the exhibition catalogue, *Caspar David Friedrich . . .*, 1972, p. 90, n. 6.

32 Van Gogh, letter no. 649, 9 July 1890.

33 Meyer Schapiro, 'On a Painting of Van Gogh', originally published in *View*, October 1946, and reprinted in *Perspectives U.S.A.*, no. 1, Fall 1952, and in *Exploring the Arts; an Anthology of Basic Readings* (eds. D. Wolfberg, S. Burton, J. Tarburton), New York, 1969, pp. 155–166.

34 Van Gogh letter no. 219, 23 July 1882.

IV Munch and Hodler

1 Such as those by Franz Servaes, quoted in Reinhold Heller, *Edvard Munch: The Scream* (Art in Context), London and New York, 1973, p. 46.

2 On this Norwegian revival of interest in Friedrich and Dahl, see *ibid.*, pp. 72ff. Munch's relation to Romanticism was also explored in a highly suggestive

lecture given by Werner Timm at the Museum of Modern Art, New York, 11 March 1973.

[3] See the exhibition catalogue, *The Romantic Movement*, London, Arts Council of Great Britain, 1959, no. 135.

[4] To my knowledge, this Peruvian mummy has not been considered as a possible inspiration for Munch's *Scream*, although it has been fully discussed in connection with Gauguin's work in Wayne Andersen, *Gauguin's Paradise Lost*, New York, 1971, pp. 89ff.

[5] On this commission, see Roy A. Boe, 'Edvard Munch's Murals for the University of Oslo', *Art Quarterly*, XXIII, Autumn 1960, pp. 233–46.

[6] Quoted in Frederick B. Deknatel, *Edvard Munch*, New York, 1950, p. 18.

[7] For two important discussions of Munch's religious attitudes and their relation to Nietzsche, see Otto Benesch, 'Edvard Munchs Glaube', and Gösta Svenaeus, 'Der Baum auf der Berg—Zusammenfassung: eine Studie über das Verhältnis Munch-Nietzsche', in *Oslo Kommuners Kunstsamlinger, Årbok 1963* (Edvard Munch 100 år), Oslo, 1963, pp. 102–10, 113–20.

[8] Van Gogh, letter no. W20, 15 February 1890.

[9] See Hugo Wagner, 'Ferdinand Hodler', in *Künstler Lexikon der Schweiz; XX. Jahrhundert*, I, Frauenfeld, 1958–61, p. 443.

[10] Hodler's definition of 'Parallelism' is given in Fritz Burger, *Cézanne und Hodler*, Munich, 1913, pp. 55–56. See

also the lecture given by Hodler in 1897, translated in Peter Selz, *Ferdinand Hodler*, Berkeley, Calif., University Art Museum, 1972–73, pp. 119ff.

[11] Hodler's connections with the origins of modern dance were elaborated by Alessandra Comini in a lecture, 'Dance, Death and the Dream: Hodler's Art Vis-à-Vis the International Scene, 1881–1918', given at the Solomon R. Guggenheim Museum, New York, 25 February 1973.

[12] The classic study of the analogies between Hodler and Cézanne is that by Fritz Burger, *op. cit.*

[13] Peter Selz, *op. cit.*, p. 58.

[14] Analogies among Hodler, Friedrich, and Rothko are mentioned briefly by Selz, *ibid.*, pp. 52, 56.

V The pastoral and the apocalyptic: Nolde, Marc, Kandinsky

[1] For more on these neo-Friedrichian landscapes, see Heiner Stachelhaus, 'Doubts in the Face of Reality; the Paintings of Gerhard Richter', *Studio International*, CLXXXIV, September 1972, pp. 76–80.

[2] Many parallels between Hopper and Friedrich were subtly drawn in a lecture given by Sanford Schwartz, then a graduate student at Columbia University, at the Frick-Institute of Fine Arts Symposium, spring 1971.

[3] See Peter Selz, *Emil Nolde*, New York, 1963, p. 11.

[4] See Emil Nolde, *Das eigene Leben*, Berlin, 1931, pp. 103–4.

[5] An analogy between these seascapes and Turner's was also made in Selz, *op. cit.*, p. 38.

[6] For Nolde's own comments on the *Life of Christ* and on its attack by the Catholic Church at the Brussels exhibition, see Emil Nolde, *Jahre der Kämpfe, 1902–14*, Berlin, 1934, pp. 169ff.

[7] See Hugo von Tschudi, ed., *Ausstellung deutscher Kunst aus der Zeit von 1775–1875 in der Königlichen Nationalgalerie*, Berlin, 1906.

[8] The phrase comes from Marc's essay, 'Die "Wilden" Deutschlands', in Wassily Kandinsky and Franz Marc, eds., *Der Blaue Reiter*, Munich, 1912, p. 31.

[9] That Marc could have known Stubbs's work is unlikely, but he may well have known some of the horse paintings by Stubbs's late eighteenth-century German counterpart, Carl Pitz, who often represented horses peacefully grazing in pastoral landscapes.

[10] This often quoted statement comes from Franz Marc, *Briefe, Aufzeichnungen und Aphorismen*, I, Berlin, 1920, p. 121.

[11] See Franz Marc, *Briefe aus dem Felde*, Munich, 1966, p. 47.

[12] Frederick Spencer Levine, *An Investigation into the Significance of the Animal as a Symbol of Regression and the Representation of the Theme of Apocalypse in the Art of Franz Marc*, Master's Thesis, Washington University, St. Louis, Mo., June 1972, p. 53. I have depended heavily and gratefully on Mr. Levine's thesis for my interpretation— both general and particular— of Marc's *Fate of the Animals* and *Tyrol*.

[13] *ibid.*, pp. 47ff.

[14] Turner's biblical reference is pointed out in the exhibition

catalogue, *La Peinture romantique anglaise et les préraphaélites*, Paris, Petit Palais, 1972, no. 261.

[15] Pointed out in Levine, *op. cit.*, pp. 95ff.

[16] Van Gogh, letter no. 604, September 1889.

[17] See Will Grohmann, *Wassily Kandinsky*, New York, 1958, p. 128. Kandinsky's remarks about the cannons are in a letter of 1913 written to Arthur Jerome Eddy, who reprinted it in his *Cubists and Post-Impressionists*, Chicago, 1914.

[18] For a discussion of these apocalyptic motifs in Kandinsky, see Sixten Ringbom, *The Sounding Cosmos; a Study in the Spiritualism of Kandinsky and the Genesis of Abstract Painting* (Acta Academiae Aboensis, Ser. A., vol. 38, nr. 2), Åbo, 1970, Chapter V.

[19] My interpretation of *Little Pleasures* depends closely upon the revealing article by Rose-Carol Washton Long, 'Kandinsky and Abstraction: the Role of the Hidden Image', *Artforum*, X, June 1972, pp. 42–49.

VI Other Romantic currents: Klee to Ernst

[1] For further details see Frederick Spencer Levine, *op. cit.*, pp. 16–17.

[2] From journal of June 1902, quoted in *Paul Klee*, New York, The Museum of Modern Art, 1945, p. 8.

[3] For the fullest and subtlest discussion of Klee's relation to the art of children and of the general question of the early twentieth-century search for simplicity and purity, see Robert Goldwater,

Primitivism in Modern Art, New York, 1967, especially pp. 199ff.

[4] For a convenient English translation of the 'Creative Credo', see Victor Miesel, ed., *Voices of German Expressionism*, New York, 1970, pp. 83–88.

[5] *ibid.*, p. 87.

[6] Carl Gustav Carus, *Neun Briefe über Landschaftsmalerei, geschrieben in den Jahren 1815 bis 1824*, Dresden, 1955.

[7] Miesel, *ibid.*

[8] The analogies between Feininger and Friedrich were first pointed out by Alfred H. Barr in *Lyonel Feininger— Marsden Hartley*, New York, The Museum of Modern Art, 1944, p. 11. See also Hans Hess, *Lyonel Feininger*, New York, 1961, p. 100. For a more general treatment of the question, see Alfred Werner, 'Lyonel Feininger and German Romanticism', *Art in America*, XLIV, Fall 1956, pp. 23–27.

[9] In a questionnaire included in Barr, *op. cit.*

[10] See William S. Lieberman, ed., *Lyonel Feininger; the Ruin by the Sea*, New York, The Museum of Modern Art, 1968.

[11] On the relation of Sutherland to Palmer, whom he thought of as 'a sort of English Van Gogh', see Douglas Cooper, *The Work of Graham Sutherland*, London, 1961, pp. 7–8.

[12] Quoted in Anthony Bertram, *Paul Nash: the Portrait of an Artist*, London, 1955, pp. 272–73.

[13] In 'On Painting; Notes by the Artist', reprinted in *An Exhibition of Paintings and Drawings by Graham Sutherland*, Arts Council of Great Britain, 1953, pp. 7–9.

[14] Patrick Waldberg, *Max

Ernst*, Paris, 1958, p. 287.

[15] These destroyed paintings are illustrated in Georg Jacob Wolf, ed., *Verlorene Werke deutscher romantischer Malerei*, Munich, 1931.

[16] Waldberg, *ibid.* John Russell has remarked that 'many of his [Ernst's] paintings of the 1930's are, in effect, elegies for Friedrich'. (*Max Ernst*, New York, 1960, p. 111.)

[17] Heinrich von Kleist, *Caspar David Friedrich 'Paysage marin avec un capucin'*, illustré et traduit de l'allemand par Max Ernst, Zürich, Hans Bolliger, 1972.

VII Mondrian

[1] On Čiurlionis, see the special issue of *Lituanus*, VII, no. 2, June 1961. In an article in this homage, George M. Hanfmann specifically mentions the affinity between Ciurlionis and Friedrich (p. 31).

[2] On Kupka and spiritualism (he was a medium in Paris), see Ludmilla Vachtova, *Frank Kupka*, London, 1968, p. 17. His cosmological works are discussed *ibid.*, Chapter IV.

[3] Specifically, the painting may reflect the work of the nineteenth-century Dutch painter, J. Th. Abels, as suggested by Robert Welsh in *Piet Mondrian, 1872–1944*, The Art Gallery of Toronto, 1966, no. 2 (hereafter referred to as Welsh-Toronto).

[4] On the self-portrait drawings, see *ibid.*, nos. 50a, 50b.

[5] For a discussion of the relation of these works to the mood of Symbolist art, see Martin James, 'Mondrian and the Dutch Symbolists', *Art Journal*, XXIII, no. 2, Winter

1963–4, pp. 103–11.

6 See Robert Welsh, 'Mondrian and Theosophy', in *Piet Mondrian, 1872–1944, Centennial Exhibition*, New York, The Solomon R. Guggenheim Museum, 1971, pp. 35ff.

7 In the essay by Welsh, *op. cit.* My reading of these theosophist works of Mondrian depends almost entirely upon Welsh's interpretations.

8 Mondrian's connection with the Roland-Holst cover design is mentioned by James, *op. cit.*, p. 103. For more on the Roland-Holst cover design, see Bettina Polak, *Het fin-de-siècle in de nederlandse schilderkunst*, The Hague, 1955, pp. 253ff.

9 On flowers, Steiner, and Goethe, see Welsh, *op. cit.*, pp. 40ff.

10 *ibid.*, pp. 48–49.

11 See Welsh-Toronto, no. 51.

12 *ibid.*, no. 54.

13 For possible allusions to Theosophy in the *Red Mill*, see *ibid.*, no. 59.

14 Welsh, 'Mondrian and Theosophy', p. 50.

15 On the whole question of the Romantic origins of abstract art, see Klaus Lankheit, 'Die Frühromantik und die Grundlagen der "gegenstandlosen" Malerei', *Neue Heidelberger Jahrbücher*, N.F., 1951, pp. 55–90.

16 See Robert P. Welsh and J. M. Joosten, *Two Mondrian Sketchbooks, 1912–1914*, Amsterdam, 1969.

17 Welsh, 'Mondrian and Theosophy', p. 50.

18 For examples of such fusions of separate motifs, see *Piet Mondrian, 1872–1944, Centennial Exhibition*, New York, The Solomon R. Guggenheim Museum, 1971,

no. 63, a drawing identified as either church façade or tree; or Welsh-Toronto, no. 78, a drawing that fuses both the Pier and Ocean and the Notre-Dame des Champs motifs.

19 These diamond-shaped funerary plaques are frequently depicted in seventeenth-century Dutch paintings of church interiors, most conspicuously in those by Sanraedam.

VIII Abstract expressionism

1 *Augustus Vincent Tack, 1870–1949; Twenty-Six Paintings from The Phillips Collection*, University Art Museum, The University of Texas at Austin, 1972. For a useful checklist of Tack's work, his exhibition record, etc., see also *Augustus Vincent Tack, 1870–1949*, The American Studies Group, Deerfield Academy, Deerfield, Mass., 1968. See also *Augustus Vincent Tack; Loan Exhibition of Seventeen Abstract Paintings from the Phillips Collection*, Washington, D.C., University of Rhode Island Fine Arts Center, Kingston, R.I., 1973.

2 Quoted by Eleanor Green in her excellent introductory essay to the University of Texas catalogue, col. 16. The essay is conveniently reprinted in *Artforum*, XI, October 1972, pp. 56–63.

3 *Tri-Unit Exhibition of Painting and Sculture*, Phillips Memorial Gallery, Washington, D.C., October 1928–January 1929, p. 16; reprinted in Duncan Phillips, *The Artist Sees Differently*, New York, 1931, p. 96.

4 See the unsigned statement about Still in *Magazine of Art*,

XLI, March 1948, p. 96.

5 See Irving Sandler, *The Triumph of American Painting; a History of Abstract Expressionism*, New York, 1970, p. 162.

6 Pollock's statement of 1944, 'The only American master who interests me is Ryder', is quoted in Bryan Robertson, *Jackson Pollock*, London and New York, 1960, p. 193.

7 See A. J. Finberg, *The Life of J. M. W. Turner, R. A.*, Oxford, 1939, p. 241.

8 On this and other solar and lunar paintings by Dove, see Frederick S. Wight, *Arthur G. Dove*, Berkeley and Los Angeles, 1958, pp. 66ff.

9 In Still's catalogue statement for *Fifteen Americans*, New York, The Museum of Modern Art, 1952, p. 21.

10 Quoted in Sandler, *op. cit.*, p. 167.

11 *ibid.*

12 See Thomas B. Hess, *Barnett Newman*, New York, The Museum of Modern Art, 1971, p. 52.

13 Vol. I, no. 6, 15 December 1948, pp. 51–53.

14 Hess, *op. cit.*, p. 56. On Newman and the theme of creation, see also David Sylvester, 'Concerning Barnett Newman', *The Listener*, LXXXVIII, 10 August 1972, pp. 169–72.

15 Hess, *op. cit.*, pp. 59ff.

16 *ibid.*, pp. 82–83.

17 On the *Stations of the Cross*, see the important essay by Lawrence Alloway in the exhibition catalogue, *Barnett Newman: The Stations of the Cross, Lema Sabachthani*, New York, The Solomon R. Guggenheim Museum, 1966.

18 The relationship between Jewish abstract artists and the traditions of Jewish icono-

clasm was suggested briefly but provocatively in George H. Hamilton, 'Painting in Contemporary America', *Burlington Magazine*, CII, May 1960, p. 193.

[19] In 'The Romantics were Prompted', *Possibilities 1*, no. 1, Winter 1947–8, p. 84; quoted in Sandler, *op. cit.*, p. 175.

[20] For many perceptive comments on Rothko and Romantic traditions, including analogies with Friedrich, see Brian O'Doherty, 'Rothko', *Art International*, XIV, 20 October 1970, pp. 30–44.

[21] In Selden Rodman, *Conversations with Artists*, New York, 1957, pp. 93–4. This important statement was called to recent critical attention in William Seitz, 'Mondrian and the Issue of Relationships', *Artforum*, X, February 1972, p. 74, note 3.

[22] For some useful accounts of the chapel and its history, see D. de Ménil, 'Rothko Chapel, Institute of Religion and Human Development, Houston, Texas', *Art Journal*, XXX, Spring 1971, pp. 249–51; David Snell, 'Rothko Chapel—the Painter's Final Testament', *Smithsonian*, II, April 1971, pp. 46–54; J. P. Marandel, 'Une chapelle œcumenique au Texas', *L'Œil*, no. 197, May 1971, pp. 16–19; and Brian O'Doherty, 'The Rothko Chapel', *Art in America*, LXI, January–February 1973, pp. 14–20.

[23] For a general consideration of the triptych as an expressive format, tracing its evolution from figurative to abstract examples (such as that of 1957–58 by Heinz Kreutz), see Klaus Lankheit, *Das Triptychon als Pathosformel* (Abhandlungen der Heidelberger Akademie der Wissenschaften, no. 4), Heidelberg, 1959.

List of Illustrations

Oil on canvas,
$40\frac{1}{2} \times 47\frac{1}{4}$ (103×120).
Kunsthistorisches Museum,
Vienna.

NASH, PAUL (1889–1946)

243 *Totes Meer*, 1940–41.
Oil on canvas,
40×60 ($101 \cdot 6 \times 152 \cdot 4$).
Tate Gallery, London.

NEWMAN, BARNETT (1905–70)

304 *Genesis—the Break*, 1946.
Oil on canvas,
24×27 ($61 \times 68 \cdot 6$).
Collection Ruth Stephan
Franklin.

305 *The Command*, 1946.
Oil on canvas,
48×36 ($122 \times 91 \cdot 5$).
Collection Annalee Newman.

306 *Onement I*, 1948.
Oil on canvas,
27×16 ($68 \cdot 6 \times 40 \cdot 7$).
Collection Annalee Newman.

307 *Cathedra*, 1951.
Oil and magna on canvas,
96×213 ($245 \cdot 2 \times 542 \cdot 2$).
Collection Annalee Newman.

308 *The Stations of the Cross,
the First Station*, 1958.
Magna on canvas,
78×60 ($198 \times 152 \cdot 4$).
Estate of the Artist.

NOLDE, EMIL (1867–1956)

194 *Before Sunrise*, c. 1894.
Watercolour,
$3\frac{1}{4} \times 4$ ($8 \cdot 4 \times 10 \cdot 2$).
Nolde-Stiftung, Seebüll.

195 *The Matterhorn Smiles*, c. 1894.
Postcard,
$5\frac{3}{4} \times 4\frac{1}{8}$ ($14 \cdot 9 \times 10 \cdot 5$).
Nolde-Stiftung, Seebüll.

197 *Marsh Landscape (Evening)*, 1916.
Oil on canvas,
$29 \times 39\frac{1}{2}$ ($73 \cdot 5 \times 100 \cdot 5$).
Kunstmuseum, Basel.

198 *Steam Tug on the Elbe*, 1910.
Oil on canvas,
$28 \times 34\frac{3}{4}$ (71×88).
Private collection, West
Germany.

200 *Sunflowers*, 1932.
Oil on canvas,
29×35 ($73 \cdot 7 \times 89$).
Detroit Institute of Arts, Gift of
Robert H. Tannahill.

201 *Life of Christ*, 1911–12.
Oil on canvas,

central panel $86\frac{1}{2} \times 75\frac{1}{4}$ ($220 \times$
191), each side panel $39\frac{3}{8} \times 33\frac{3}{4}$
(100×86).
Nolde-Stiftung, Seebüll.

202 *The Family*, 1931.
Oil on canvas,
$44 \times 29\frac{1}{8}$ ($111 \cdot 5 \times 74$).
Nolde-Stiftung, Seebüll.

203 *The Great Gardener*, 1940.
Oil on canvas,
$29 \times 23\frac{1}{4}$ ($73 \cdot 5 \times 59$).
Collection Sprengel, Hanover.

O'KEEFFE, GEORGIA (1887–)

192 *Cross by the Sea, Canada*, 1932.
Oil,
36×24 ($91 \cdot 5 \times 61$).
Currier Gallery of Art,
Manchester, New Hampshire.

295 *Red Hills and Bones*, 1941.
Stieglitz Collection.

303 *Evening Star III*, 1917.
Watercolour,
$9 \times 11\frac{3}{4}$ ($22 \cdot 9 \times 29 \cdot 9$).
The Museum of Modern Art,
New York, Mr and Mrs Donald
B. Straus Fund.

310 *Red Hills and Sky*, 1945.
Oil on canvas,
30×40 ($76 \cdot 2 \times 101 \cdot 6$).
Private collection.

311 *Light Coming on the Plains, II*,
1917.
Watercolour,
12×9 ($30 \cdot 5 \times 22 \cdot 9$).
Courtesy Amon Carter Museum,
Fort Worth, Texas.

PALMER, SAMUEL (1805–81)

61 *Study for a Resurrection*, 1824.
Drawing from Ivimy
Sketchbook,
$7\frac{1}{2} \times 4\frac{1}{2}$ ($19 \cdot 1 \times 11 \cdot 5$).
British Museum, London.

62 *Study for Altarpiece*, 1824.
Drawing from Ivimy
Sketchbook,
$7\frac{1}{2} \times 4\frac{1}{2}$ ($19 \cdot 1 \times 11 \cdot 5$).
British Museum, London.

63 *Study for the Creation*, 1824.
Drawing from Ivimy
Sketchbook,
$7\frac{1}{2} \times 4\frac{1}{2}$ ($19 \cdot 1 \times 11 \cdot 5$).
British Museum, London.

66 *Rest on the Flight into Egypt*,
c. 1824–25.
Oil on panel,
$12\frac{1}{4} \times 15\frac{3}{8}$ (31×39).
Ashmolean Museum, Oxford.

67 *Study for Shepherd and Flock*,
1824.
Drawing from Ivimy
Sketchbook,
$7\frac{1}{2} \times 4\frac{1}{2}$ ($19 \cdot 1 \times 11 \cdot 5$).
British Museum, London.

68 *Coming from Evening Church*,
1830.
Oil and tempera on canvas,
$12 \times 7\frac{1}{2}$ (31×20).
Tate Gallery, London.

70 *Moonlit Landscape*, c. 1829–30.
Pencil and sepia wash,
$3\frac{3}{4} \times 4\frac{1}{2}$ ($9 \cdot 4 \times 11 \cdot 5$).
The Art Museum, Princeton
University.

71 *The Harvest Moon*, c. 1830–31.
Watercolour and gouache,
$4\frac{3}{4} \times 5\frac{1}{2}$ ($12 \cdot 1 \times 14$).
Carlisle Art Gallery.

72 *Pastoral with Horsechestnut*,
1831–32.
Oil on panel,
$11\frac{3}{4} \times 15\frac{3}{4}$ (30×40).
Ashmolean Museum, Oxford.

73 *Pear Tree Blossoming in a
Walled Garden*, c. 1829.
Watercolour and gouache,
$8\frac{3}{4} \times 11\frac{1}{8}$ (22.2×28.3).
Collection Mr and Mrs E. V.
Thaw.

76 *Self Portrait*, c. 1826.
Black chalk, heightened with
white, on buff paper,
$11\frac{1}{2} \times 9$ ($29 \cdot 1 \times 22 \cdot 9$).
Ashmolean Museum, Oxford.

77 *Portrait of the Artist as Christ*,
c. 1833.
Oil on panel,
$13\frac{1}{2} \times 9\frac{1}{2}$ ($34 \cdot 3 \times 24 \cdot 1$).
Collection Kerrison Preston.

239 *The Bellman*, completed 1879.
Etching,
$7\frac{1}{2} \times 10$ ($19 \cdot 1 \times 25 \cdot 2$).
The Art Museum, Princeton
University.

POLLOCK, JACKSON (1912–56)

297 *Autumn Rhythm*, 1950.
Oil on canvas,
105×207 (267×527).
Metropolitan Museum of Art,
New York, George A. Hearn
Fund, 1957.

298 *The Flame*, 1937.
Oil on canvas,
$20\frac{1}{8} \times 30\frac{1}{8}$ ($51 \cdot 2 \times 76 \cdot 4$).
Collection Lee Krasner Pollock,
Courtesy of Marlborough

Photographic Acknowledgments

ACL, Brussels: 6, 9, 69.
Bulloz: 171, 245.
Courtesy Christie's: 90.
Courtauld Institute of Art,
London: 56, 77, 143, 144.
Giraudon: 8, 31, 80, 88.

Solomon R. Guggenheim
Museum, New York: 265,
269.
Mas, Barcelona: 4, 10, 11.
Munch-museet, Oslo: 167, 168.
National Film Archive: 190.
Réunion des Musées Nationaux,
Paris: 7.

Rheinisches Bildarchiv,
Cologne: 44.
Schweizerisches Institut für
Kunstwissenschaft, Zurich:
175.
Eileen Tweedy: 82, 240.

Index

Figures in italic refer to illustrations